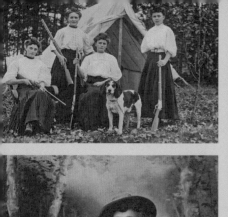

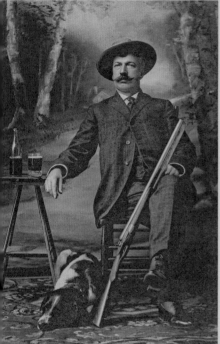

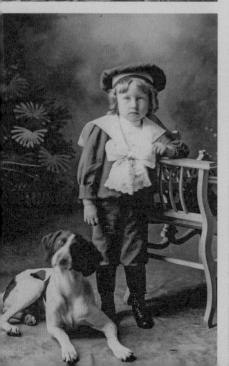

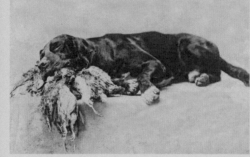

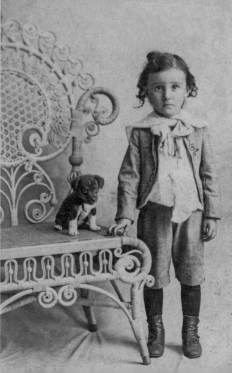

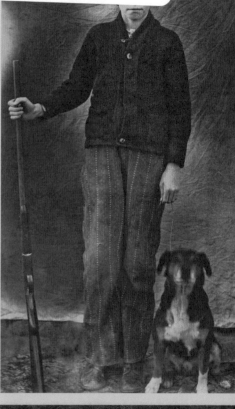

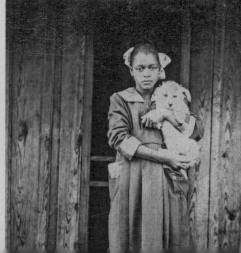

PICTURING DOGS, SEEING OURSELVES

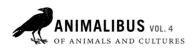

ANIMALIBUS VOL. 4
OF ANIMALS AND CULTURES

Nigel Rothfels and Garry Marvin,
GENERAL EDITORS

ADVISORY BOARD:
Steve Baker
University of Central Lancashire
Susan McHugh
University of New England
Jules Pretty
University of Essex
Alan Rauch
University of North Carolina at Charlotte

*Books in the Animalibus series share a
fascination with the status and the role of
animals in human life. Crossing the humanities and the social sciences to include work
in history, anthropology, social and cultural
geography, environmental studies, and
literary and art criticism, these books ask
what thinking about nonhuman animals
can teach us about human cultures, about
what it means to be human, and about how
that meaning might shift across times and
places.*

OTHER TITLES IN THE SERIES:
Rachel Poliquin, *The Breathless Zoo:
Taxidermy and the Cultures of Longing*
(VOLUME 1)

Joan B. Landes, Paula Young Lee, and
Paul Youngquist, eds., *Gorgeous Beasts:
Animal Bodies in Historical Perspective*
(VOLUME 2)

Liv Emma Thorsen, Karen A. Rader, and
Adam Dodd, eds., *Animals on Display: The
Creaturely in Museums, Zoos, and Natural
History* (VOLUME 3)

PICTURING DOGS, SEEING OURSELVES

[VINTAGE AMERICAN PHOTOGRAPHS]

ANN-JANINE MOREY

THE PENNSYLVANIA STATE UNIVERSITY PRESS, UNIVERSITY PARK, PENNSYLVANIA

Library of Congress
Cataloging-in-Publication Data

Morey, Ann-Janine, author.
Picturing dogs, seeing ourselves : vintage American
photographs / Ann-Janine Morey.
 p. cm — (Animalibus : of animals and
cultures ; Volume 4)
Summary: "Explores antique photographs of people
and their dogs to expand the understanding of visual
studies, animal studies, and American culture. Uses
the canine body as a lens to investigate the cultural
significance of family and childhood portraits,
pictures of hunters, and racially charged images"—
Provided by publisher.
Includes bibliographical references and index.
ISBN 978-0-271-06331-7 (cloth : alk. paper)
1. Photography of dogs
2. Human-animal relationships—United States.
3. Dogs—Symbolic aspects—United States.
I. Title. II.
Series: Animalibus ; v. 4.

TR729.D6M67 2014
779'.329772—dc 3
2013046852

The Pennsylvania State University Press is a member
of the Association of American University Presses.

It is the policy of The Pennsylvania State University
Press to use acid-free paper. Publications on
uncoated stock satisfy the minimum requirements
of American National Standard for Information
Sciences—Permanence of Paper for Printed Library
Material, ANSI Z39.48–1992.

FRONTISPIECE: Unused RPPC, 1910–1918, 8.6 × 13.8 cm.

Designed by Regina Starace

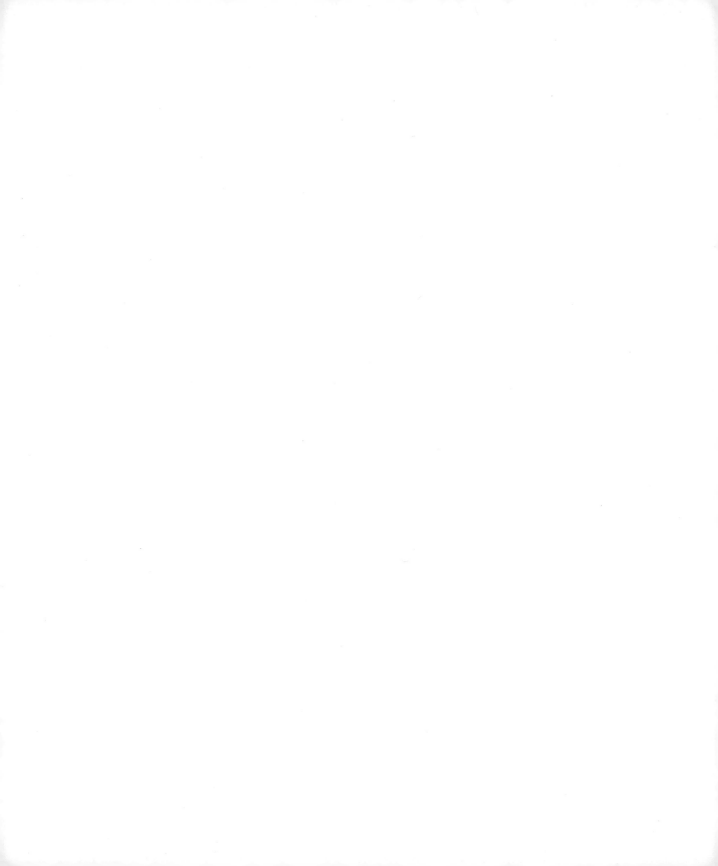

CONTENTS

PREFACE

[SOME WORDS ABOUT THE PICTURES]

I began my career as a religious studies professor, but I've been an English professor for the last twenty years, so it's safe to say that no matter where I've been in my career, I've lived by words, if not "the word." I never planned on writing a book about pictures, although I have always had dogs, as have my sister and my brother, the latter of whom is the anthropologist who documents the funerary tenderness between dogs and ancient human civilizations (see the introduction). Yet my own family history I pretty much took for granted until one day—sometime in the mid-1990s—I was reading a library book and a picture fell from its pages. It was a trimmed snapshot of a woman sitting on the grass with her dog, probably dating from the 1920s. The original is sepia toned, which adds to the gentleness of the image, but I was pleased with the way in which the woman was gazing so thoughtfully at the dog, who is occupied with something beyond the frame but leaning comfortably against her. I kept the picture because I liked it, not anticipating how much I would later enjoy the symbolism of having the image come tumbling from the words.

Several years later I was rummaging around in an antique store and decided to flip through the photo postcards. I came across two more pictures. One of them is a small image of a pretty young woman who has posed herself and her dogs for a picture. She's thoughtfully provided not only a chair for one dog but also a blanket to cushion the chair for the alert dog, and her proprietary hand indicates her ownership of the moment. She is proud in her stance, and her handsome dog seems to mirror her posture. Her dress is a functional work dress, and the outdoor setting suggests a farm or even frontier setting.

The other is "Buster," so identified by the good-humored message on the back, addressed to G. M. Sneed of McLeansboro, Illinois: "This is Buster Dimond [?]. what do you think of him. Lovingly, Sister Sue." This portrait reminded me of one

FIGURE 1

Unused RPPC, 1908,
5.5 × 8.7 cm.

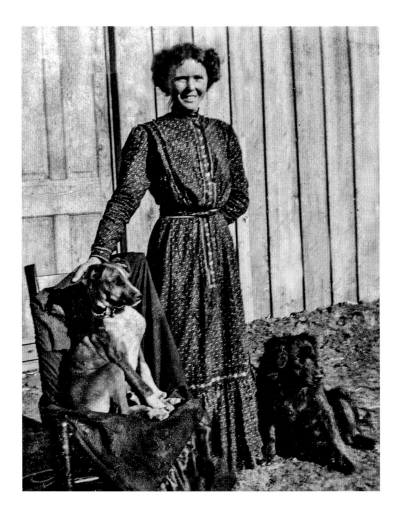

of my own family dog pictures, and in pursuing my topic, I discovered that it was common for people in the late nineteenth century and early twentieth century to produce solo portraits of their dogs, who sometimes became the subject of a post-card message. Charmed, I began collecting, and in doing so found an unexpected way not only to discover my own visual intelligence but also to redeem a childhood of reading beloved dog stories at the same time. In time, the words—stories—took a back seat to the photographs, which was another unexpected outcome for me.

I'm not the first person to collect antique photographs of people and their dogs. Barbara and Jane Brackman, for example, present a collection of informal and formal photographs, pairing their collection with comments about dogs over time. Their work testifies to the appeal of the human-dog relationship, but the

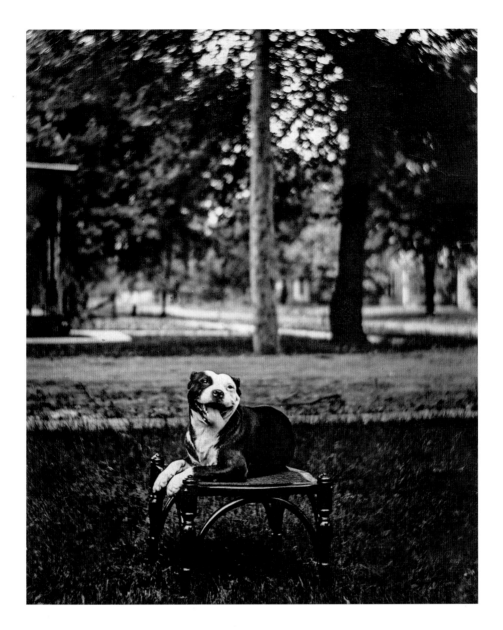

FIGURE 2

Buster. Used RPPC, 1911,
8.7 × 13.7 cm.

appended comments about dogs rarely have any historical connection to the picture at hand. Libby Hall has produced several beautiful volumes of pictures that are worldwide in their scope, but she presents her pictures solely to document the dog love of previous generations, not as artifacts suggestive of further meaning. The same is true of a similar collection offered by Gary Eichhorn and Scott Jones.

Moreover, Hall and Eichhorn and Jones prefer formal portraits, which means that their collections have a fairly narrow social dimension as well.

Other photo collections offer a much wider social perspective in terms of white owners particularly. Donna Long offers some historically pertinent information about the various dog breeds that appear in her collection of cute kids and dogs. Cameron Woo gathers his collection—*Photobooth Dogs*—by location. Catherine Johnson's book *Dogs* presents more than four hundred cabinet cards, *cartes de visite*, and snapshots of people and dogs, coupling the photos with ahistorical quotations in honor of dogs. Ruth Silverman's *The Dog Observed: Photographs, 1844–1983* begins with antique photos where we often don't know the photographer, but focuses on images by famous photographers as we move through the volume. The purpose of these collections is to demonstrate the enduring affection between people and dogs. For example, Barbara Cohen and Louise Taylor gathered portraits in *Dogs and Their Women* to celebrate "the loving relationship that women have with their dogs,"[1] and they couple their portraits with comments about the dog from the woman in the picture. In fact, all of the editors of these collections suggest the same goal, sharing their enjoyment of these pictures as any dog enthusiast would. They aren't pursuing historical accuracy in these collections; they are documenting emotional and spiritual commitment over time.

This also means that no work considers what the dog in the photograph might mean beyond the visual surface of the subject. My work picks up from this documentation in order to delve more deeply into the cultural revelations that might arise from considering a collection as a visually expressive vehicle of cultural values. For example, there is a photograph toward the back of Johnson's book of two white people in a doorway with a group of Great Danes. The dogs are facing the white people, clustered around them as if looking for a treat. To their left is a black woman dressed in white (perhaps a maid's uniform) and a black man with his hat in hand. If this image were part of my collection, I'd probably suggest that the white people are displaying their possession of the dogs and the hired help. Perhaps there is other information about the photo that would clarify the relationships of the people, but in its absence, the visual information that I present in chapter 3 urges us to attend to these racial dimensions.

No archive is value neutral, and this statement certainly includes one as modest as what I present here. Paula Amad comments on the seeming objectivity of archival collections, noting that we should be aware of how much an archive is "produced, ideological, and often deeply personal."[2] To illustrate from the *Picturing Dogs* collection, in order for these photographs to be available, their originators or owners had to have the means of preserving them. So we have many more artifacts

from middle- and upper-class subjects than from the working class and poor. I had to have the time to look for them and the financial means to purchase them, both class-based elements. The process of selection was subject to my liberal arts educational framework, along with my class, gender, and racial biases. I gravitated toward pictures of women, for example. And then my intuitions were in play as well. I often purchased a photograph without being able to say at the time why it seemed important. But as the collection grew, so did my vision of what was required to tell the emerging story.

Other factors that shaped the collection may also be significant. In contrast to some of the sources mentioned above, I prefer informal poses to formal studio portraits, although I use both. Unlike a collector, I have not been concerned with acquiring a pristine image, feeling that a battered image was also part of the record, although I have sometimes improved the clarity of the digital image with Photoshop. My collection was sometimes limited by cost, and since I began collecting, most of the traffic in photographic images has been rerouted through the Internet. It is increasingly rare to find a good image by canvassing antique stores.

The cost of clean images in cabinet-card or *carte-de-visite* format (I discuss the various image formats in chapter 1) can range from $9.99 to $50, with real photo postcards commanding somewhat less. When toys or guns are part of the ensemble, images of people and dogs may cost anywhere from $75 to $200. Photographs of African Americans with dogs are rarer, and an image in good condition can sell for several hundred dollars. In the case of material on African Americans and dogs, I have looked at many more images than I own, including major collections of African American photography housed at Yale University and the New York City Public Library.

Over the past decade, I've gathered more than three hundred antique photographs of people with their dogs. While the collection ranges from a possible early date of 1860 to the mid-twentieth century, most of the images date from the late nineteenth and early twentieth centuries. When possible, I indicate dates or decade frames, but these attributions are necessarily tentative because very few of the pictures are actually dated. The easiest photographs to date are the real photo postcards, because the stamp box and lettering, along with postmarks, can place the card within several years of its origin. There are also guidelines for dating cabinet cards and *cartes de visite* based upon the thickness, cut, and embellishment of the cards, although these standards are difficult to use without expert guidance. In most cases I have been content with identifying a decade, unless there is something particular to an image that narrows the time frame. Sometimes clothing can be helpful, and I have used several sources to better identify the time frame

and the content of the image itself, relying largely upon Joan Severa's beautiful presentation in *Dressed for the Photographer: Ordinary Americans and Fashion, 1840–1900*, supplemented by Olian, Blum, Dalrymple, and Harris.[3]

For dating snapshots, I used my dad's collection of family photographs. By comparing sizes and formats with dated images in his collection, I devised a rough template for approximating dates. For those pictures, not only was clothing helpful, but the appearance of the family automobile also indicated a rough time frame. In addition to the obvious vagaries and uncertainties of dating, most of my photographs come from persons and contexts unknown, so any conclusion about a single photograph must be taken as suggestion, not fact. Having said that, however, the operating perspective of the book assumes that while no single photograph can have meaning by itself, these photographs do have meaning as a collection. They were gathered randomly at first. I simply bought pictures that appealed to me visually. I took pleasure in looking at them, and in contacting local historical societies in an effort to identify persons or dates. When I discuss the several image formats (chapter 1), I offer some average measurements for each format that include the backing and framing. But in the text, I measured only the image itself and did not include the borders around it or the backing material. The size of each image is given in centimeters for greater precision. What I discovered in the process of looking at the pictures was the cultural force of a shared visual rhetoric. I added to this sense of visual coherence my own childhood reading of dog stories, which, I realized, could illustrate what I was seeing in the photographs. Finally, I consulted a number of authorities in cultural studies, with special attention to scholars working across a variety of disciplines in animal studies. How and why we represent animals—in this instance, dogs—becomes more than a pleasant historical moment when viewed as part of larger cultural patterns. I submit that we can better understand the broad fabric of cultural attitudes and values by looking at the artifacts that have been left behind, and by assembling them in ways that restore at least the public portion of the cultural story that gave them life. I also assert that the role of visual and material culture in shaping and sustaining cultural values and prejudices has yet to be fully reckoned or integrated, so much have we been a people absorbed by words and narrative. Women and African Americans in particular have long been cognizant of the power of visual images to free or constrain a person, and the struggle of identity and self-determination for many people on American soil has been a matter of recognizing that "the field of representation (how we see ourselves, how other see us) is a site of ongoing struggle."[4] While not every discussion in the pages that follow is about cultural struggle, I was astonished by how a topic that had seemed so simple and transparent—pictures of people with

their dogs—proved to be far more enigmatic than I could have imagined. Perhaps that enigma can be traced directly to the dog itself, which, in the historical record, is treated with great tenderness and love but also with disgust and cruelty. Because of the dog's uncanny ability to adapt to our cultural expectations and reflect our emotions, the canine is a mirror of ourselves and our society, and so we have treated and used the dog in ways that reinforce this atavistic ambivalence. Or, to use another metaphor, our relationship with dogs is steeped in all the contradictory and multiple purposes of any great passion, bringing us great comfort and love or great satisfaction in our ability to dominate and hurt. Both elements—comfort and love, domination and hurt—tell the story of our romance with dogs, and this collection of photographs brings us closer to that story in ways that words alone cannot.

ACKNOWLEDGMENTS

We are so bombarded with communication that it's difficult to find time to read or consider pictures at length, much less reflect upon what we've encountered. So it took me a long time to write this book, because thinking doesn't always happen on a convenient schedule. I have been fortunate to have colleagues and friends who encouraged me to protect that reflective space and take my time. My writing group—Melissa Aleman, Erica Bleeg, Dolores Flamiano, and Laurie Kutchins, all gifted writers —were wise, kind, and critical in just the right proportions, and I am grateful for their support and encouragement. Julie Caran was a sounding board for early material, and her sensitivity to visual and verbal nuance encouraged me to improve my own encounter with the pictures. Kristi McDonnell recovered one chapter for me, and rescued several others from my formatting. She also improved a scruffy image of Buster Brown whose rehabilitation was beyond my skills. Kristi tactfully offered cheerful support and know-how when she heard muttering coming from my office, a considerable contribution to the book as far as I was concerned.

Many people volunteered their own pictures, bought me pictures, or looked at my pictures with me, and every single such instance became part of my education for this book. For keeping me company with pictures, I thank Mary Handley, Kathleen Newcomb, David Dillard, Alton Mosley, Susan Ghiacuic, Laney Lindor, Don and Mart Morey, Heidi Collar, Vince Drumheller, Tom Barr, Gina Niemi, Kristi Shackelford, Melissa Aleman, Rachel Bowman, Maureen Shanahan, Scott Jost, Mark Tueting, and Paul Bogard. In particular, I want to note my sister's support for this project. Laney Lindor started looking for pictures for me, and the first one she sent me contained a dog statue, not a living dog. I had been ignoring these, but when I held the picture in my hands, the import of the fake dog jumped out at me, because the dog in this particular picture was so small (see fig. 34). Because

of Laney, chapter 2 took far better shape than it would have otherwise, and I am so fortunate in the dog love and sister love Laney has shared with me.

Colleagues near and far lent their considerable knowledge to my project. I laughed in surprise when Kevin Borg commented enthusiastically on the automobiles in the pictures, which I had barely noticed. He kindly set me straight, and applied his car expertise to several dating questions. Tom Barr was disappointed that I didn't want to learn how to shoot a gun, but he generously took time to identify weapons in the hunting pictures. Jo-Ann Morgan, Mary Zeiss Stange, Ross Kelbaugh, Robert Bogdan, David Kidd, Mark Parker, Ken W. Goings, and Patricia Hills communicated with me about my pictures and/or my writing. Their combined interest and expertise helped me write a better book.

Additionally, I contacted many public libraries and historical societies, looking for information about photographers or subjects that would assist me in dating or placing my images in their original context, and I want to list here the kind people who responded, even when they couldn't turn up information for me: Carolyn Etchison at the Tipton County Heritage Center (Indiana), Lyn Martin at Willard Library (Evansville, Indiana), Kelly Halbert at the Des Moines County Historical Society, Shannon Simpson at the Ellis County Museum (Texas), Darlene Grams at the Blooming Prairie Branch Library (Minnesota), Karen Davis at the Sylvester Memorial Wellston Public Library (Ohio), Craig Pfannkuche and Holly Haupt at the McHenry County Historical Society (Illinois), Nancy Claypool at the Marshall Public Library (Illinois), Paul W. Schopp, John McCormick, and Gary Saretsky at the Riverton Historical Society (New Jersey), a thorough correspondent for the Chicago History Museum, and Chris, who responded on behalf of the Southwest Michigan Business and Tourism Directory. After *Picturing Dogs* is published, I will be donating photographs with studio identification to local historical societies.

I also want to acknowledge the array of colleagues affiliated with Pennsylvania State University Press, starting with the readers whose reviews educated and encouraged me. I appreciate the collegiality extended to a newcomer in visual studies and animal studies. Laura Reed-Morrisson and Robert Turchick, Penn State Press production and editorial staff, were always prompt and helpful, and I was so reassured to have such able colleagues at the other end of the line. Getting copyedited is an educational and humbling experience. I want to thank Suzanne Wolk for her care and diligence in making my prose as clear and lively as possible. It was a pleasure working with her. Editor-in-chief Kendra Boileau's sense of humor and creativity in moving my manuscript toward approval and publication proved a powerful ally in helping me keep perspective, and I am grateful for her professionalism and humanity at every stage of the journey.

Officials at James Madison University provided subvention support, which I gratefully acknowledge: David Jeffrey, dean of the College of Arts and Letters; Ken Newbold, director of Research and Development; A. Jerry Benson, provost; and Mark Parker, chair of the Department of English.

As I was completing the manuscript, our family dog, Rascal, was suddenly taken ill. He was my daughter's dog, a sweet-natured retriever-collie mix that she raised from puppyhood. She came home from college to be with him and us when we made the difficult decision to put him to sleep. I have not altered the textual references to him, however, wanting to keep him alive a little longer that way.

My husband, Todd Hedinger, managed to keep his composure when I kept buying pictures, and he was often the first admiring audience for a new find. He also endorsed my unexpected request to adopt two older dogs—dachshunds—after Rascal died. Now I wonder how we lived without Louie and Cobe. Todd, for your loving support of my creative bents, which certainly required an adventuresome spirit in our marriage, thank you!

Finally, I include a warm acknowledgment to Anneke Schroen, Carmel Nail, Christiana Brenin, and Amanda Lane at the University of Virginia's Emily Couric Clinical Cancer Center. Their combined skills in 2004 and subsequent years made it possible for me to be writing these words.

I come from a family of picture takers and storytellers, and after a while it is diffi-cult to tell the words from the pictures. The pictures begin with my Grandpa Morey, who wasn't much for words but who had a mechanical and technological intelli-gence that was quick to recognize the potential of the camera. Like many people of their time, my grandparents were minimally educated but schooled for a lifetime of hard work, stemming from their rural upbringing. Both of my grandparents Morey were employed by the Agricultural and Industrial School in Industry, New York (near Rochester), a facility run by the New York State Department of Corrections that housed juvenile delinquents who served time in this benign "cottage system" for six months to a year. Alice Elizabeth (White) Morey was the housemother who cooked and cleaned for a dormitory of miscreants. Ibra Franklin Morey, a shop teacher at the facility, lived virtually in the shadow of Eastman Kodak, and had even worked as a machinist at Kodak before moving to Industry. Grandpa Ibra passed on his visual intelligence to his only son, my father, who has taken and developed pictures all his life. Dad works only in black and white, on the grounds that it is the true revelatory mode for photography.

Both of my parents are storytellers, however, so both have conspired to create memorable images whose genesis is neither picture nor text, but both. My mother

is the daughter of a Free Methodist minister who traveled the coast from Florida to Georgia during the Depression, hauling his family from one poverty-stricken post to another. There are virtually no photographs of her childhood, which might explain the wealth of words at her disposal. Her stories are El Greco grotesques, embellished by her gimlet eye for detail, records of a South and a religious framework that have largely disappeared. A scientist by training, she has an acute sense of observation that extends from the human to the animal world, and because she loves animals, she naturally constructed memorable stories about the family pets along the way to preserving the larger moments of family history.

My dad has a gift for verbal snapshots, and he has created memorable images of my Canadian great-grandmother and the hardscrabble farm that was a summer home for him. In an unpublished memoir, he describes the scene in figure 3 as indicative of his grandmother's ingenuity in finding things for him to do:

> One of those jobs was that of "breaking" calves to a halter. At milking time I fed the calves, holding a bucket of separated milk under their noses while they drank, at which time they would frequently buck the pail and slop quantities of milk over me. Grandmother's solution was to have me teach the calf to lead and to that end she had me tie a rope around the calf's neck and the other end around the neck of our faithful dog Sailor. Of course this made for a totally unmanageable situation and I found I was neither strong nor heavy enough to counter the wildly bucking calf and the bewildered dog. Nevertheless I was quite serious about training the calf to walk on the end of a rope, for what good purpose it never occurred to me to ask.

Dad's stories preserve a sense of a childhood at once rare (not many middle-class boys grow up with juvenile delinquents for playmates) and filled with longing for a childhood no longer possible, if it ever existed at all. Except that it does, now, because the pictures and the stories have made it so, and it took both words and images to make this happen.

As a child, I pored over the family photograph albums created by my young parents, who, like most parents, documented less and less as time went on. The pictures that fascinated me most were the ones of my beautiful young parents and their dogs. Probably the largest photo in our family album is of Lord Jim, a black and red dachshund out of CH Favorite von Marienlust from the Heying-Teckel kennels. He was purchased on Valentine's Day 1947 and renamed Cupid, or Cupie. My parents were proud of his lineage, for Cupie's sire was a world champion. Several

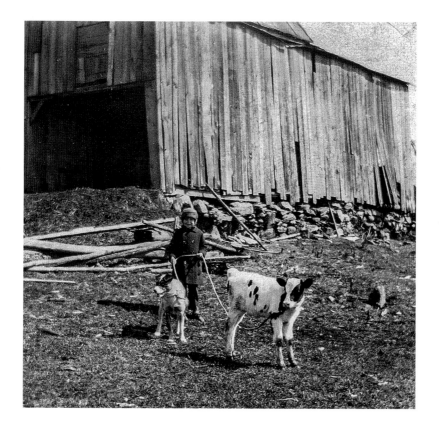

FIGURE 3

Don Morey and Sailor.
Snapshot, 1929, 10 × 6.1 cm.
Photograph by Ibra F. Morey.
Harlowe, Ontario.

years later, Cupie was joined by a peasant companion, a dowdy red female dachshund named Mitzi, whose biography included the romance of rescue from abuse. Although our extended family has owned several dachshunds, clever, good-looking Cupie (fig. 4) was the ur-dog, setting a narrative and visual standard for canine achievement that no other dog could approximate. Cupie did have a short-lived predecessor, however, who adds a significant visual to the family romance with dogs.

In figure 5, my parents are standing at the backdoor of Huron, one of the cottages on the grounds of Industry. It is September 1946, they are posing for my Grandpa Ibra, and they have been married just a few days. My mother is slim and proud in her elegant dressing gown and slippers, my dad resplendent in a satin-trimmed bathrobe and unscuffed slippers. The foliage behind them—cannas and morning glories—suggests a garden, and the embrace of mature trees as part of the frame indicates an unseen lawn. In the palm of my mother's hand, sitting upright and begging for a treat, is their miniature dachshund, Buddy von Hixel. My mother and

FIGURE 4

Cupie. Snapshot, 1950s, 14.4
× 17.2 cm. Photograph by
Donald F. Morey. Los Angeles,
California.

father are smiling at each other and the dog, and their hands are joined through the dog.

I never saw them this way; no child ever does. We catch up with our parents in the grueling middle, and sometimes the lost brightness is irrevocable. In that sense, this picture is like a glimpse of a lovely garden that has since been forfeited. To add to the poignancy of the moment, Buddy died months later of distemper. My parents were so distressed by his death that they replaced him literally and symbolically with the next canine Cupid, the Valentine's Day Lord Jim. From the beginning and through all the vicissitudes of a long marriage, dogs remained a faithful, comforting constant. This photograph summarizes one of the themes that attend the presence of dogs in our lives, an Edward Hicks vision of a peaceable kingdom of mutual and loving communication across species, across time.

In the 1893 canine autobiography *Beautiful Joe*, the eponymous dog narrator tells a story about Eden he has heard from his human companions: "Well, when Adam was turned out of paradise, all the animals shunned him, and he sat weeping bitterly with his head between his hands, when he felt the soft tongue of some creature gently touching him. He took his hands from his face, and there was a dog that had separated himself from all the other animals, and was trying to comfort him. He became the chosen friend and companion of Adam, and afterward of all men."[1] More contemporaneously, there is a quotation on nearly every website

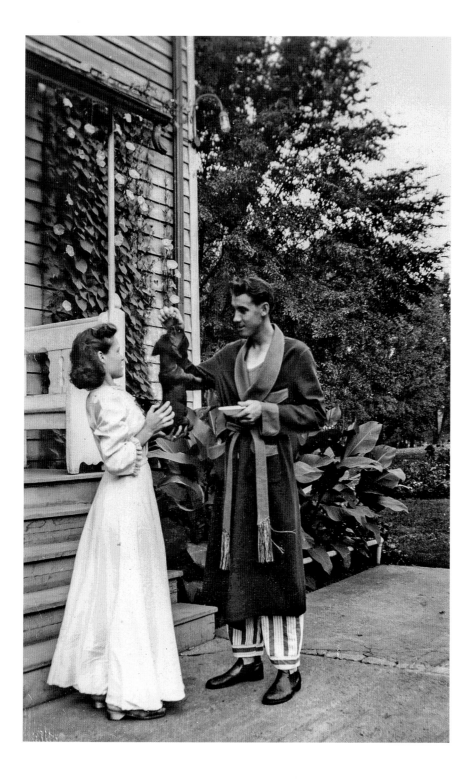

FIGURE 5

Honeymoon Buddy.
Snapshot, 1946, 5.9 × 10.7 cm.
Photograph by Ibra F. Morey.
Rochester, New York.

devoted to dog love that says, "Dogs are our link to Paradise. They don't know evil or jealousy or discontent. To sit with a dog on a hillside on a glorious afternoon is to be back in Eden, where doing nothing was not boring—it was peace."[2] These sentiments underscore the uniqueness of the canine-human relationship, and hint at why photographs of humans and their dogs could be about more than simply recording our attachment to our pets. There is something ineffable about the quality of communication between ourselves and dogs that draws us back.

ANIMAL STUDIES

"It is a lovely thing, the animal / The animal instinct in me." These lyrics from a 1999 CD by The Cranberries appeared at a cultural moment when scholars and artists alike were engaging in a growing conversation about how "human" is related to "animal." This academic and applied social movement—animal studies—continues to gather strength a decade later, and shares with these lyrics the affirmation of "animal," "instinct," and "animal instinct" as not only a force demanding new reckoning but a "lovely thing," through which we may find our way to a healthier understanding of "human."

Speaking of humans and all animals, John Berger argues in *About Looking* that the gaze exchanged from the animal to human world and back again crystallizes the profound atavistic connections between humans and animals, a connection that surfaces in both metaphor and visual art. W. J. T. Mitchell underlines this idea, noting that "as figures in scenes of visual exchange, animals have a special, almost magical relation to humanity."[3] As we'll see, this kind of mystical language about the animal-human relationship closes the circle no matter what the starting point, whether the discussant is an academician, novelist, memoirist, or musician. The enigmatic relationship between animals and humans is part of a long-standing philosophical tradition dating back to Plato and Aristotle and proceeding through the usual greats of Western philosophy—Descartes, Kant, and Foucault, for example—as a range of commentators have documented.[4] In an article prosecuting the dishonesty of metaphysics, B. A. G. Fuller discusses "the messes animals make in metaphysics." In most philosophy, it is impossible to find a place for other kinds of conscious beings, and yet we routinely award dogs a kind of consciousness that automatically confers on them moral agency and purpose. And if they have some kind of moral purpose as conscious and communicative beings, then how will we address their lives, not to mention their suffering, in a philosophical universe composed of rational agency, free will, and divine decrees? The only way to keep the "system in order and man master of it

is to shoo [the animals] out of the house altogether and stop one's ears against their scratching at the door."[5]

Writing in 1949, Fuller long preceded the animal studies movement that has so complicated and enriched our contemplation of animals in the past decade or so. His questions remain unanswered, although animal studies proponents are making a concerted effort to open that door, permanently. So challenging is this territory that Cary Wolfe compares giving an overview of the field to herding cats. "My recourse to that analogy is meant to suggest that 'the animal' when you think about it, is everywhere (including in the metaphors, similes, proverbs, and narratives we have relied on for centuries—millennia, even)." Additionally, once the animal is foregrounded, we are confronted with a "daunting interdisciplinarity" that makes the relationship between literary studies and history look like an orderly affair by comparison.[6]

Animal studies is moving beyond representative collections of animal images that document the presence of animals in art and photographs, although those treatments are a valuable platform. Art historians regularly have taken note of dogs in Western painting. While these presentations offer some commentary about the shifting functions of dogs in human life or the potential symbolic meanings of the dog, their primary purpose is to trace the presence of the animal over the centuries, thereby illustrating the close, but largely unexamined, relationship between humans and animals.[7] Most of these treatments tell us more about the artist or the artist's subjects than about the animal. However, multiple sources that document the presence of animals, and especially dogs, in cultural representations finally have compelled scholars and historians to train their gaze upon how all animals become troubling mirrors to humanity. With that awareness intrudes a counter-reflection, an intense consideration of the ethical dimensions of this relationship. The animal nature of humanity intersects the human nature of animals as we jockey for some purchase on ideas about consciousness, ethical behavior, and spiritual selfhood, which may not be the exclusive province of the superior human. Indeed, in anthropomorphizing animals, we humans have created visual and textual images that at once trivialize our own lives but also the lives of animals, taking for granted that their lives may be manipulated for symbolic purposes that seemingly have no consequence for them or for us. But is this true? May we do this with impunity?

One response through animal studies is to reexamine our representations of animals, looking for what the animal might mean to us but with a concern for what our representation might mean for the animal. This approach tries to take seriously the proposition that our representations have meaning and import in ways beyond the "merely" visual or the "merely" literary. Susan McHugh asks that we

take literary animals seriously, arguing that, "now that scientists are identifying the interdependence of life forms even below the cellular level, the pervasive companionship of human subjects with members of other species appears ever more elemental to narrative subjectivity."[8] Steve Baker, in *Picturing the Beast*, says that the representation of animals in popular visuals is an important pathway to understanding how we see them, and how we use them in our own cultural constructions. Erica Fudge calls for an animal studies that will promote an "interspecies competence," by which she means "a new way of thinking about and living with animals," such that the meaning of "human" and "nonhuman" must shift radically.[9] Finally, scholars are asking about the difference between "animal" and "animality," in reviewing cultural representations of animals and humans.[10] Whether they are referencing painting, literature, film, or photography, what all these scholars have in common is their shared urgency about how much our intellectualized perspectives on "animal," and thus on "humanity," must change. "Animal" is, in Wolfe's words, "in the heart of this thing we call human," whether we approach it from a humanistic point of view or a postmodern point of view.[11] We must engage in animal studies, for it is a crucial pathway for rediscovering ourselves as human animals who live in what Donna Haraway, in *The Companion Species Manifesto*, calls "natureculture." Moreover, many of these discussions share a common trope, that of the liminal territory between the animal and the human.

In reviewing the philosophical tradition about animals, Akira Lippit offers a dense semiotic discussion leading to the conclusion that animals are neither here nor there, but in this liminal state they trouble our conscious reflections by their indeterminate status. Just as we toggle between our contemplation of the brain and our musings on the meaning of the mind, animals become the emblem of that journey. We imbue them with, or they possess, more meanings than are apparent in the mere facts of physical existence. In Lippit's words, "animals are exemplary vehicles with which to mediate between the corporeality of the brain and the ideality of the mind."[12] We may perceive and understand more about animals than we are able to put into words, another conundrum for human beings who are so thoroughly determined in Western philosophy, if not overdetermined, by our ability to live by words. Animals may also perceive and understand more about us than they are able to put into words, although for different reasons. Again, humans meet other species in this liminal space where words largely dissolve but communication persists, perhaps because animals are more important for constituting human reality than we have realized or acknowledged. Lippit concludes that the presence of the animal is always poised to "disrupt humanity's notions of consciousness, being and world. . . . Contact with animals turns human beings into

others, effecting a metamorphosis. Animality is, in this sense, a kind of seduction, a magnetic force or gaze that brings humanity to the threshold of its subjectivity."[13]

Thus we return to the mystical language of a visual force created and sustained by our relationship with animals. Temple Grandin has famously and successfully argued that persons on the autism spectrum have many things in common with animals. In particular, they share a common sensory field. Her groundbreaking work doesn't denigrate "regular" people, but it does gently suggest that autism might be our doorway to a better way of understanding animals, and to understanding ourselves as animals with more capacity than we have realized. And Grandin wouldn't mind if we reversed that statement and said that a better understanding of how animals perceive and respond to their world might open latent parts of our brains that we have closed off, including our understanding of autism as part of a spectrum of human creativity. "The animal brain is the default position for people," she suggests, and in her hands the animal instinct is indeed a lovely thing.[14]

THE ROMANCE PLOT

This language of mutuality, visual force, and the liminal space occupied by animals and humans well suits my exploration of photographs of dogs and their owners, for there are few animals that carry as much history and cultural freight as canines do. The unattributed legend of Adam cited above is but one of many narratives that fill in what is missing from the biblical account and build upon a treasury of dog stories, legends, and myths. According to the Kato Indians of California, the creator was going around the world creating, and he took along a dog. "Nowhere in the story is any mention made of the creator creating the dog—evidently because he had a dog."[15] Not only is the dog a first companion in the creator's opening activities; dogs are also the companions to the last human breath, guides to the underworld, and guardians of afterlife crossings both in myth and in practice. Cerberus, the three-headed dog, guards the gates of Hades, and in British folklore a large black dog with glowing eyes is a portent of death. In Louise Erdrich's *The Last Report on the Miracles at Little No Horse*, the reservation priest is alarmed by a visit from the devil in the form of a malevolent black dog that enters through a window, puts its foot in his soup, and bargains with him for the life of a child.

Russell Hoban makes extensive use of this lore in *Riddley Walker*, his remarkable novel about post-nuclear-war England and its fragmented language. Riddley, the postapocalyptic Huck Finn of the title, goes on a quest to understand the story fragments that record the devastation. Early in the novel, he tells the story of "why the dog wont show its eyes," explaining that when humans enticed the first dog to

FIGURE 6

a fire, they saw that the dog had the "1st knowing," and it shared that knowledge with them. But they misused this insight, and finally their cleverness and scheming brought humankind to the Power Ring and nuclear destruction. From then on, "day beartht crookit out of crookit nite and sickness in them boath," leaving humans and dogs hunting each other in a desperate search for food.[16] Riddley says he's heard that dogs could be friendly, but he's never seen it. But later in the narrative, as Riddley's pursuit of the story of the destruction of the world begins to reknit the narrative, Riddley makes friends with a lonely black dog, signaling one more small measure of healing in the blasted landscape.

While we would not expect to see such portentous implications in family photographs with dogs, the Eden-to-Hades versatility of the dog in its mythological form does help explain some of its manifestations in ordinary daylight. For example, when bereaved families created mourning pictures of loved ones, and

especially of children, it was not uncommon to include an image of a dog as part of the funerary decoration. Figure 6 is a memorial card. These mementoes usually feature a picture of the deceased from life, but the image is decorated with flowers, wreaths, and other funerary emblems. In American culture, the dog represents home, and in this context it reminds the viewer that the home is now bereft of the beloved child, although the presence of the dog could also be a throwback to atavistic mythological meanings associated with canines. The association of the dog with death takes on a different aspect when we look at archeological information. In North America we have evidence of dog burials extending as far back as 9500 B.C.E., and in more recent North American sites (from 6600 to 4500 B.C.E.), humans and dogs were buried together. As the anthropologist Darcy Morey notes, "considering the attention commonly lavished on dogs in mortuary contexts . . . it seems clear that they are about as close to being considered a person as a non-human animal can be."[17] Although many animals have served as metaphysical companions for humans, dogs seem to occupy a special category.

As an avid young reader of dog books, I imbibed many of these dog motifs. I moved quickly from picture books to adult-style narratives in which dogs or horses were no longer talking animals but main characters along with the humans. I remember my mother ordering two books for me, Anna Sewell's *Black Beauty* and Jules Verne's *Twenty Thousand Leagues Under the Sea*. I never did read Verne, but I still own that copy of *Black Beauty*. But alongside Walter Farley's black stallion series and Elyne Mitchell's brumby stories, I read Jack London's wild dog adventures, Albert Payson Terhune's collie stories, and Jim Kjelgaard's Irish setter books. I also loved Fred Gipson's less well-known *Hound-Dog Man*, preferring it to *Old Yeller*, which most children find horrifying because the dog dies. Inspired by these books as an adolescent, I yearned for a purebred collie and fed every stray that came by our back door, much to my mother's consternation. We adopted some of them, of course, so there was never a time I was without a dog, or a dog book, for that matter. Collecting antique photographs of dogs unlocked the cascade of words about dogs that I'd absorbed during my own childhood reading.

Rereading these stories was fun and troubling at the same time. I hadn't realized how much these beloved stories were romances about human-canine communication. Interestingly, we seem to be enjoying a renaissance of dog romance, most of it retailed in nonfiction accounts of personable, remarkable dogs and their human relationships. I do not reckon with these narratives in this book, however. As heartwarming as many of these stories are, they are largely one-dimensional accounts of the canine-human relationship. As such, they occupy the same cultural role as any conventional romance fiction, where the central relationship is at first tenuous or

difficult, misunderstandings must be overcome, the owner finally learns to "read" the love object (who has been reading the owner all along), and they live happily ever after. My photographs certainly document the longevity of American dog love, but many publications before this one have already accomplished that task, as I've discussed in the preface. *Picturing Dogs, Seeing Ourselves* provokes a different kind of conversation, one about the covert cultural meanings ascribed to the dog or marked by the dog's presence in the photograph. The current spate of dog-valorization stories are not intended to stimulate cultural introspection; they are intended to make us feel better. While feeling better is a legitimate outcome of reading, it isn't the only outcome I am pursuing here.

Furthermore, there is an unsettling underbelly to the romance plot. Romantic love can prove to be blind if not lethal. The romance plot is a formulaic structure that asserts the necessary domination of male over female, and encourages women to see their fate in these power-based terms. Through romance, women learn that they cannot trust their instincts in assessing the safety of relationship with any given male, and that they must be protected and rescued by that same male, whom they cannot understand but will come to adore.[18] The romance plot may also encourage women to accept an implicit, and sometimes explicit, brutality in the relationship. Perhaps the heroine is foolish and hardheaded, and needs to be "taken" by force before she can see the rightness of the male's conquest. A bad woman—someone who has used her sexual powers illicitly—is usually killed or otherwise punished in the romance plot. Our contradictory attitudes toward women are much like cultural ambivalence about dogs. James Serpell comments on the enigma of contradictory cultural attitudes toward dogs, observing that "ambivalence about dogs seems to be almost universal."[19] It seems that humans love and loathe dogs in equal proportions. We love them when they act least like dogs and most like adoring sycophants. Speaking generally, this mirrors cultural attitudes about women, who are praised most highly for being affectionate, beautiful, obedient, and servile.

The connection I'm making here, using the cultural and literary structure of "romance" to find women and dogs inhabiting the same script, is unsettling, but it is important to acknowledge the connection between women and animals, especially dogs.[20] In the romance plot, dogs are to humans as women are to men. This also means that our romance with dogs has its dark side. Our domination and domestication of dogs has not always produced benevolent outcomes for dogs, any more than the romance plot has always produced benevolent outcomes for women. The literary device of the romance plot serves as an apt narrative model for how we construct our relational world with other sentient creatures. From animal

experimentation to genetic engineering and dog fighting, men have ruthlessly exploited the canine capacity for assimilation. That is the shadow side. My photographs do not engage us in direct conversation about our cruelty to dogs, but they do reveal how we have used and manipulated animals for what are often ethically craven purposes. Although I want to honor the genuine beauty of the canine-human relationship, I also persist in exposing the cultural moments when our dog love means much less than the appearance of love and respect.

I also use the word "romance," however, in relation to my own beloved childhood stories. While some of these stories revisit the masculine fascination with naturalism and primitivism (itself a form of romance), others offer an enticing invitation to visit a benign paradisal world where dogs and humans communicate intuitively, where dogs are always noble and self-sacrificing and humans are willing to be tutored by the exemplary canine. These fictions are part of the cultural fabric that informs this collection, and they indeed have shaped our cultural values and sensibilities, even if we are only now discovering the dimensions of these fictional influences. Jennifer Mason argues convincingly that the dominant thread of American cultural criticism has favored the theme of wilderness as a critical formative factor in American culture and society. This focus, long the generative fence between male/female and nature/culture, is an artificial barrier to a richer understanding of the meaning of America. What is missing from the "manly male fleeing into the wilderness" trope? It is the presence of domesticated animals among us—and the meanings they carry. In Mason's words, "domesticated animals have remained a critical blind spot in American studies, even in the work of those most committed to rejecting the dichotomized view of nature and culture, in which humans exist 'outside' of nature and contact between human and nonhuman renders the nonhuman 'unnatural.'"[21] Mason takes careful measure of some signal fictions and fiction writers in making her case, and work like this is an important ally in my consideration of photographs as another piece of evidence about the cultural importance of animals, dogs in particular.

In her study of modernist to contemporary fiction, Susan McHugh says that "as fictions record the formation of new and uniquely mixed human-animal relationships in this period, they also reconfigure social potentials for novels and eventually visual narrative forms."[22] Here, McHugh claims the entire expanse of cultural production as the legitimate territory of animal studies, flagging the fact that fictions about animals get translated into film, television, and digital media. Words do not supersede pictures; they become pictures. Although film, television, and digital media are beyond the scope of my book, the implicit heritage from photography and stories to moving pictures is clear, and so I call on a range of literature

from the early twentieth century to the current twenty-first century. I have additional motives for including some reference to contemporary fiction, and they have to do with the substance of that fiction. I include fictional works about dogs and purportedly by dogs because so many of them offer a complex affirmation of the persistence of our Edenic longings, which have generated so much of our great dog literature. In *The Dogs of Babel*, by Carolyn Parkhurst, grieving husband Paul Ransome decides that he will teach his dog, Lorelei, to talk. His wife, Lexy, has died by falling, or jumping, from the apple tree in the backyard. Paul decides that the dog must have seen the tragic event, and he becomes convinced that if only Lorelei could speak, she could help him understand Lexy's Edenic plunge earthward. At once a mystery and a meditation on what can be communicated wordlessly, *The Dogs of Babel* can take for granted that readers will accept the idea that an otherwise rational man might expect the dog to help him in his grieving because, in fact, we imbue our dogs with just such mysterious capacity. Invoking the mythological resonances of the dog's name, Paul explains his project this way: "I sing of an ordinary man who wanted to know things no human being could tell him." *Picturing Dogs, Seeing Ourselves* originates from the same conviction—that the dog can tell us something. In Paul Ransome's words, "dogs are witnesses. They are allowed access to our most private moments. They are there when we think we are alone. Think of what they could tell us. They sit on the laps of presidents. They see acts of love and violence, quarrels and feuds, and the secret play of children. If they could tell us everything they have seen, all of the gaps of our lives would stitch themselves together."[23]

VISUAL STUDIES

I couple my collection of antique photographs of people and their dogs with literature, where appropriate, in order to better understand some of the gaps in our public testimonies. But the photographs are always the starting point and the narrative stepping-stones. The field of visual studies articulates the understanding that images are not merely illustrations of cultural moments best represented by words but are themselves of cultural moment. In *Visual Genders, Visual Histories*, Patricia Hayes discusses visual studies as a new field. Quoting Christopher Pinney, she makes a case for acknowledging and studying the power of the visual to shape cultural history. Suppose that we "envisage history as in part determined by struggles occurring at the level of the visual." And what if pictures are "able to narrate to us a different story, one told, in part, on their own terms"? What she is talking

about, Hayes specifies, "is not so much a history of the visual, but a history made by visuals."[24]

In the same spirit, I have tried to let the pictures suggest the story, rather than simply using them as illustrations for a story already determined by other sources. Moreover, while I want to give literature its due, I think that the communicative skills of dogs themselves prompt our interest in a more skillful visual comprehension. Alexandra Horowitz comments that she treasures dogs because they don't use language. "There is no awkwardness in a shared silent moment with a dog: a gaze from the dog on the other side of the room; lying sleepily alongside each other. It is when language stops that we connect most fully."[25] That most animals don't have language in the way in which we understand the term does not mean that they can't and don't communicate. It just means that we haven't figured it out. But one effect of animal studies, on the applied side of things, is the awareness that better communication with animals is possible, whether we are talking about the most social of critters—dogs—or the mysteries of horses, cows, or pigs. We are learning more about visual cues in language and the subtleties of those cues. Temple Grandin says that animals see in pictures, much as autistic people do. So taking pictures seriously as evidence, inspiration, and narrative art could be a good step toward understanding what a more visually, as opposed to linguistically, oriented intelligence can discover.

I discuss my "visuals-first" approach to *Picturing Dogs* in chapter 1, where I introduce the physical formats that characterize the photo collection and offer some examples of how the images might be construed. More important, this chapter also broaches the question of a "visual rhetoric" created by juxtaposing seemingly unrelated images and weaving them back into their cultural context. "Rhetoric" is the ancient art of persuasion, a form of communication intended to sway an audience through eloquence, reason, or emotion. By "visual rhetoric" I simply mean the persuasive power of the visual and, in the case of the materials here, the communicative power of groups of thematically related images.

John Berger points out that, by itself, a photograph cannot lie, but "by the same token, it cannot tell the truth; or rather, the truth it does tell, the truth it can by itself defend, is a limited one."[26] That is, without the story that could accompany an image, all photographs are ambiguous, "except those whose personal relation to the event is such that their own lives supply the missing continuity." Photographs without narrative, that is, photographs that have been disconnected from their context, are permanently ambiguous unless we construct a narrative pathway. The discontinuity of the images I have gathered here, for example, "by preserving an instantaneous set of appearances, allows us to read across them and

find a synchronic coherence. A coherence which, instead of narrating, instigates ideas."[27] It is those prompted ideas that constitute the "half-language" of the visual rhetoric of photographs. Julia Hirsch says something similar in commenting that "family photography does not preserve the shadows of our experience but rather their external share in ancient patterns,"[28] and these patterns take their shape and structure from cultural context. I extend Berger here by suggesting that we cannot only instigate ideas but create meaningful narratives from the half language of visual rhetoric. I do so using the photographs as primary artifacts, and contextualizing them with stories.

In her guest column for the *PMLA*, Marianne DeKoven comments that literature is replete with meaning-laden animals, and that "analyzing the uses of animal representation" can illuminate the ways in which we use animals and animality to perpetuate human subjugation or to obscure pernicious but subliminal value systems.[29] Borrowing from DeKoven, my photographs are replete with meaning-laden dogs, and analyzing the photographs can illuminate the ways in which we use dogs to perpetuate malign and benign value systems. As I demonstrate throughout *Picturing Dogs*, these images offer further evidence and narrative for understanding race, class, family, and gender in American culture. In these photographs, the animal body—in this case, the dog—communicates the presence of multiple "pernicious," "subliminal," and, I would add, sentimental and fervently affirmed value systems in American culture. The dog in the picture is part of a larger system of visual rhetoric.

The American preoccupation with respectability and achievement leans toward an index that involves the display of material goods. The dog came into play when "breeding" emerged as one of those watchwords designed to isolate the uncouth. Americans did not invent the snobbery of breeding, but we were quick to assimilate its implications. Speaking of the English, Harriet Ritvo shows how pet keeping became respectable among ordinary citizens, who came to think of the pet as a reflection of oneself, such that "most observers felt that ownership of mongrels revealed latent commonness."[30] It is no accident that the fascination with pure dog breeds coincided with the rise of nativism in American life, as political and cultural pundits used animal metaphors to analyze and judge human society. Chapter 2 considers the contribution of literature and photography to the American concern with material appearances, and the role of the dog in facilitating this kind of representation.

American racism and resistance to racism are represented in ways both saddening and surprising. Images of African Americans with dogs can be found throughout *Picturing Dogs*, but the ambiguous meanings of "animal" and "dog" take

on ominous proportions when dogs and African Americans are in the same frame. The material in chapter 3 bypasses the spectacular racism of "black Americana images" and looks at ordinary photographs and snapshots of black and white people with dogs, wherein the gaze of the viewer may readily and inadvertently reinforce the insult offered to black subjects through the original composition.

The mystery, and sometimes playfulness, of family life surfaces in chapter 4. These photographs represent and misrepresent the reality of American family life. The display of home, children, and dog all go to the heart of the American dream. At the same time, these images surface the unarticulated dimensions of power and gender and race that are explored in other chapters. Defining "family" has become a way of excluding unwanted intruders. And yet the facility of the dog's representational value undercuts the severe family boundary drawn by cultural purists. Several animal studies theorists have commented pointedly that the canine body stands in for the marginalized other. Teresa Mangum argues in "Dog Years, Human Fears" that the aged dog speaks for the aged person in literature, a sentimental strategy that upholds the value of marginal creatures. Marianne DeKoven and Cary Wolfe argue the same thing in relation to women. Following Carol Adams's thought in *The Sexual Politics of Meat*, Wolfe endorses the idea that the sexualized bodies of women and the edible bodies of animals are both housed within the same "logic of domination, all compressed in what Derrida's recent work calls '*carno*phallogocentrism.'"[31] In fact, because most marginalized persons are at one time or another represented as animal rather than human, the dog, with its cultural fluidity, is most likely to stand in for any number of marginalized persons, not just women.

Chapters 5 and 6 follow up on the gender discussion initiated in chapter 4 by examining the collusion of literature with long-standing gender prejudices. Hunting photographs indicate the women who are missing from the cultural narrative, while also documenting male anxiety about masculinity at the turn of the century. Moreover, while the appearance of the woman hunter issues a cultural challenge to constructs of American masculinity, the female hunter also challenges current feminist positions about gendered perspectives on animals. Finally, the anxiety of white manhood is inflected by male attitudes not only toward women but toward African American men as well. While women seem to be excluded in the masculinity narratives, African American men may find themselves either assisting the great white hunter or being displayed as the prey, as is well documented in lynching photographs. Ironically, this same group of photographs invokes a well-attested cultural fascination with wilderness and American Edens, the narrative headwaters where childhood, innocence, and new beginnings are

perpetually renewed, even if those paradisal cultural locations are not accessible to every American.

Traces of gender, race, and class dynamics knit all of these images into a cultural whole. In the conclusion, I revisit the perspectives of animal studies and visual studies in order to reflect upon what we can learn from a photographic collection like this one. An animal studies approach takes animals seriously as significant presences in our lives. We can learn more about ourselves as human animals by understanding more about what animals experience, on the one hand, and by understanding what animals contribute to our own understandings as persons, as a culture, on the other hand. In *Animals Make Us Human*, Temple Grandin looks patiently at each animal species—its unique abilities and requirements—by way of suggesting what each species can offer us and how we can better communicate with them. While the word "human" is the foundation for the word "humane," we humans fall far short of that implied value in our behavior toward animals. Being more humane in our treatment of animals could lead to our becoming better humans. Thus it seems appropriate to acknowledge the Edenic longings that we attach to the canine body, and while I have undermined its efficacy in places, I also want to validate the honesty of that yearning. I don't want to lose sight of the beauty that is expressed through a collection like this, so I allow a closing set of photographs to tell that story, and perhaps it is the story of our yearning for a more perfect and peaceful world.

THE CONTRIBUTION OF DOGS

Early in this project, one of my writing group members asked, "Why dogs?" I wanted to whip a smart answer back—"Because that's what I collected." But her question made me realize that, as much as I love horses, there is a reason why the antique dog pictures are so appealing. Of all domesticated animals, dogs have become our best friends forever. Cats are too independent to appeal to a broad spectrum of human personalities, and horses, which are more like magnificent aliens in our world, require a much different kind of communication from dogs. Horses can see nearly 360 degrees around them, but not immediately in front of them, because they need to be constantly surveying the landscape for predators. Despite the fond imaginings of horse owners, most horses would prefer to be with the herd, and their herd behavior makes them malleable to our interventions, which must be composed more of physical cues than voice and facial messaging. The cues we give to horses have to be unlearned from what we know about dog behavior, because what dogs respond to seems so natural. I talk too much

to my horse, but I never talk too much to my dog, who responds alertly to tone, face, and physical cues all at once. We've learned that when a horse licks its lips and chews, it is mulling over what you have just tried to teach it, but the horse still has to decide whether it wants to comply. A good deal of enlightened horse training these days is more about the way we ask for cooperation than about the brutal "breaking" that once passed for training. Like dogs, horses are greatly romanticized, but they are also much more like mythological creatures who haven't quite realized how powerful they are, so they tolerate our impositions without fully joining our culture. We don't "ask" for a dog's cooperation. We assume that will happen once the dog understands what we want, and we assume that the dog wants to cooperate no matter what.

More than any other domestic animal, dogs are cultural travelers, crossing back and forth from the canine to the human world, bringing their exotic animal natures into our homes while learning our language and our manners. Indeed, we are so close to dogs that we easily recognize the truism that owners and their dogs come to resemble one another over time, in much the same way that longtime married couples begin to resemble each other physically. A diversity of writers insist that there is something special about dog love. Marjorie Garber, for example, calls attention to the anomaly of masculine attachment to dogs from males who otherwise would be culturally expected to keep those unseemly emotions under control. In the title of one of her chapters, she summarizes one reason why we humans are so devoted to our dogs. It is their ability to convince us that we are the recipients of "unconditional love," a quality of loyalty and dedication uncomplicated by sexuality or ambiguity. Moreover, dog love (our love for them, theirs for us) occupies "an emotional place that is not determined by sex or gender," or for that matter by race, nationality, or age.[32] Dogs seem to look beyond our physical selves and our faulty selves and lovingly accept the best parts of us.

In addition to their emotional and spiritual contribution to our lives, dogs have provided necessary services to human beings. Dogs hunted, herded, and guarded precious livestock, goods, and families. They pulled carts, wagons, and sleds—from door to door or across forbidding frontier expanses. They were playmates and companions. Children who saw their parents harness a horse for travel played with their dog by harnessing their patient pet to a wagon or cart. Or perhaps the parents colluded in that play, as we see in figure 7. This is "King the Alsatian Husky" and Spaulding T. Eaid, who is five months and seventeen days old, and not yet ready to hold the reins. Spaulding is propped up in a sulky. There are many play pictures like this from the turn of the century, often with older children who are perfectly capable of driving the dog. But at one time folks might have expected to

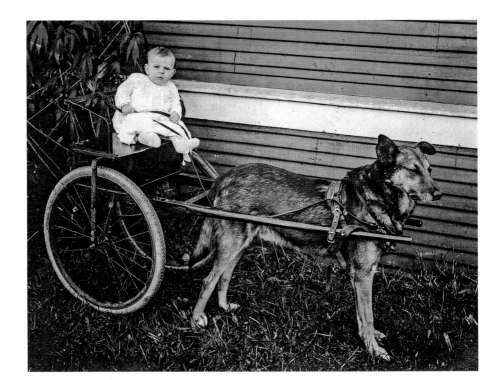

FIGURE 7

Spaulding T. Eaid and King the
Alsatian Husky. Used RPPC,
1907–1920, 12.1 × 8.9 cm.

harness the dog as a means of conveyance, and sometimes for more serious pur-
poses than backyard play. Figure 8 is an early image showing a young woman, pos-
sibly Chinese, in her driving rig, which could have been originally intended for
a pony but seems well adapted for a dog. In a much later photograph, "Carlo" is
the dog power behind John M. Tuttle's wheelchair, which has been constructed so
that he can steer as the dog pushes (figure 9). Today, dogs still play a vital role for
disabled persons, as well as serving as guardians and protectors in a larger cul-
tural sense—they are used in police, military, and forensic work because of their
keen sense of smell and their ability to understand the task before them. Their
persistence and empathy has touched and supported humans through many a cul-
tural upheaval. The dogs brought to Ground Zero to find survivors and victims have
been lionized in a variety of publications and anniversary commemorations of the
September 11, 2001, attacks on the World Trade Center.[33] Studies of the World
Trade Center's dogs and their handlers after those traumatic events are producing
medical and mental health insights, as we use the experience of dogs to better un-
derstand our own.[34]

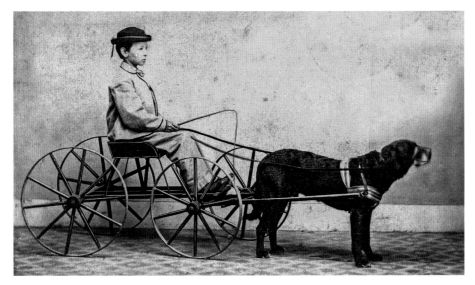

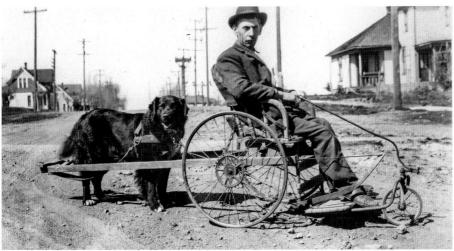

Finally, dogs provide the not inconsiderable service of companionship and entertainment. In the United States, it is this feature of dogs that largely defines their presence in our lives today, and we are accustomed to a culture that dotes on dogs, sometimes to extremes. At the same time, we are aware that dogs (and often other animals) are exploited, witness reports about dog-fighting rings and puppy mills. Sadly, the history of humans and dogs is filled with as many stories of our cruelty and indifference as of our admiration and love. And yet, no matter how we

FIGURE 10

Snapshot, 1920s, 7.7 × 10.5 cm.

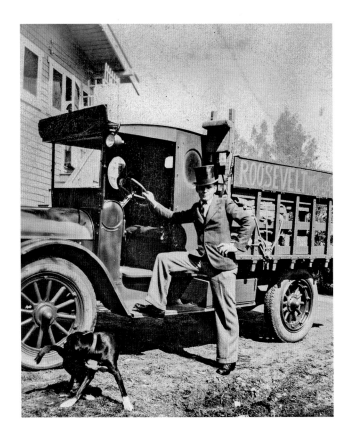

treat them, dogs come back. They are part of the picture even when we didn't plan for it (figure 10).

The dogs in *Picturing Dogs* are witnesses whose bodies and presence speak far beyond the literal. Could we achieve some of these insights using other kinds of photographs, some other animal? Yes and no. For me, the dog was an accidentally chosen sorting device, and perhaps I might have assembled a different group of antique photographs to much the same effect. Thus the question must be posed another way: what does the canine bring to a photo that is not available in its absence? First, it adds a relational element that complicates the way in which we view the subject. Like occupational implements in photographs, the dog is part of the human subject's self-definition, and the staging of the photograph offers insight into the various meanings that can accrue around the canine body. A sitter stooping to greet a dog chooses a different presentation from the sitter who has selected a formal setting, where the human and canine never touch. Moreover, although both may be isolated from the human, a canine posed at the feet occupies a

FIGURE 11

Used RPPC, 1912–1915,
8.7 × 14 cm.

different meaning space from the canine perched on a table. As I argue throughout this book, the canine body is symbolic of cultural values that still define our family life today. These images are not merely illustrative. They are part of a visual history whose import we have felt and internalized.

Second, the dog also adds a compositional element that enriches the photograph. Even if all of these pictures could have been taken without the dog, many of them would be diminished, if not disintegrated, by the loss of the dog. In figure 11, it is impossible to imagine the man without his dog. They are entwined, and the note scribbled on the back does nothing to disentangle or separate the two: "Who is this" could refer to the man, the dog, or both. They belong together. Similarly, the exuberant energy of the toddler and her setter in figure 12 makes a captivating image. Either subject could have stood alone for a portrait and made a pleasant image, but their shared energy animates the portrait in a way that neither could have accomplished alone. Obviously, not all photographs with dogs will offer interesting aesthetic or compositional dimensions. Sometimes the living dog is merely a

FIGURE 12

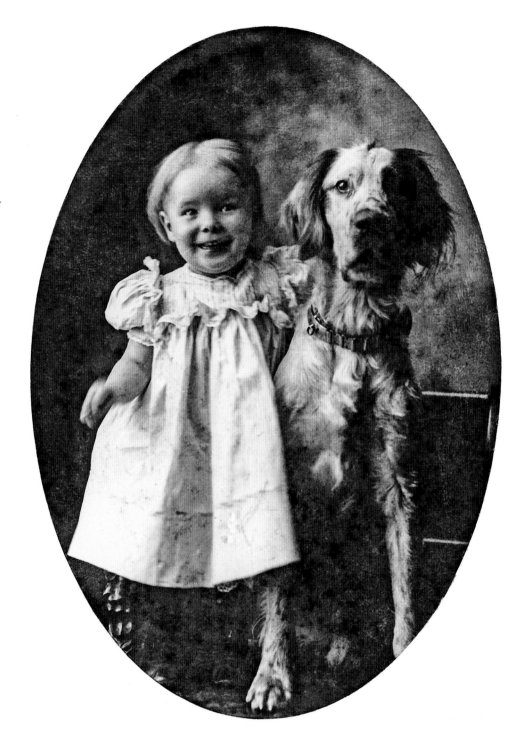

Cabinet card, 1900–1910,
8.8 × 12.2 cm. Photograph by
Hatton. Lansing, Michigan.

prop, and eliminating the dog from the picture would not change the overall suggestion of the image, although even that comment tells us something about the sitter, as we learn more about the use of the dog in photographic composition.

Third, seeing dogs in pictures enhances our sense of the humanity of our forebears, especially when we consider how messy and even fragile an enterprise dog ownership was at the turn of the century. Flea control, now a matter of a monthly dose between the shoulder blades, would have been a constant issue in the spring and summer months (and in the South, all year round). Distemper and rabies vaccines were not developed until the late 1920s, so that loving a dog (as opposed to simply owning one) would have subjected one to predictable and periodic loss.

Fourth, unlike any other animal, "home is where the dog is."[35] Certainly in American photography, the dog becomes part of the patriotic iconography embracing all the meanings of home—family, fidelity, comfort, protection, nurturance, and love—as well as symbolizing some of the less palatable meanings of home and family—domination, subservience, and violence. Generations of American politicians have used dogs to validate their claim to an upright character, and so an entire nation can debate what kind of dog the president will chose, because dogs are such an important symbol of everything we say we hold dear.

Finally, the dog invites our participation in a moment otherwise largely inaccessible to us. One of the features of antique photographs is the stiffness of the unsmiling subjects. For example, my Grandma Morey was suspicious of the camera, and not always very supportive of Grandpa's interest in the new instrument. She is famous in family pictures for crimping her lips instead of smiling, and I was given to understand that she was vain, and didn't think she looked good smiling. But histories of late nineteenth- and early twentieth-century photography suggest that people were advised that only a lower-class person would be so vulgar as to show his or her teeth in a photograph. A slack, open mouth suggested a slack character. So Alice White, born in 1897, may simply have been following the conventions of the day. The commanded smile is a later development in the history of photographic conventions, and has become a conventional artifice. But for contemporary viewers the smile establishes a friendly, welcoming moment. Smiling people are inviting, opening the doors so that we can easily see ourselves joining those scripted moments around the birthday cake, graduation ceremony, or family picnic table. Without the smile, there is no implicit welcome that speaks to us.

I suggest that the dog is the missing smile in the photograph. The strangeness of our ancestors' clothing, homes, and manners is normalized by the dog, who, in the photographic moment, seems timeless. Dogs sprawl, sleep, pant, and wriggle, just as they always have. And because we recognize dogs as familiar and valued,

the dog smiles to us that these people are not so different from us, and that despite their stiff demeanors and strange clothing, they too might have joined the dog on the floor in a game of tug-the-sock. Whether we meant for them to be in the picture or not, dogs are unselfconsciously themselves, speaking across time and cultural boundaries. By presenting their dogs, our forebears open the door and welcome us in.

THE VISUAL RHETORIC OF EVERYDAY PEOPLE

"Am still in Des Moines and working for my pa. I worked in a downtown drug store for some time slinging soda water but the late hours and Sundays left me no time for my family which I send a cut of. Sid." Posted in 1906 to a Mrs. Chas Vorhies (?), the real photo postcard (RPPC) in figure 13 features a photograph of five neatly dressed young men with a dog seated in the middle of the group, elevated to eye level with the human companions by a crate. Sid captions the image: "Me 'n' me friends." The image is a good example of a mascot picture, a thematically popular genre in the late nineteenth and early twentieth centuries, and we can reasonably suppose that Sid and his friends are a team, club, or group of co-workers who have a shared animal that represents them, grounds them, and expresses something about their collective spirit. The format of the RPPC is relatively late in the chronology of photographic formats, so the centrality of the canine is not surprising. But even the earliest and usually most costly form of photographic images for collectors, daguerreotypes, sometimes included dogs, as do all of the formats that followed them.

With the RPPC it is possible to have pictures and words in the same communication, as we have with Sid's card. Here is yet another meaning of visual rhetoric—that words, spoken or written, stand in relationship to something visual, and they are mutually enhancing. I begin by describing the conventions of dog photography,

FIGURE 13

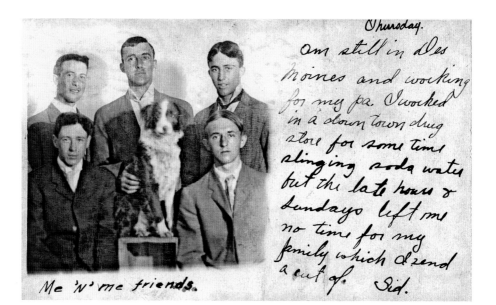

Thursday.

am still in Des
Moines and working
for my pa. I worked
in a down town drug
store for some time
slinging soda water
but the late hours &
Sundays left me
no time for my
family which I send
a cut of. Sid.

Me 'N' me friends.

along with introducing the photographic formats that make up the bulk of the collection. It is important to describe the protocols that governed the dog in the picture, because, as with any folklore, deviation from what is expected is part of the surprise and charm of the event. What is different, or what is absent, is part of the reading.

PHOTOGRAPHIC CONVENTIONS

Although the dog is the animal most commonly presented in antique photographs, people documented their household menageries with a generous inclusivity. People kept horses, chickens, cats, rabbits, and a variety of tamed wild animals and birds, and all of these critters can be found in nineteenth-century photography. Even before urban sprawl, animals have always occupied an ambiguous position in the economy of family values. Some of these animals were destined for love and others were destined for the market or the dinner table. Moreover, displaying livestock in a photograph was one further way of documenting one's success, so the animating motivations for making a portrait with an animal could be ambiguous. In figure 14, both the image and the history of race relations require us to wonder if the black man holding the horse is the proud owner or one of the proud owner's hired hands, that is, one of the creatures on display. He is standing at an angle rather than greeting the camera head-on, as a proud owner might do. The dog is

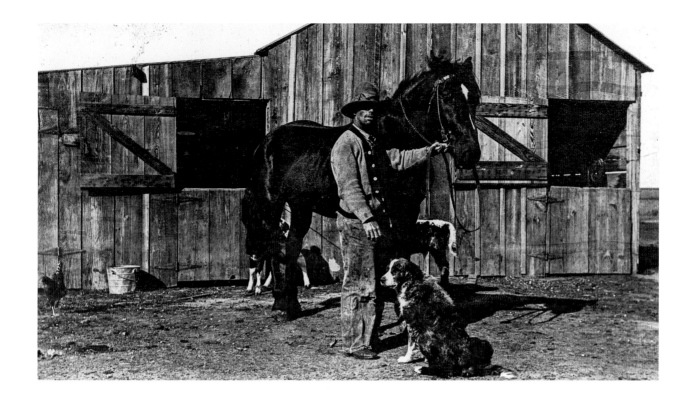

FIGURE 14

Unused RPPC, 1910–1918,
13.2 × 8.2 cm.

attentive to him, suggesting that he cares for the dog, but that doesn't mean he owns the dog any more than he owns the horse. In figure 15, the effect of including livestock is more comical. The little girl's worried face makes us suspect that it was not her idea to hold the disheveled fowl. In this family group, the dog, an English setter, and the bird are meaningful possessions for display. It's surprising how often animals—not just dogs—show up in studio photographs, because the presence of animals also pushes the presentation toward the casual, if not the unexpected.

But photographs with dogs reveal a wide variety of settings, from forests to fields, to front porches and parlors, to the front seat of the family wagon or automobile. Wherever people could go, so could dogs. And where people were relaxed and comfortable, so was the dog. Conversely, where people were formal and rigid in their demeanor, so was the dog. Typically, we explain the stiffness of nineteenth-century photographs by referring to their exposure time. Headrests and stands were used to ensure the stillness of the subject, and many photographs of people standing show the "third foot" of the stand that is keeping them fixed in place. But while it was important for subjects to remain still, the exposure time was not the entire explanation, nor was it just that the subjects were uptight. The

FIGURE 15

Cabinet card, 1880s,
13.3 × 9.6 cm. Photograph by
A. Hurst. Marshall, Illinois.

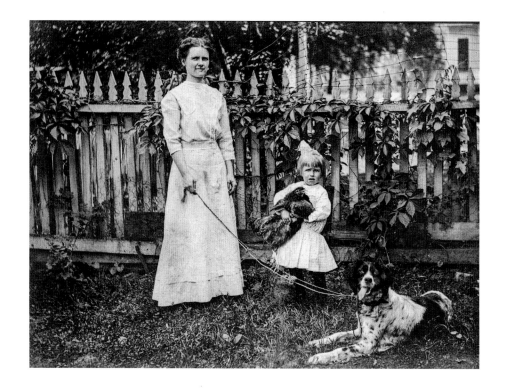

exposure time for the daguerreotype was less than sixty seconds, and that format was rapidly succeeded by far more sitter-friendly modes. As early as 1851, the use of glass-plate negatives reduced the sitting time to a few seconds for outdoor exposures and thirty to sixty seconds for indoor portraits.[1] Yet we have stiff-looking portraits long past the time when such rigidity was necessary. Why?

The formality of portraiture has to do with both the novelty of the medium and the way in which the camera invaded private space. Much like Native Americans, who felt that the camera robbed one's soul, many Americans felt that "unguarded facial expressions were reflections of deep and sincere feeling," and that the undisciplined face revealed emotions and feelings that perhaps were better reserved for private spaces. "Kodakers" took gleeful pleasure in catching people off guard, and thereby surprising them as their real selves, so late nineteenth-century Americans had to be constantly on guard to "avoid exhibiting the wrong feelings."[2] It was the marketing of the camera by George Eastman that moved the technology beyond its original class-based exclusivity. By 1889, photography had been pronounced a "craze" by the *New York Tribune*, and Eastman sold more than 150,000 Brownie cameras in 1900, the year of their introduction.[3] As I mentioned in the introduction, smiling made

a relatively late appearance as one of the commanded gestures of the photographic moment. People who showed their teeth in pictures were likely to be lower class, inebriates, or children.[4] The decision to include the dog in the solemnized photographic moment was not casual, then. Undoubtedly, some people brought the dog with them because their fondness designated the dog as a valued family member. Others, however, were being attentive to the accoutrements of middle-class life, and introducing the potential mess and exuberance of a dog into this dignified occasion required care, so that the dog participated in delivering a controlled message.

Figure 16 presents one of those stiff-looking portraits that we associate with nineteenth-century photography, and in it we see how the dog contributes to the communication. The original image is a cabinet card, which became a popular format for preserving and displaying photographs.[5] The distinguishing feature of a cabinet card is that the photograph is mounted on stiff cardboard, thus providing a flat frame so that the picture could be propped for display on a cabinet shelf. A photo on a 20.3 × 12.7 cm (8 × 5 in.) card was typically 10.1 × 12.7 cm (4 × 5 in.), although both cards and photos can be much larger. Sources vary on the approximate dating for cabinet cards, but it is generally accurate to say they were introduced in the 1860s and enjoyed peak popularity between 1870 and 1910; their use had waned by 1920. Typically, cabinet cards involved a studio setting, and we are most likely to discover recognizable dog breeds in the studio photos, because these are the folks who could best afford the purebred dog and the studio setting. At the same time, it is important to note that while the professional photographer took his or her place in the economics of image making, the accessibility of the technology made it possible for individuals to take charge of their own image making. Some cabinet cards offer a polished studio presentation, while others show the hastiest of backgrounds and poorly cut, processed, and pasted images.[6]

The cabinet card in figure 16 is imprinted with the name of the photographer, who has embellished his logo and provided a classical background of pillars and an urn. The woman's hair and clothing are good indicators for dating. Her hair, with its soft, off-the-face styling, is incongruously accented by a hair ornament that appears to be stabbed into the bun at the back of the head, and, along with the leg-of-mutton sleeves, suggests a time frame of 1895–1900,[7] keeping in mind that not everyone immediately updated their wardrobe every time a new fashion emerged. It was common in the last decade of the century for men to sit and women to stand, following the expectation that seating belongs to those of higher status.[8] The woman in this portrait lays a proprietary hand on the man's shoulder, but otherwise there is no physical or visual contact between the subjects or between subjects and viewer. The man is entirely self-referential in his physical pose, despite the dog

FIGURE 16

Cabinet card, 1890s,
9.8 × 14.2 cm. Photograph
by Eugene Popp.
Evansville, Indiana.

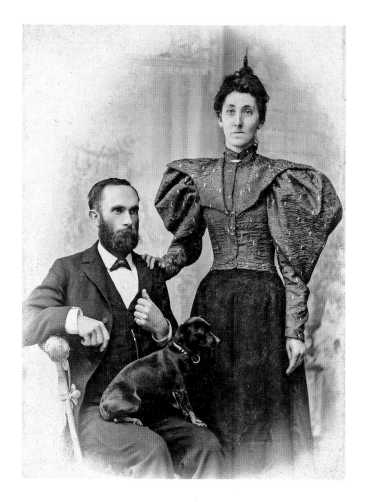

on his lap. In fact, the dog is the only warming touch in the photo, but even the dog looks uncomfortable. There is something ambiguous about bringing the animal up from the floor, putting it in a potentially close relationship, and yet creating a scene in which each creature remains isolated and lonely-looking.

It was not the mechanical requirements of the camera that enforced this rigid image, and the difference is readily obvious if we compare this portrait with portraits presented in an earlier format, the *carte de visite* (CDV). These images, introduced around 1854, are typically 6.3 × 10.1 cm (2.5 × 4 in.). They are presented in a convenient calling-card size, which is in fact what they were used for, as well as for trading with friends to add to an album collection. Eight to twelve images at a time could be made from a single negative. The CDVs are easier to date than the cabinet cards, and

PICTURING DOGS, SEEING OURSELVES

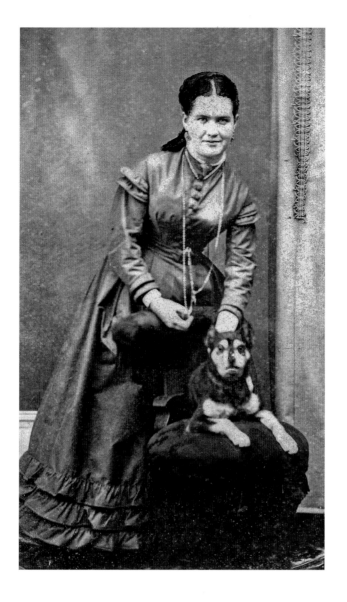

FIGURE 17

Lillie and Carlo. CDV,
1865–1870, 5.4 × 8.9 cm.
Photograph by Payne &
Bagley, New Star Photograph
Gallery, 205 Third Street,
San Francisco, California.

experts usually look at the color of the card, its thickness (the thinner it is, the older
it is), the kind of edges and decorations embellishing the card, and the setting and
composition (the more elaborate the setting, the more recent the card). The peak
popularity for CDVs was the first half of the 1860s, and they are uncommon after
1885. Thus, if exposure time was an issue, we might expect that this older presen-
tation format would show stiffer subjects. Yet while there are certainly formal CDV
images, there are also many that show a relaxed subject, such as figure 17.

FIGURE 18

CDV, 1860s, 5.6 × 8.7 cm.
Photograph by H. W. &
B. D. Bolles. Le Raysville,
Pennsylvania.

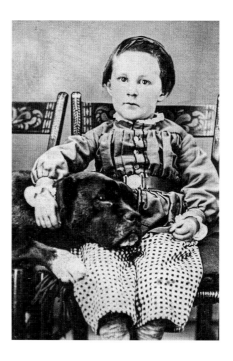

This playful image has been hand-tinted and the upholstered chair colored a dark green. The back of this small card identifies not only the photographer but also the subjects, Lillie and Carlo. Lillie's hair and dress, and the format of the card itself, suggest a date in the late 1860s. Lillie is leaning forward, probably steadying the dog, and she's smiling about it, clearly enjoying the frivolity of the moment. During the auction at which this image was sold, there was also a solo image of a much more conventional Lillie without the dog, standing straight and with a solemn face. The image in figure 17 seems to be the one taken between the prepared shots—the one that records both the human and the canine smile.

In addition to the cabinet card and CDV, the tintype was another popular format. Tintypes could be produced in any number of sizes, including the tiny "gem" portraits that were sometimes mounted in a CDV-size card (i.e., 6.3 × 10.1 cm). Tintype images were made in a durable metal, but the image itself tended to be dark and was subject to scratching, so I have included very few of these. The CDV and the tintype, however, were convenient for their portability, and many Civil War families had pictures made in the CDV or tintype format for soldiers to carry into war. Figure 18 is a CDV with a wistfulness about it, which, along with the possible dating, suggests that such a usage might be part of the missing narrative. The large dog, probably a Newfoundland, has been made an integral part of the

photographic relationship. His big body is draped over a chair that is pulled along-side the boy's, and both have kept very still. There is a light pinking on the boy's cheeks, added to give a more natural appearance. Both the tinting and the pose suggest an implicit warmth and affection that is lacking in figure 16. Thus neither the technology nor the format required a stiff, unsmiling presentation, but until Kodak was able to persuade Americans that the smile was a necessary feature of family documentation, the dog filled in that missing smile. However, as we have seen in figures 16 and 17, the dog can function as the visual welcome only if the human subjects have allowed it, so choices about poses and settings are important elements in this communication.

None of the conventions that present a dog in a photograph is particularly sur-prising. Dogs may be put on the floor, sleeping or sitting at the feet of the master. The erect young African American man in figure 19 is tall and so formal in his demeanor that it is easy to overlook the sleeping pug on the floor. The sparseness of this studio setting is interesting, because the time frame for this portrait would lead us to expect a more decorated setting. Photographers often charged for addi-tional props, or perhaps this man was not offered the usually amenities because of his race. Riverton, New Jersey, did not have a large African American popu-lation at the turn of the century. The subject is wearing a suit the boxy jacket of which looks too big for him, and its bottom edge is puckered, as if the jacket has not been hemmed by a professional tailor. Still, it is clear that, whether this man improvised his clothing or not, he has dressed well for the record. Like the jacket, however, the dog may also have been borrowed, as there is no visual indication of a relationship between the two. The dog is part of the iconography that seems to have been expected for a middle-class presentation, as we'll see in chapter 2.

Depending upon the context, then, sleeping and sitting dogs may occupy no particular relational or aesthetic purpose but are present as iconographic filler, although that choice is in itself a comment about the identity of the sitter. As we have just seen in the preceding figures, however, dogs can also be found on chairs, chair arms, tables, and studio pedestals, often occupying the dominant visual space in the image and suggesting a loving equality and respect. Even large dogs can be posed on furniture so as to appear at lap level, if not eye level, as is evident in figure 18. In figure 20, the dog gets the couch, with one leg extended over the arm of the couch so that the girl can "hold paws" with her pet. In fact, it is possible for the human to have the uncomfortable position, just to make sure that the pets get appropriate billing, as in figure 21, an outdoor presentation with little compo-sition or planning beyond bringing the chair outdoors. I am treating this image as if the dog and cat belong to the woman, although, as chapter 3 documents, white

FIGURE 19

Cabinet card, 1900–1910,
9.9 × 14.1 cm. Photograph by
Lothrop. Riverton, New Jersey.

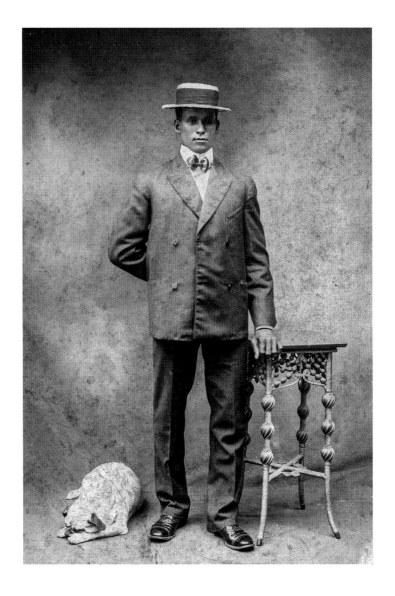

employers sometimes had pictures made of the domestic help and pets, as if they were the same category of creature. When pictures of African Americans and dogs are involved, interpretation is even more tenuous.

The image is not pristine. There appears to be melting snow on the ground, suggesting that additional discomfort was involved in producing this picture. Although there were African American photographers working at the turn of the century, many African Americans would not have had access to the amenities of a

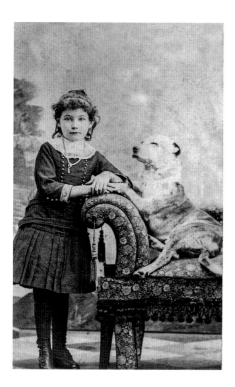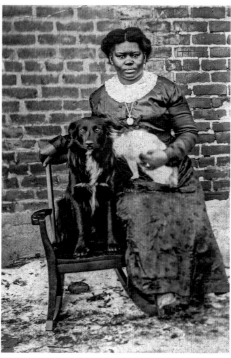

FIGURE 20

[LEFT] CDV, 1880s, 6 × 9.6 cm.
Photograph by J. O. Knutson.
Blooming Prairie, Minnesota.

FIGURE 21

[RIGHT] Unused RPPC,
1913–1922, 7.7 × 11.2 cm.

well-furnished indoor studio. Despite the incongruity of her clothing in the casual outdoor setting, this formally attired African American woman perches on the arm of a rocking chair so that the dog gets the comfortable seat. She's trying to hold on to the uncooperative cat as well, making the balancing act especially challenging. Her forthright gaze, however, replicated by the dog's gaze and posture, claims the dignity of the moment.

In figure 22, professionally attired Mr. Streck has put his alert Dalmatian on a table beside him. Although he is not touching the dog, the tilt of their heads and their symmetry of expression suggest a comfortable relationship between the two, especially in that putting a long-legged dog on a small table and having it sit so nicely suggests that the dog trusts its owner. In figure 23, the dog gets equal billing with the child, both visually and in words. On the back of the image, the two are identified as "Helka and Queedle." Unlike Mr. Streck, who gets overshadowed by his dramatically colored and positioned dog, Helka holds her own with Queedle thanks to her commanding hat and equally commanding gaze.

Images of children with the family pet are probably the most numerous of all dog presentations. Much like occupational photographs, images of children

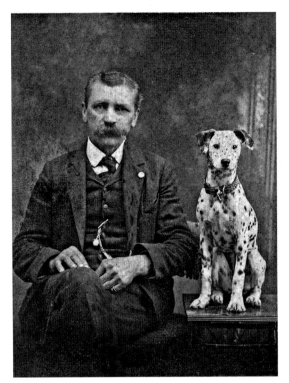

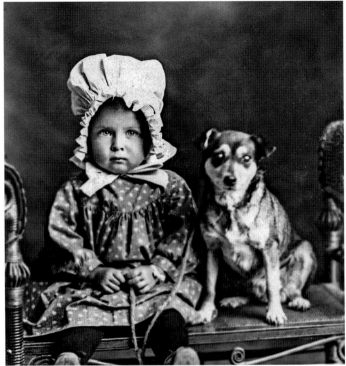

FIGURE 22

[LEFT] Mr. Streck. Cabinet
card, 1900–1910, 7.9 × 10.3 cm.
Photograph by Dingeldey,
780 Jefferson Street, Buffalo,
New York.

FIGURE 23

[RIGHT] Helka and Queedle.
Used RPPC, 1910–1918,
8.2 × 11.5 cm.

contain visual documentation about their childhoods, including toys (dolls and guns), wagons, bicycles, and the family dog. The RPPC in figure 24 shows "the young sprout at play," a boy with his wagon, his dog, and his cloth-faced doll riding in the wagon. His backdrop is a drying bear skin, and his Buster Brown clothing suggests that he has been dressed up for this picture, despite its casual setting. Generally, the RPPC was 8.8 × 12.7 cm (3 × 5 in), although there can be noticeable variation from company to company. Postcards were introduced by the Columbian Exposition (World's Fair) in 1888, and by 1906 most delivery routes in rural areas had been established. Anyone could have an image developed in small batches—maybe ten at a time. Traveling photographers visited towns and rural homes, setting up impromptu studios in the house, on the front porch, or in the garden, and all the possible conventions of dog positioning evident in the cabinet card or *carte de visite* are available in the RPPC format.[9]

As noted with figure 13, the RPPC offers the appealing, if dangerous, possibility of wedding text and image. A person could write a quick message in the morning, post it, and have someone in an adjoining county receive it that afternoon.

PICTURING DOGS, SEEING OURSELVES

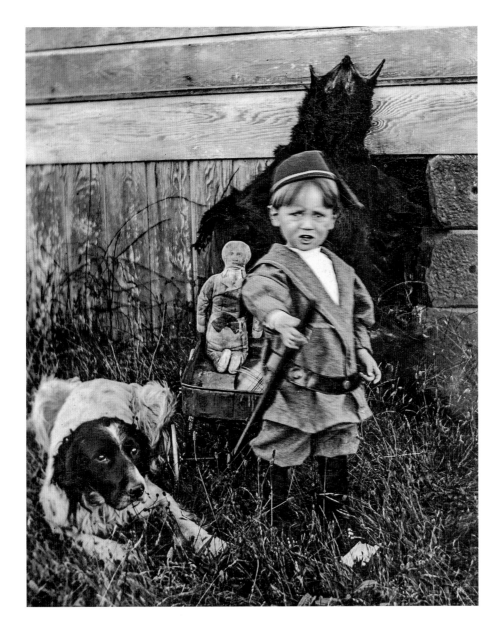

FIGURE 24

Young Sprout and Bird.
Used RPPC, 1906–1908,
8.2 × 11.3 cm.

The speed of this communication is comparable to the advent of e-mail, and, like e-mail, the postcard brought private lives under public scrutiny. Folks were careful about what they put on the cards, knowing that the postmistress and the mail carrier might very well be interested in their comments, leading some to pen terse and cryptic messages, while others crammed as much commentary as possible into

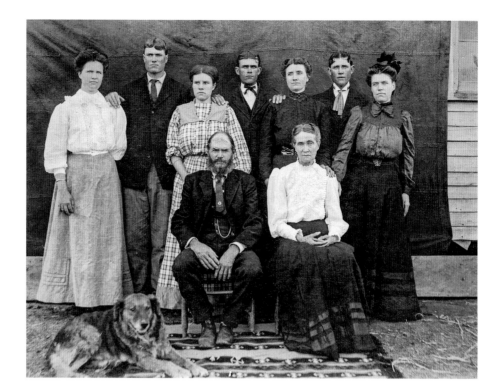

FIGURE 25

Cabinet card, 1910s,
17.2 × 12.2 cm.

the small space allocated, as we saw in figure 1. In figure 24, the writer mentions the dog's name but not the boy's, writing in a neat cursive hand, "The young sprout at play. Will send another of the boy and Bird as soon as finished." The affectionate message suggests that the dog—Bird—is as much of interest as the nameless "sprout." Like today's text messaging, these cards perform the same work, though their effect may be less ephemeral.

In addition to the various stagings with furniture that put the dog front and center, makeshift outdoor presentations often import an element from the formal studio portrait, and that is the piece of carpet for the human and dog to stand on. The carpet seems to suggest the domestic amenities of a civilized household, and perhaps a certain income level as well. By bringing the carpet outside, the subjects imply that a full, respectable household supports the picture, and they introduce an element of control in an outdoor setting. That piece of carpet is so ubiquitous that, along with the dog, we can recognize it as an essential part of the visual rhetoric. It is common to find a small carpet on the front porch, but sometimes it is on the bare ground, as in the family photograph in figure 25. In this large cabinet-card presentation, we find a formally posed family of nine in the informal

outdoors, positioned in front of a tarp or blanket that has been affixed to cover a house wall. The family members are neatly centered around a small square of carpet, which looks like a home-loomed pattern rather than the Oriental design sometimes favored in studio presentations. Although they all look serious, and it's possible that two of the women are in mourning clothing, both the dog and the hands on the shoulders hint at more affectionate demeanors off camera. Even formally, they are in physical contact with one another. The interesting exception is the patriarch in front, who is touched by no one, and the dog positioned at the feet of its master.

While the RPPC belonged most to lower- and middle-class Americans, it is not the photographic format that determines the content and presentation. There are any number of CDVs and cabinet cards that, like the RPPC, may capture an improvised or poorly composed moment, indoors or outdoors, as well as presenting thoughtfully arranged subjects in ornate settings. Moreover, some presentations are staged, and have their roots in "earlier nineteenth-century customs, such as amateur theatricals."[10] Some studio settings, such as figure 26, suggest not the handsome parlor but the stage show or carnival backdrop. Rosamond Vaule, in *As We Were: American Photographic Postcards, 1905–1930*, documents the range of campy settings that were used in RPPC photographs, so this image is not unusual except for the fact that the romantic setting has been defined around the dog. A note on the back of this RPPC says, "1910, Silver Beach, St. Joe, Michigan." Silver Beach was an amusement park on the shores of St. Joseph, Michigan, that operated from 1891 to 1971, and the website documenting its history notes that "it was common for courting couples to promenade along the boardwalk at night." In figure 26, it seems that the young man had a date with his elderly dog, which leans comfortably against him, framed by the romantic crescent moon.

But even when the framing, posing, and editing of extraneous detail is casual, if not haphazard, the result can run the gamut from comical to compelling. Figure 27 is an example of the latter. The boy and his dog stand amid the rubble of a backyard and the back porch of a store. Behind the boy, on his left, is a crate that says "Borden's Evaporated Milk," and the box farther back on the porch behind him says "Ridgeway Tea." There is adult-size laundry flapping on the line to his right. The boy is dressed in a school outfit that could have been found in the Sears catalogue anytime between 1909 and 1920, although the RPPC stamp box indicates that it could be as late as 1930. It appears that the dog is on a chain, which the boy may be gripping at the collar. This lonely-looking child appears to be Asian, making this a rare image for that reason alone, and he is biting his lower lip, as if apprehensive. Perhaps he is facing a first day of school and is marching off into

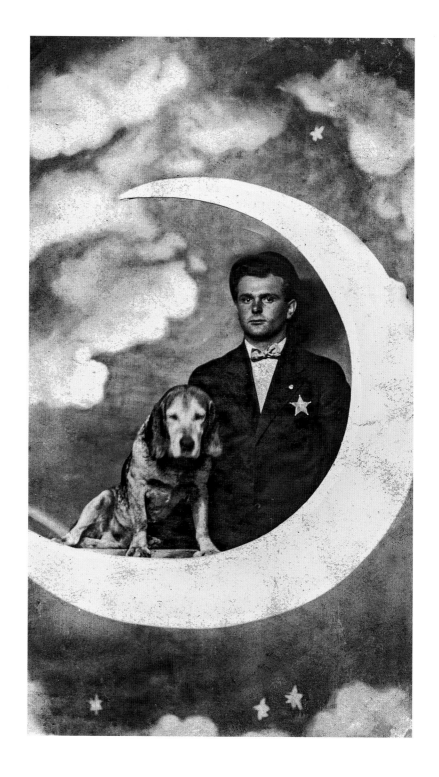

FIGURE 26

Used RPPC, 1910, 7.5 × 13 cm.
Silver Beach Amusement Park,
St. Joseph, Michigan.

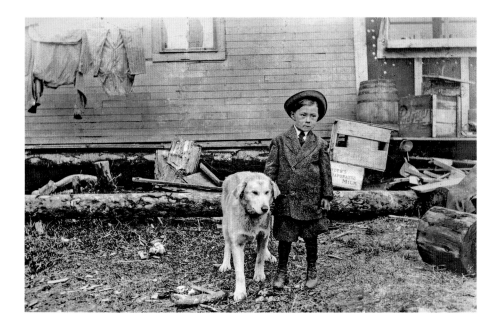

FIGURE 27

Unused RPPC, 1918–1930,
13.2 × 8 cm.

the world from the rubble of his private world, with only the stalwart dog standing beside him for comfort. The dog, looking much like Little Orphan Annie's Sandy, functions as a guardian figure in the photograph. *Little Orphan Annie* debuted as a newspaper strip in 1924, so the visual suggestion that Annie's dog has made its way into this photograph as part of a deliberate communication is enticing. If the background were removed, and this child were simply standing in front of a tarp backdrop, or within a regular studio setting, his face would still be interesting but not nearly so compelling. It is the setting, in combination with the boy's evocative face, that gives the image such implicit narrative poignancy. His context suggests a life lived amid workaday rough-and-tumble, where unseen adults have tossed crates and lumber and litter but have also taken the time to button his jacket and shoes. There is both care and carelessness here, and it takes both elements to produce an image like this.

VERNACULAR AND VISUAL FOLKLORE

But we are not just looking at singular images; we are looking at them as a collection and a group from within which I am creating narrative juxtapositions. It's important to suggest why and how a seemingly random collection can come to have a significance larger than any of its individual components. Photography is now so

pervasively associated with advertising and consumer culture that it takes some deliberation to contemplate the trajectory of cultural influence represented by the technology. Although people wanted their portraits to look respectable, which means that there was a shared visual formula to follow, they also wanted to appear as individuals. Gwen Wright says that "middle-class Victorians wanted to believe that their houses were impressively unique. At the same time, certain patterns were necessary so that other people could clearly read the symbolism of social status and contented family life in the detail."[11] This drive for a homogenous individuality is also a feature of these photographs. We can certainly understand this oxymoronic impulse today. As consumers, we are urged to purchase brand-name products in order to be individualistic, which is hardly possible if everyone in our income range is purchasing the same product. Then as now, consumers, and especially housewives, were urged to show how "smartly" they could dress, and how they could lift their families above the toil and trouble of everyday life simply by purchasing and maintaining the right accessories. Indeed, advertising promised "the maintenance of domestic harmony through intelligent consumption."[12]

This consumerist vision is intimately linked to photography, as Susan Sontag and many others have pointed out. Photography and its products provide compelling visual instruction about what to want, and the visual desire produced through our consumerist culture becomes our ruling value. "Our very eyesight has been pressed into service as a mode of social control," comments Laura Wexler. At the same time, there is something about photography that encourages us to take the appearance as sufficient representation or explanation. Because a photograph seems to make something visible and apparent, it becomes difficult to press upon that appearance for further insight. "The institutions of production, circulation and reception of photographs effectively discourage inquiry into how things got to be the way that they appear."[13] The seeming realism of the moment captured on film seems to trump all discussion, in part because we are so conditioned to seeing these images as dominant without recognizing the extent to which photographic images are also domineering and coercive.

In short, we fail to converse about photographs. Wexler suggests that our "active and selective refusal to read photography" can be called *photographic anekphrasis*, which is a play on the Greek word *ekphrasis*, meaning the skill of putting words to images. In *Tender Violence: Domestic Visions in an Age of U.S. Imperialism*, Wexler argues that our failure to discuss and read photographs as artifacts implicit in creating cultural meaning is a "class-and-race-based form of cultural domination. It represses the antidemocratic potential of photography and distorts the history of the significance of race and gender in the construction of the visual field."[14] Since

its inception, photography has been a key element in the design and perpetuation of cultural hierarchies, but we have yet to grapple with this powerful visual rhetoric and its historical impact. Thus the role of photography in the expression and creation of American identity is at once fascinating and vexed. In her article "The Treacherous Medium: Why Photography Critics Hate Photographs," Susie Linfield nicely summarizes the problem with photography, if not its critics, saying, "Who can admire an activity—much less an art—that so many people can do so damn well?"[15] Are photographs documentary or aesthetic products? Although the debate has sometimes been framed around this dichotomy, the actuality is much richer. Alan Trachtenberg encourages us to study photographic "ensembles" that offer an "intelligible view of society implicit in the internal dialogue of images and texts, and their external dialogue with their times."[16] Observing Lewis Hine's work as part of a visual narrative, Trachtenberg suggests both the enduring power of "social photography"—what Hine later called "moral realism"—and the accumulated narrative power of photographs gathered together. Photographic artifacts command a narrative presence on multiple fronts: as individual aesthetic expression, as symbols speaking from within a larger nexus, and as documents or records of times, events, and people.

Some photographs may partake of the dense intersection of both life story and public event, so that "social photography" refers to the effort to document historical realities, such as the work of Jacob Riis, who took his improvised camera equipment into New York City's Lower East Side. But even at that early stage, the documentary function of photography was a complicated construct, for Riis staged some of his starkest images in order to enhance their implicit narrative power. And while Alfred Stieglitz was arguing that composition and tone virtually commanded photography into art, Lewis Hine was seeking that powerful intersection between the accidental and the composed in order to preserve the narrative power elicited by his images. For Hine, who often took great risks in taking pictures under arduous conditions, the accidental observations of the camera were part of its artistic and moral value.

In a later development, when Henry Luce planned *Life* magazine, he envisioned a format in which text and pictures worked together, seeing photographs—layout, composition, sequence—as commentary and documentary. Luce understood "sequenced photographs as rhetoric," suggesting that "photographs are like written language that can be manipulated and that interpret events."[17] Initially, the photographer supplied the raw images but had little control over how they were used. W. Eugene Smith struggled to maintain editorial control over his images by researching and writing the printed text and selecting, editing, annotating, and

arranging the pictures into a coherent essay. His work increasingly sought to guide the reader's values and perceptions, controlling not only aesthetic and narrative reading but also political and ideological reading, and Smith's passion for social justice led him into intricate manipulations of his images in the service of this vision. Hine was working toward the same kind of rhetorical control. His preference for the term "interpretive photography" never really caught on, "yet it was there from the beginning of his career and was an attempt to define, even at the start, the peculiar synthesis of aesthetic and social purposes that he was aiming at."[18]

My collection does not meet the definition of "social photography," because in the case of Riis, Hine, and Smith, the photographer's intention is an integral part of how the picture is defined. These photographers were trying to reveal the simultaneity of personal lives and public forces, seeking ways to embrace the beauty, ambiguity, and narrative implications of the images they created. But family and private relationships are inextricably entwined with the larger matrix of cultural forces and public history, no matter what the photographer's intent. To distinguish the largely anonymous photographers who produced the images in this book from the self-conscious artistry of people like Hine or Smith, my collection might best be referred to as "vernacular photography," in that these images reveal "no apparent aesthetic ambition other than to record what passes in front of the camera with reasonable fidelity."[19] With the possible exception of images commissioned by wealthy people from famous photographers, vernacular photographs are truly "folk" images—by and of the people. At the conclusion of *Counter-Archive*, Paula Amad talks about what it means to reclaim the everyday life of artifacts (in her discussion, it's film), noting that working with these materials is at once enchanting and boring, constituting a remarkable space where "lostness" and "foundness" exist side by side, where discovery creates the future, re-creates the past, and then complicates the future once more. The everyday vernacular life embodied in these folk relics contain culturally significant memory at the same time that they project our fantasies for the future.

The conventions of dog photography as they emerged in the mid- to late nineteenth century are not especially surprising, and it assists our interpretation to recognize that while certain mannerisms were adopted for the portraits, deviation from those mannerisms is also part of the communication. Here I borrow an insight from folklore studies by way of emphasizing the origin of these "folk" pictures and the narrative qualities highlighted by bringing forward groups of images. Generally speaking, the formulaic nature of folklore—which consists of patterned repetitions—is how storytelling was adapted for memory and oral performance. Those patterned repetitions, as well as departures from the formula, are part of

the heritage of folktales. To adapt to the visual context, we can look for the pattern of presentation, finding insight in that pattern, and then discover further insight when the pattern of presentation is shifted or reinforced, despite the resulting incongruities.

The connection between vernacular photography and folklore is useful because, unlike Trachtenberg's Civil War photographs, my pictures have no compelling cultural event that immediately supplies a primary context. They are everyday images of ordinary people whose names, families, and social location are lost to us. How, then, can we reclaim the communication represented by their presence? The answer is that groups of common images can communicate something that a solitary image cannot. I am reading my way through these photographs using the perspectives of both visual studies and animal studies, perspectives that further coalesce the message of these pictures.

Exemplars of my approach can be found in the work of Laura Wexler, Rosamond Vaule, and Arnold Arluke and Robert Bogdan. In *Tender Violence*, Wexler explores the way in which gender "becomes a delivery system for race and class distinctions" by considering the work of white women photographers, looking at images of black women, and backfilling the spaces between them with historical and cultural perspectives, a complicated process that inevitably casts a different light on a seemingly marginal detail or a seemingly transparent offering.[20] Rosamond Vaule uses the RPPC to document ordinary and extraordinary events and lives in America. In *As We Were*, Vaule celebrates the democratic variety of the RPPC, which she sees as belonging "most securely to lower and middle-class Americans," and her alertness to the implications of this feature of RPPCs is evident throughout her perceptive commentary.[21] Arluke and Bogdan, in *Beauty and the Beast: Animal-Human Relations as Revealed in Real Photo Postcards, 1905–1935*, group photographs of animals and people thematically but then steadily provide context for what we are seeing, so that the import of the images in *Beauty and the Beast* is more readily available. In each of these books, the writers put words to photographs, creating and re-creating a meaningful cultural narrative that calls our attention to what is both visible and invisible in the photographs. For example, Arluke and Bogdan go out of their way to remind us that in our relationship to animals we don't have much documentation for what we know is true—that our history with animals is replete with as much gratuitous cruelty as it is with love. By and large, pictures of pets do not document our ugliness toward animals. But by putting words to the photographs, these writers undo that sleight of hand, while at the same time lifting into view the rich and varied record of animal-human relationships.

Finally, all of these books are based on the idea that groups of photographs can have meaning. By gathering thematically related images and reviewing them as a group, we can also see similarities and differences that suggest further interpretive possibilities. Through the juxtaposition of similar images, questions and insights begin to emerge, as the photographs speak to us of their context. The visual rhetoric that first gave them birth is renewed in the juxtaposition. The possible communication of any single image is limited, but as a group these photographs can and do speak to us—about family values, about race and class and gender, and about the mystical communication between dogs and people. I am stringing these photographs back onto the cultural thread that once gave them immediate stability and coherence. I am, of course, creating a new story in doing so, but I am also allowing the original story as much moment as possible. Re-created as a group through my agency in writing this book, these images can generate insight and cultural energy through what they fail to show, through what they inadvertently reveal, and, most significantly, through their juxtaposition with one another. In his essay "Appearances," John Berger contemplates how meaning is available only through connections and cannot develop without narrative impetus. "Without a story, without an unfolding, there is no meaning," he writes, so that "when we find a photograph meaningful, we are lending it a past and a future."[22] I am suggesting here that by attending to the visual rhetoric of an image in the company of others like it, and by attending to literary and cultural contexts, we can connect these images in ways that bring those meanings to light. In this way we can turn vernacular photography into the kind of revelatory "social photography" that Hine envisioned. Trachtenberg argues that photographers like Hine used photos simultaneously as document, symbol, and art, leaving us with a "contradiction within the social work of the image between the power of its beguiling specificity and the open-ended possibilities of its rhetorical uses."[23] In the case of the photographs in this book, both the "beguiling specificity" and the "open-ended possibilities" of interpretive uses are readily visible, and they are enhanced by their juxtaposition with one another and with narratives of the time.

Viewing these thematically similar photographs as part of a collection shows us how important this reclamation of vernacular photography can be. American values about family, which include dialogue about civility and class differences—breeding, if you will—slowly but forcefully assert their presence when these images appear in juxtaposition with one another. American racism and resistance to racism are presented in ways both saddening and surprising, while family portraits bring to the surface dimensions of class and gender power. The collusion of literature with long-standing gender prejudices appears through the

agency of the hunting photograph. In all of these thematically grouped photographs, the dog is the catalyst for discussion and insight, a movable marker that invites our contemplation of what the power of race, gender, class, and love has meant to us over time.

The presence of the dog insists that we consider the role of animals in shaping and expressing our values. As Steve Baker suggests in *Picturing the Beast*, we must take our representations of animals as seriously as we take animals themselves. Indeed, through the very title of his book, Baker calls attention to the importance of encompassing pictures and words in contemplating the meaning of animal representation.[24] Much of the visual rhetoric that Baker examines reveals how much we use animals to express two atavistic human preoccupations—power and pollution—both of which depend upon a series of long-standing binary oppositions for their endurance. While Baker is largely concerned with the negative manifestations of power and pollution in the visual rhetoric of animality, he is aware of the conflicting tenderness and pride that we invest in our animals. That is why the dog, culturally speaking, can stand for fidelity, courage, love, and domesticity as well as for cowardice, promiscuity, bad manners, and dirt. To adapt a comment by Arluke and Sanders, the ambivalence with which we attribute meaning to animal lives creates animals as rich and flexible symbols, which is why dogs are such labile resources for expressing our conflicted feelings about people.[25]

This ambivalence gets at the heart of the human-dog romance as a narrative about tenderness and domination, love and loathing, exploitation and care. For generations, scholars and writers have attempted to explain the bond between humans and dogs. Darcy Morey, in *Dogs*, documents the development of the social bond between dogs and humans and points to the several ways in which dogs and humans mirror each other's emotional lives. Rescue dogs become depressed when they can't find living human beings, and humans become depressed when their canine companions die. Dogs mirror facial expressions, and people come to resemble their pets. Owners understand their canines so well that the owner can unselfconsciously produce a narrative of the dog's thoughts.[26] "In our dogs, we see ourselves, . . . [and] when we watch our dogs progress from puppyhood to old age, we are watching our own lives in microcosm."[27] Sometimes people act as if dogs were more important than people, so tightly are their heartstrings tied to their dogs. This is my "child," or my "granddog," someone will say matter-of-factly. Dogs matter, and they mattered to our forebears as well. In the pictures I've gathered here, the appearance is certainly that people wished to include their dogs as part of the family, whether it's a single owner or a group involved in the portrait.

Recent animal studies and visual studies scholarship invites us to look beyond the appearance. In these photographs, the dog is not simply "in" the picture. It is an essential part of the visual rhetoric of the picture, and we are looking at the evidence of a long, complicated romance between dogs and their everyday people.

PICTURING DOGS, SEEING OURSELVES

2

THE DOG ON THE TABLE

[From *The Great Gatsby* to the Great White Middle Class]

"Nobody now who is anybody can afford to be followed about by a mongrel dog."
Thus spoke noted canine writer Gordon Stables in 1877, and his words continue
to express widespread cultural sentiment.[1] Any number of epithets attach to the
canine who is not a purebred animal, and none of them is a term of endearment.
A *mongrel* is a dog of no definable breed but also an insulting term indicating a
person of mixed descent, more specifically a person of low or indeterminate sta-
tus. It is a term of abuse or contempt whether it refers to an animal or a person. A
mutt can refer to either a slow racehorse or a mongrel dog, and when the term is
attached to a person, it indicates someone who is an awkward, ignorant, blunder-
ing, incompetent fool. For a time, the term could also mean an unattractive woman.
Similarly, one would do no better to be called a *cur*, a word that may have arisen
from an onomatopoeic verb meaning to murmur or growl. The term *cur* is always a
contemptuous epithet meaning a worthless, low-bred, or snappish dog or, as be-
fits the slide from animal to human, a surly, ill-bred, or cowardly fellow.

Although some of these usages strike us as faintly antiquated, we still recog-
nize their derogatory intent. And yet, in the contradictory way we have with dogs,
the right canine can also symbolize good breeding and genteel family values such
as loyalty, domesticity, and love. In Great Britain, "elevated" members of society
were cautioned to avoid "vulgar" companionship in their choice of dog. "Manual

after manual warned that a careless choice of pet could signal the owner's lack of distinction and discrimination." And how to distinguish the right kind of dog from the wrong kind? The answer was that the well-bred dog was identified by the right people, and the "elaborate structure of pedigree registration and show judging" further confirmed the good status of the owner. "The institutions that defined the dog fancy projected an obsessively detailed vision of a stratified order which sorted animals and, by implication, people into snug and appropriate niches."[2] While dogs are promiscuous in their affections, and conceivably can be obtained by anyone, the right kind of dog can be acquired only by someone with means. Resorting to the language of breeding as a way of enforcing social distinctions is a powerful metaphorical tool. "Representations that appeal to prevalent notions of the dog as a despised and degraded human make subtle feelings of prejudice toward other people visible and immediate,"[3] while images of nobility and courage derived from verbal and visual images of purebred dogs can endow a person with benevolent and admirable qualities. Taking inspiration from our British kin, Americans embraced an aristocracy of breeding that was subtly connected with wealth, race, and social standing. In this chapter I document how the canine body is linked verbally and visually with the upward mobility of the white middle class. The dog gets used as part of a racially and socioeconomically charged social sorting.

The presence of the dog in the photograph speaks about the commodification of animal and human life, doing so within the framework of a crucial, coercive technology—photography. There are thousands of antique photographs of well-dressed Americans in the portrait studio, and it is clear that Americans enthusiastically embraced the photograph as a resource for documenting and achieving respectability and success. The image documenting the success of the sitter is also one of the commodities that can be purchased by that success. Photographs not only offer us goods for consumption; "they also offer us identities to inhabit, constructing and circulating a systematic regime of images" that encourage us to center our lives around acquisitive discontent and aspiration.[4] As I argue here, those identities are about consumer culture, class status, and racial purity. From *Little Lord Fauntleroy* (1886) to *Buster Brown* (1902) and *The Great Gatsby* (1925), words and images about dogs collaborated in representing the aspirations of the white middle class as the twentieth century moved toward the Great Depression.

MYRTLE WILSON'S DOG

In what seems to be a throwaway line, Nick Carraway, the narrator of *The Great Gatsby*, comments that when he moved to West Egg he had a dog; "at least I had

him for a few days until he ran away."[5] Nick's tossed-off line about the dog signals something that will become manifest only when another dog—and the metaphorical pathway unleashed by the presence of the dog—becomes an item in Myrtle Wilson's living and dying toward a middle-class life. Emblematic of hunger, pollution, promiscuity, and low social class, the literal and metaphorical dog skulks in the byways of literary history, such that Fitzgerald's later introduction of a second dog, Myrtle's abandoned cur, has substantial cross-cultural reference points. For example, Ivan Kreilkamp's graceful essay on Dickens's employment of the dog in *Great Expectations* indicates how the metaphorical logic of the novel calls attention to the "likeness between humans and animals" and underlines the almost primeval fear of "being treated as or forgotten like a dog."[6] This is exactly what Fitzgerald does with Myrtle Wilson.

The Great Gatsby is the archetypal novel of the American dream, in which the promise of the new land is rendered as a triumph of leisure-class consumption. The narrator, Nick Carraway, gets caught up in observing and facilitating the ill-fated romance of the self-made hero, Jay Gatsby, with Daisy Fay Buchanan, the socialite married to Tom Buchanan of old money. In *The Great Gatsby*, there are "many seemingly trivial references to photographs," which, like the references to automobile accidents, accrue to a critical mass of interpretive opportunity.[7] In fact, the references to photography not only occur as narrative about pictures within the novel; the language of photography and moviemaking also becomes part of the metaphorical vision and fabric of the novel. Much of the photographic language is employed around the figure of Myrtle Wilson, the coarse, sensual woman who engages in an affair with the wealthy Tom Buchanan.

Readers of *The Great Gatsby* may recall the odd scene in which Myrtle rides into the city with Tom and stops to purchase a puppy from a street vendor before ascending to the hotel suite where she will play the role of the lady of leisure. Myrtle thinks the apartment needs a dog, as though owning a dog is a decorative strategy. She wants a "police dog," that is, a purebred animal, but she is easily deflected from this purpose and selects a puppy with a weatherproof coat and "startlingly white feet." The street vendor, who bears "an absurd semblance to John D. Rockefeller," cannot identify what breed the animal is but assures her that the dog is a sturdy "boy" dog, although Tom Buchanan decisively pronounces the animal "a bitch" (31–32). Tom's language is part of a metaphorical definition of Myrtle, who is later seen "straining at the garage pump with panting vitality" as Gatsby and Nick drive by (72). She is not the only bitch in the story, but she's the only person who is slaughtered "like you'd run over a dog" in the road (187).

The dog is part of a larger motif of animal imagery used by Fitzgerald to ridicule the nouveau riche of Long Island. The hapless animal has only one further brief narrative moment, and it is last seen sitting on a table like a bibelot, "looking with blind eyes through the smoke and from time to time groaning faintly" (41). As Myrtle is to Tom, the dog, to Myrtle, is a "possession to be played with, fondled, and in due course ignored."[8] Fitzgerald's use of the dog occurs within a narrative sequence laden with visual and photographic tropes that lend themselves to the optics of the novel and suggest how photography, "generally associated with clarity and realism, is an instrument of instability in *The Great Gatsby*." Like actual photographs, "the novel's fictional photographs recreate their subjects," simultaneously reflecting and replacing reality through the artificial agency of time fixed as bounded space.[9]

Figure 28 offers us one of those re-created subjects. The young man in the picture is identified on the back of the card as Ed Mitchell, although the author of the message is someone else. Jaunty and well dressed down to the cigar, Ed Mitchell could have been presenting himself for a Gatsby-like business transaction. The carpet on the floor, the table, covered with a tasseled brocade fabric, and the delicately leashed Boston terrier on the table are all part of the conventional portrait. Mitchell presents himself as a successful young man, and the purebred dog on the table is part of that visual communication. However, the dog is not Mitchell's dog. In a lengthy message that begins "Hello Mother," the unidentified correspondent says that the dog in the picture is *his* dog. He goes on to lament his homesickness and pleads with his mother to write soon. Thus the ambiguous meaning of the middle-class studio portrait presents itself in the collusion of word and image. Does Ed Mitchell even own the clothing he is wearing, and could he really afford that cigar?

Apparently, borrowing or lending a dog was not unusual. Photographer Richard Avedon says that he and his family planned family portraits carefully:

> We dressed up. We posed in front of expensive cars, homes that weren't ours. We borrowed dogs. Almost every family picture taken of us when I was young had a different borrowed dog in it. . . . It seemed a necessary fiction that the Avedons owned dogs. Looking through our family snapshots recently, I found eleven different dogs in one year of our family album. There we were in front of canopies and Packards with borrowed dogs, and always, forever, smiling. All of the photographs in our family album were built on some kind of lie about who we were, and revealed a truth about who we wanted to be.[10]

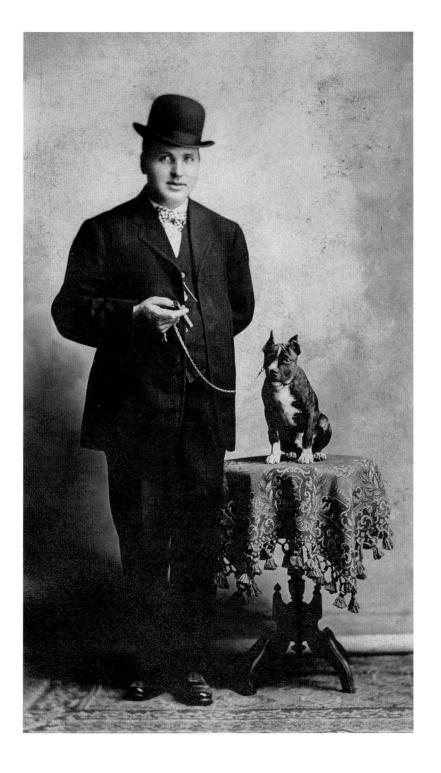

FIGURE 28

Ed Mitchell. Used RPPC, 1908,
8.8 × 14 cm.

Avedon was born in 1923, and he and his family certainly didn't invent this form of improved reality. Borrowing dogs or livestock for portraits is a long-standing tradition in painting, so it would not be surprising to see evidence of this gambit in photography as well. In fact, Avedon's story suggests that we might be skeptical about any number of groupings around houses and cars in antique photos; as we'll see, studios provided dog statues for clients, as well as clothing and scenery.

The few family pictures that Avedon reproduces in *Richard Avedon Portraits* show at least one purebred dog and two shaggy canines of questionable origin. Perhaps by the late 1920s, the issue of breeding was not as compelling as it had been at the turn of the century. Not all families who took to the studio with the family dog presented a purebred animal, but we are most likely to see recognizable breeds in cabinet photos and *cartes de visite* (CDVs), both of which were usually studio products. In purchasing a dog of "indeterminate breed," Myrtle Wilson misunderstands the visual rhetoric of middle-class consumption and confirms her own outsider status. Marianne DeKoven argues that the dog in *The Great Gatsby* "steadily declines in a way that suggests its possible or probable death,"[11] reading the pup as a symbol of Myrtle's and Gatsby's ambiguous social status. The pup is the "baby Myrtle will never have with Gatsby" and the opposite of Daisy's aristocratic daughter. As a little mongrel, the abandoned dog carries the symbolic freight of illegitimacy. The photographer at the apartment party flatters Myrtle by considering her for an "art" photograph, but Myrtle, who married her husband because she "thought he knew something about breeding, but he wasn't fit to lick my shoe" (39), misses her cue. Although she smiles brilliantly for the edification of the photographer, in fact she never has her portrait made, and the mongrel dog, which should have been part of her visual record of conspicuous consumption, is left sitting on a table, waiting for a photograph that won't happen. The moment is an astute comment on the viability of Myrtle Wilson's social aspirations, using what would have been a commonplace photographic norm for the time, the purebred dog on the table with its proud middle-class owner.

A MATTER OF BREEDING: THORSTEIN VEBLEN AND ALBERT PAYSON TERHUNE

In *The Great Gatsby*, it is important that Myrtle Wilson's dog is a mutt, because in the historical time frame of the novel, the matter of dog identity had become a feature of social class. It was not always so, however. Dogs became specialized critters in the late 1880s. Until the Industrial Revolution and the rise of urban landscapes, American life was saturated with animals, most of whom supplied food or essential economic labor. This included canines, which provided companionship as

PICTURING DOGS, SEEING OURSELVES

well as essential services to pre-urban communities. Dogs were used to pull carts and wagons. They hunted, herded, and guarded. But complex technological and economic changes not only isolated human beings—especially those who lived in the city—from sources of primary experience but also pushed animals into a different cultural space. Cart-pulling animals gave way to machines; food protection and production was separated from the lives of most Americans. As animals disappeared from cities, veterinarians, once disparaged as crude farriers, shifted their emphasis from large farm animals to dogs and cats. With that shift, the working animal became a pet whose value was measured in terms of sentiment, not because it produced food or a service to people.[12]

Dogs moved from roles as companions and guardians to status and identity symbols. The visual presence of the dog in the portrait brims with meaning, for the canine body has been subjected to the same forces of social ambition that condition the human body. These forces are symbolized by the American Society for the Prevention of Cruelty to Animals (ASPCA), on the one hand, and the American Kennel Club (AKC), on the other. The ASPCA, established in 1866 in emulation of the British movement, may have originated in tender feelings for animals, but it also become a vehicle for palliating lingering guilt and confusion over the plight of human creatures in cities. Arguing for economic and labor reforms that would benefit largely poor immigrants would strike at the very social arrangement that made the middle class so comfortable. Moreover, as with the debates about immigration today, neither citizens nor politicians at the turn of the century had any useful clarity about how to acculturate or control the influx of foreigners, who were needed to keep the wheels of industry turning. Unable or unwilling to change social conditions for humans in any meaningful way, the middle class turned to alleviating animal suffering.[13]

Animal rescue was a matter of a higher class graciously assisting a lower class of creature. As James Turner explains in *Reckoning with the Beast*, "SPCA supporters justified their campaign for kindness by a line of argument based on a transparent analogy to the relations of employers to workers: 'We are bound to reciprocate duties: brutes give us their labor, and in return, we are bound to provide them food and tender treatment.'" Moreover, teaching even the working poor to be kind to animals would uplift them and enhance civilization. Thus SPCAs increasingly devoted their time to "humane education," hoping to "tame the savage dispositions of the working classes."[14] Additionally, being kind to animals was not only a civilizing way to practice empathy, if not noblesse oblige; it was also a mechanism for developing self-control, another hallmark of the socially distinguished person.[15] Teaching the poor to be kind to animals would somehow uplift them by also

encouraging the practice of discipline and self-control necessary to alleviate their impoverished condition.

While the ASPCA struggled to minister to the "unkempt dogs of the urban and rural poor and of laborers,"[16] the American Kennel Club emerged as its class-based counterpoint. Established in 1884, the AKC promotes the sport of purebred dogs, an activity designed to protect bloodlines and social exclusivity. As Susan McHugh notes, the "dog show set a precedent for a value system of breed that increasingly became a hallmark of bourgeois life."[17] The confluence of nativist, anti-immigrant sentiments—human breeding—with the world of dog breeding is exposed by Mark Derr. As dogs lost their working utility, they became pets, and the people who created them promoted them as exemplars of middle-class breeding. At the same time, "every attempt was made to strip the cur of its dignity and sagacity, because of its low breeding, just as blacks were denied full humanity and other ethnic groups, including poor European and Irish immigrants, were deemed morally and intellectually deficient."[18] While the ASPCA struggled in its truncated witness to the value of lowly and crossbred working-class creatures, the AKC wielded the rhetoric of human racial purity.

Writing in the wake of these developments, Thorstein Veblen clarified the meaning of class consciousness for Americans, further underlining how matters of animal husbandry played a role in the development of consumerist culture and class consciousness. Veblen gave us a phrase that has become a permanent reference point in our cultural lexicon, "conspicuous consumption"; less often noted is that Veblen devotes several pages to the role of purebred animals, most notably dogs and horses, in this emerging society of consumerism. As one of the many "must-have" accoutrements of middle-class luxury, the purebred dog, like its status-hungry owners, was distinguished by its high cost and practical uselessness. Veblen outlines how the purebred dog has "advantages in the way of uselessness as well as in special gifts of temperament," notably the dog's faithfulness, intelligence, and servility, along with our romantic association of the dog with "the chase," a "meritorious employment and an expression of honorable predatory impulse." However, it is all for show, as no purebred dog actually performs any labor or service except inasmuch as the animal has a "special claim to beauty on pecuniary grounds." While taking a swipe at the monstrosity of purebred standards, Veblen declares that the value of these purebred dogs "lies chiefly in their utility as items of conspicuous consumption"; because they are expensive, they are also considered beautiful. These traits also describe the American middle class, whose characteristic feature is a "conspicuous exemption from all useful employment." Thus the "pervading principle and abiding test of good breeding [in human

beings] is the requirement of a substantial and patent waste of time."[19] Exactly the same is true of dogs, which are the testimonial mirrors of middle-class attainment.

Veblen's sarcastic critique of purebred animals and their owners was not solely determinative of cultural attitudes, however. The language of breeding seized the American imagination. In the early to mid-twentieth century, a cadre of writers produced literature about dogs, literature that we now largely ignore or consider more suitable for children than adult readers. Many of these writers are associated with stories of wilderness adventures and coming of age for boys and dogs (see chapter 5), and others are associated with particular breeds. One of these writers was Albert Payson Terhune (1872–1942), a contemporary of Fitzgerald's. Terhune engaged in a spirited defense of purebred dogs while inadvertently verifying Veblen's outlook on the leisured middle class.

Although his writing career was varied and extensive, if Terhune is remembered at all, it is as the master of a larger-than-life collie named Lad. Figure 29 is an RPPC of Terhune with several of his famous collies, including Lad, who lounges at his feet. Even in his time, Terhune's writing was not regarded as great literature, so Terhune is not part of the conventional educational canon of American literature. But the publishing history of Terhune's collie books suggests that his influence was substantial and ongoing. For example, the first of the series, *Lad: A Dog*, arrived in bookstores in April 1919 and went into second and third printings in June and July of the same year. By 1940 the book had surpassed seventy printings, and Terhune's biographer, writing in 1975, was able to claim that *Lad: A Dog* was in its eighty-second printing.[20] *Lad* was still being reprinted in 2013; Amazon.com lists the book as no. 71,845 on its best-seller list, not a bad record for a 1919 collection of dog stories.[21]

Terhune pays tribute to the superior qualities of the thoroughbred dog in a series of repetitive dog stories that flicker with the compromised light of archaic social postures. Terhune's estate, Sunnybank (referred to as "The Place" in the dog stories), represents the garden fortress that shelters the Master, the Mistress, and the noble collie population from the periodic intrusions of the crude outside world. Class distinctions pertaining to both humans and dogs provide the dramatic fulcrum for most of Terhune's dog stories. Mongrels, along with their poorly bred human counterparts, make multiple appearances as villains.

Sometimes the narrator refers to the Master at work on his writing, but the estate's Mistress is a lady of leisure. Terhune defends social hierarchy primarily by extolling the courtly virtues represented by his dogs. Like a knight of yore, Lad is a courageous and loyal protector of the weak, always devoted to justice. Not only are mongrels, low-bred white people, and foreigners to be suspected, but even

FIGURE 29

Albert Payson Terhune with
Sunnybank collies Lad, Bruce,
and Wolf. Autographed RPPC,
1918–1930, 12.8 × 8.4 cm.

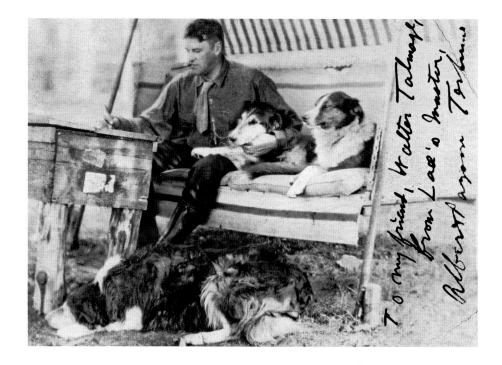

purebred creatures are not all equal in Terhune's world. The owners of AKC pure-
bred dogs are often foppish and dishonest, leaving the Sunnybank collies to tri-
umph at every dog show while disdaining the standards that are affirmed by their
victory.

In the final analysis, Terhune makes a better case for the valuable work of the
purebred dog than he does for the middle-class dog owner. His collies are not only
beautiful but offer an essential service in modeling worthy values and defend-
ing the garden from mongrelized intruders. Moreover, the finely bred collie can
detect human unworthiness at any distance; the loyalty of a fine dog is as much
a comment on the owner's character as the dog's. Terhune's collies are symbols
of his own moral and genteel persona, and although he presents his alter ego
(the Master) as bumbling and good-hearted, his stature is enhanced by the dogs.
Why is it important to note this self-serving motif? Because, like the dogs in the
middle-class portrait, Terhune's collies provide a character reference. In *The Great
Gatsby*, judgment on human character issues from a nameless dog. That fleeting
narrative moment where Nick tells us that he had a dog but it ran away means, in
the iconography of early twentieth-century consumerist culture, that Nick himself
may not be worth our admiration or loyalty. It is a small but telling moment for
readers who are uneasy with Nick's claim that he is "one of the few honest people

that I have ever known" (64). Similarly, Myrtle Wilson's hapless mutt signifies her hapless ambitions. By the end of the novel, she is as abandoned as that dog.

Terhune's insistence that the thoroughbred is the only pathway to lofty character typifies the cultural sorting that pertained to both dogs and humans in the early decades of the twentieth century. In *The Dog Owner's Handbook* (1936), for example, Fredson Thayer Bowers argues that no self-respecting dog owner would want a mongrel; "the owner of the mongrel is always on the defensive," he says, because a mongrel "is a dog of little distinction." "Handsome is as handsome does," says Bowers, moving to the heart of his argument, which is that the superior beauty of a purebred dog makes it the natural accessory for any right-thinking dog owner.[22] Lineage and bloodlines, along with appearance, matter, and the middle-class photograph was the medium for documenting the achievement of good breeding and appearances.

THE MIDDLE-CLASS PORTRAIT

The visually calculated middle-class presentation may have been as shallow as the time spent in the studio setting was short, and yet the ability of the physical image to lend authority to that captured moment confuses our ability to read the image clearly, as we've seen in the example of figure 28. Similarly, F. Scott Fitzgerald's romantic fascination with the rich is constantly under assault by his realist distaste for their corruption, leading readers to vacillate between condemning and admiring Jay Gatsby, an ambivalence undoubtedly complicated by how well the novel anticipates and mirrors our own era of consumer excess. But the culture of consumption and class longing captured so well in *The Great Gatsby* is a culmination of multiple cultural threads. These include the power of the photograph itself, and then the several literary engagements that, combined with photographic technology, created a culture of visual consumption that we still inhabit today.

The competing values represented by the ASPCA and the AKC are replicated and reified in various literature and commentary written between 1886 and 1925, and are given visual life through the middle-class studio portrait. As Stuart Ewen puts it, what Veblen identified as the "conspicuous consumption habits of the leisure class were now propagated as a democratic ideal within mass advertising."[23] Advertising strategists encouraged the working class and aspiring middle class to see consumption of the correct commodities as a path to the democratic promise of freedom and equal opportunity. By emulating the tastes of the upper middle classes, working-class and middle-class persons were taught to see themselves as participants in something they could not actually afford but could imitate.

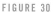

Moreover, advertisements strove to prevent the working classes from examining the actual conditions of production, and their own entrapment, by dangling before them a class status they couldn't actually attain.[24] Like their middle-class owners, pets became consumers of products in that modernist loop wherein buying and using goods became the sole and sufficient work of the middle class. At the same time, dogs functioned as one of the products to be consumed by aspiring middle-class persons who were intent upon verifying their membership in the classes above them.

Photographic portraits of the upper middle class were hailed as a resource for inspiring noble character in ordinary working people. "Viewing portraits of the nation's elite," Barbara McCandless observes, "could provide moral edification for all its citizens who needed to learn how to present themselves as good Americans in a quest for upward mobility."[25] Rather than depict people at their work, the middle-class studio portrait presented its subjects "in a setting that suggests consumption of the luxuries of middle-class life. . . . The photograph begins to function as a key element in the project of modernity in a society where the self

could be constructed as a public object in order to achieve upward mobility."[26] Not only did people desire dignified studio portraits of themselves; they also paid for solo portraits of their dogs, which could be found inhabiting the same calculated settings as their owners. In figure 30, a beautiful collie has been given a romantic setting and a plush chair to emphasize its noble lineage.

In addition to the conventions for dog photography mentioned in chapter 1, there are stable, recognizable conventions for the middle-class portrait, including any or all of the following: ornate furniture, draperies, gently indicated landscape backgrounds, a small table, and a carpet of some kind. Figures 28, 30, and 32 contain many of these essential elements. Books, flowers, and urns might also be used to compose an interior setting that shows the sitter in tasteful surroundings that imply educational attainment and a civilized worldliness, as we see in figure 33. A dog might be added to the studio setting as a further reflection of the sitter's status and sensibilities. These conventions of the middle-class portrait were so powerful that we see them reproduced in the far more casual settings of makeshift studios, though sometimes the draperies have become a blanket and the Oriental rug has become a small swatch of carpet laid down on the grass. Because the swatch of carpet in figure 31 is rumpled, this portrait of a dog and baby appears to be a typical outdoor presentation that mimics the studio standard. That is, even when people could not afford or lacked access to a studio, it appears that they and the photographer tried to create a setting as much like a studio product as possible.

The importance of the middle-class portrait is entangled with the meaning of the photograph itself—its questionable reality, artistry, and documentary utility. The competent studio could provide costumes and scenery to assist in simulating a middle-class standard of dignified conspicuous consumption. Thus we don't necessarily have pictures of the middle class; we have pictures that re-create the subjects as they wished to think of themselves. For those who found the dog an important symbol of success, one's own good breeding could be affirmed through the selection of one's dog. A startling illustration of how important the dog could be in this respect is the use of a dog replica in place of a living animal in some studio portraits. Replicas were made of ceramic, iron, chalk, and even cardboard. This practice of using a dog replica in photographs has early origins. It appears in one of the oldest CDVs I own, which dates from the early 1860s. The image shows a straight-backed chair on which a ceramic dog is seated, with a little girl dressed in winter clothing standing next to it. The flooring is probably linoleum, and, as in most early images, the background is plain, so that the ceramic dog and the child's clothing must carry the message of prosperity and domestic security.

FIGURE 31

Cabinet card, 1890s, 7 × 10 cm.

In figure 32, many more of the late nineteenth-century signifiers of middle-class gentility surround two polished children. There is the Oriental carpet on the floor, the column on the left denoting something vaguely classical, and a gently indicated garden backdrop. The children are suitably solemn, and the baby's dress, with its lacy border, is pristine. Anchoring the photograph is a dog statue, probably intended to be a whippet or Italian greyhound, both admired at the turn of the century. The triangulated staging draws the viewer's eyes naturally toward the dog. The presentation of the children suggests that their parents could afford a live purebred animal if they wished, but they've chosen to augment the visual language of good breeding by including a replica instead.

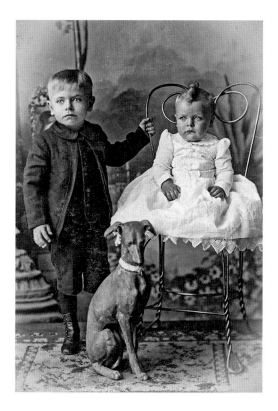

FIGURE 32

Cabinet card, 1890s, 9.7 × 14
cm. Photograph by C. Aroaouet,
91 Fox Street, Aurora, Illinois.

The youth in figure 33 enjoys not only the carpet, the columns, and the land-scape; he's been furnished with a ponderous book (a Bible?), an urn with what appear to be artificial flowers, and, of course, the artificial dog, a pug. The dog is not the center of the composition, but it is one of several rhetorical complements. This setting communicates the boy's natural membership in the realm of beauty, knowledge, breeding, and gentility. He appears to be secured in his pose by a stand that would have gripped his head or neck to keep him from moving, although such devices were hardly necessary at this late date, suggesting perhaps just how firmly the lad is in the grip of middle-class visual rhetoric. That said, there is something ironic and charming about the dog figure. Upon close inspection, the tail appears to be broken, a wink, however inadvertent, on the part of the photographer re-garding his subject.

The ubiquity of the dog as a marker of good taste and breeding is underlined in figure 34. Here, the unidentified family stands on a small carpet, suggesting that the domestic homestead itself would not have been a suitable setting for commu-nicating one's breeding, or that a studio was not available to these folks. At their

FIGURE 33

Cabinet card, 1890s, 10 × 14 cm.
Photograph by Hos Ryerse,
31 Emslie Street, Buffalo,
New York.

feet is the absurdly small figure of a pug. Visually, the dog is much too small to serve as a replacement for a real dog, but in this context size clearly doesn't matter. The dog "speaks" authoritatively about this family's participation in American values, as does the carpet.

LITTLE LORD FAUNTLEROY AND BUSTER BROWN

Frances Hodgson Burnett's popular novel *Little Lord Fauntleroy* (1886) seems to have been crucial for the emergence of visual class consciousness, as well as expressing

FIGURE 34

Cabinet card, 1880s,
11.5 × 19.3 cm.

a lingering cultural ambivalence about these matters of class and breeding. *Little Lord Fauntleroy* evinces the same romantic fascination with wealth that *Gatsby* does, minus the leavening cynicism. The American boy who is transported to England to claim his fortune proves that breeding will tell, because while he has been raised as an American, and therefore is presumed to be of low class, he has aristocratic blood. He comports himself with the dignity of inherited good breeding, thereby winning over the mean old Earl of Dorincourt, and in the end, Fauntleroy gets to be wealthy, aristocratic, and virtuous all at once. Nick Carraway cannot keep the loyal affections of a dog, but Fauntleroy immediately makes friends with his grandfather's "majestic" mastiff, Dougal, showing himself to be courageous and worthy of his inheritance.

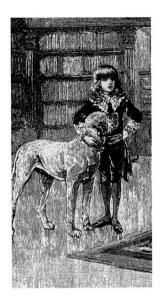

FIGURE 35

Fauntleroy and Dougal. Original
illustration by Reginald Birch
for 1886 edition of Frances
Hodgson Burnett's *Little Lord
Fauntleroy.*

Studio photographers and their subjects turned prose into visual testimony by incorporating the Fauntleroy model into the middle-class portrait. The purebred dog was assisted in its role as a middle-class signifier by the clothing worn by little boys, who joined their pets on the altar of family respectability. Although Burnett praises Fauntleroy as "manly," with his sweeping curls and sturdy limbs, his name has become associated with the foppish, thanks to Reginald Birch's illustrations (figure 35). Typical of the Fauntleroy suit was the white shirt with huge lacy collar and monstrous cuffs, framed with a velvet or wool suit, usually knee breeches, vest, and jacket. Boys from the late 1880s to the 1920s were afflicted with the extravagant Fauntleroy garments and sometimes the signature curls. Little boys were occasionally overwhelmed by their costumes, as in figure 36, where Frank Autrieth isn't quite in control of the shirtfront but has a firm grip on the dog, an English pointer. The dog is identified on the card as Royal, and both the outfit and the purebred dog (if not its name) confirm the good breeding and social status of this subject from Warsaw, Missouri.

However, if you live in the boot heel of Missouri and are aware of what fashionable boys are wearing but find the studio display and costumery beyond your means, how will you participate in the cultural trend? Figure 37 offers a poignant look at the imperative of middle-class visual rhetoric. The photographer, W. W. Limbaugh, helpfully identifies his product as "Amateur Photography" in a stamp on the back. The mount and the photo are unevenly cut and trimmed, and the backdrop looks like a painter's tarp, as does the floor. This kind of casual backdrop is more typically seen in RPPCs than in cabinet cards, indicating just how transient Limbaugh's studio probably was. Monford Craig has been prepared for his photograph. His hair is smoothed down and he is wearing shoes and socks with his too-short overalls. Most telling, however, are the incongruous Fauntleroy shirt and the dozing dog. Monford's parents and the photographer have observed the conventions of middle-class visual rhetoric, and it appears that despite their limited aesthetic and economic resources they have done their best to participate.

Figure 38 displays a similar moment in a badly preserved artifact. The working poor were less likely to indulge in studio photographs such as cabinet cards or CDVs, and more likely to resort to the more casual real photo postcard.[27] Even if they did spend resources on a formal portrait, they were not as likely to have access to a studio, or stable enough circumstances for preserving family records.

However, the lexicon of the middle-class portrait still commands the shot, even in the outdoors. The little girl, dressed in the white typical of the decade between 1900 and 1910, has brought a doll and buggy, displaying some key possessions that might be associated with a genteel girlhood. Between the girl and boy,

PICTURING DOGS, SEEING OURSELVES

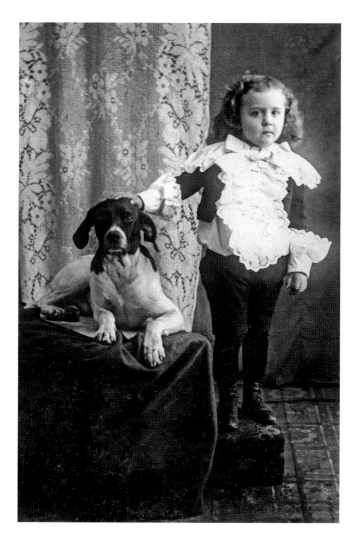

FIGURE 36

Frank Autrieth and Royal. Cabinet card, 1890s, 9.5 × 14 cm. Photograph by Moore. Warsaw, Missouri.

in a place of equality and honor, is the dog. The picture was planned inasmuch as someone had to bring out a chair for the dog, but it is a rude wooden chair without decorative consideration (in contrast to the studio furniture visible in figure 32, for example). Someone also had to corral the boy, who might have been wearing that shirt anyway or who may have been coerced into changing into the garment associated with formal studio portraits. His hair has been parted and smoothed. He's wearing a modest version of the popular Fauntleroy shirt, although the collar is rumpled and the shirt is pulling across the front as if it is too small. The boy is barefoot and is wearing shorts, although the image is too degraded to tell much

more. The dog, perhaps a spaniel of some sort, is scruffy-looking in comparison
to the whites of the shirt and dress, suggesting that its normal state of affairs is
a matted and stained coat. Nonetheless, whether the animal is present as a fond
indicator of warm family life or of good breeding, the dog is a purposefully chosen
element that knits the portrait into the American dream lexicon of the aspiring
middle class.

Little Lord Fauntleroy and his foppish outfit were absorbed and succeeded by
another American original, Buster Brown. The Buster Brown image took over the

FIGURE 38

Cabinet card, 1900–1910,
9.7 × 14 cm.

gentrification of dogs and boys from Fauntleroy, becoming another weapon in the advance of consumerist culture. Figure 39 shows a Buster Brown advertisement from 1904 in which the plucky youth is wearing his trademark hat and jumpsuit and is accompanied by his dog. From the beginning, the creator of the Buster Brown cartoon character, Richard Felton Outcault, intended to market the character as both a money-making comic strip and a profitable advertising icon. The image was sold to the Brown Shoe Company in 1904 as well as numerous other franchises, so that the comic strip character ran simultaneously with the brand-name products he was advertising. Ian Gordon sees the Buster Brown franchise as a pivotal moment in American visual culture, commenting that "Buster Brown was the crucial link between comic strips and the development of a visual culture of consumption in America."[28]

Outcault had experimented with ambiguously white or nonwhite characters, including a short-lived African American child hero, "Poor Lil' Mose," who first appeared in 1900. Mose is often depicted wearing the clothing we later associate with Buster Brown, but he does not have the signature dog. Rather, he

Buster Brown and Tige.
Illustration from the front cover
of sheet music for "Oh, Gladys!,"
a song in Broadhurst and
Currie's production of *Buster
Brown* (New York: M. Witmark
and Sons, 1904).

communicates with talking animals as he makes his way around New York City.
But while stereotypical black figures were successfully used in an array of adver-
tising gambits (Aunt Jemima, Uncle Ben, the Gold Dust Twins), the same was not
true of African American comic characters.[29] In order to succeed, the comic char-
acter needed more dimensionality than could be imparted by standard African
American stereotypes, and apparently no audience was ready for a humanizing
presentation of black people. Additionally, while children and immigrants may
have relished the adventures of the underdog characters in the funnies, the largely
white audience with money determined enduring success.

Thus Buster Brown entered the lists as a white middle-class youth in 1902, and
figure 40 seems an apt expression of the cultural icon. His charm seemed to be
that while he was a rascal, he was a middle-class rascal who always repented of his
misdeeds. Although variations on Buster Brown clothing were introduced over the
years, his trademark outfit became a sailor suit and jaunty cap atop his Dutch-boy
hair cut. The shoes with straps were called "Mary Janes" after his cartoon sister,
and they were marketed for both boys and girls. Finally, Buster Brown is always
accompanied by his dog, Tige. Tige variously looks like a boxer or an American
Staffordshire terrier, what today we would call a "pit bull," which, despite its
reputation as a vicious animal even then, was a popular family dog at the turn of

PICTURING DOGS, SEEING OURSELVES

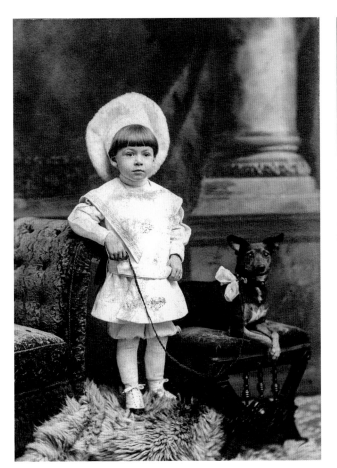
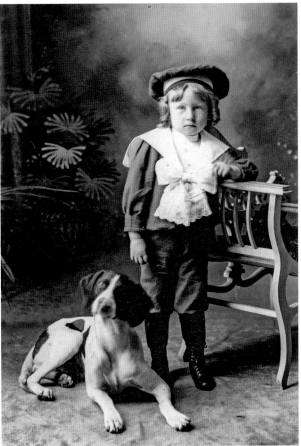

the century. As proud parents dressed their little boys for studio portraits, the Fauntleroy image was seamlessly integrated with Buster Brown, so that the implicit visual claim to good breeding remained intact throughout the decades. Thus, as in figure 41, a youngster might be afflicted with the prissy Fauntleroy shirt *and* the Buster Brown hat and haircut.

THE COLORED MAN IN *THE GREAT GATSBY* AND BEYOND

The Buster Brown in figure 40 seems to be clad in an all-white outfit, although there may be some patterning or color in the fabric that has faded over the years. Perhaps this was merely the result of parental aesthetics, or perhaps, given the racial dynamics of the early twentieth century, the whiteness of his image is more

FIGURE 40

[LEFT] Cabinet card, 1900–1910, 9.8 × 14.1 cm. Photograph by Demers and Son. Holyoke, Massachusetts.

FIGURE 41

[RIGHT] Cabinet card, 1900–1910, 9.8 × 14 cm. Photograph by Moechkli, 1111 North 8th Street, Sheboygan, Wisconsin.

purposeful. The language of breeding and the visual rhetoric of the middle-class portrait became discourses about race at a time when conflict over racial purity and immigration boiled over in the political realm with some regularity. "Belief in the superiority of the pure-blood dog and of scientific breeding were of a piece with the justifications of class, racism and eugenics," as Mark Derr observes.[30]

The triumph of middle-class consumerism and its intricate relationship to whiteness seems inevitable in retrospect, and F. Scott Fitzgerald told it truly in his color-suffused masterpiece. Not only did Fitzgerald examine the moral bankruptcy of the Jazz Age consumer; he linked it to race as well. *The Great Gatsby* appeared during the flourishing of nativism and racist activities, and Fitzgerald has Tom Buchanan read a book by "Goddard" that has him mightily upset about the impending destruction of the white race. The reference is to Lothrop Stoddard's *The Rising Tide of Color Against White World-Supremacy* (1920), wherein the pure Nordic race is warned of the dangers of the "mongrelization" of America through unchecked immigration and interracial marriage, although Fitzgerald could as easily have referred to Madison Grant's *Passing of the Great Race* (1916), which gained cultural ascendancy in the 1920s. These commentators and their followers were concerned about the "biological power of immigrants to effect a kind of conquest by procreation,"[31] necessitating a careful classification of superior and inferior races and a firm, eugenically based stance against miscegenation. Madison Grant pulls no punches in this matter, announcing that once we understand the implications of mixed marriage, bringing "half-breeds into the world will be regarded as a social and racial crime of the first magnitude. The laws against miscegenation must be greatly extended if the higher races are to be maintained."[32] Along with politicians, authorities such as Stoddard and Grant warned about the dangers of "mongrelizing" the white race and advocated the thoughtful breeding of vigorous Anglo-Saxon stock in order to preserve the American polity.

The elusive meaning of "white," however, was finally anchored by a bias that we still recognize—that "American" means "white." In *The Great Gatsby*, ironic references to "white," accompanied by a palette that makes Jay Gatsby the "colored" man in the story, culminate in Tom's confrontation with Gatsby over Daisy. Tom shouts, "Nowadays people begin by sneering at family life and family institutions and next they'll throw everything overboard and have intermarriage between black and white," as if what Gatsby represents is nothing less than miscegenation.[33] But the crowning line belongs to Jordan Baker, who immediately murmurs, "We're all white here" (137). In this context, "white" has come to mean shallow, dishonest, materialist, amoral, and, finally, murderous, so that Jordan is actually telling one of the monumental truths about the characters in the novel, if not about America itself.

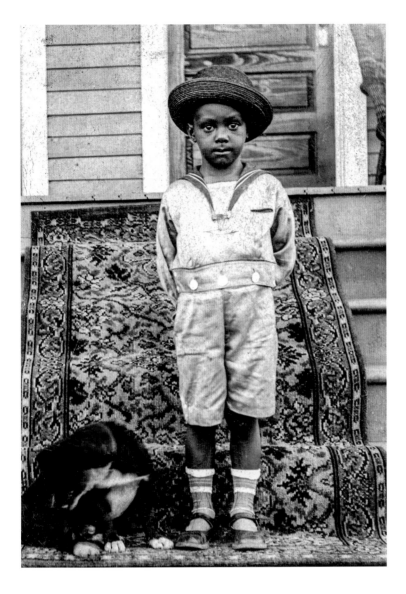

FIGURE 42

Unused RPPC, 1917–1930,
7.5 × 11.5 cm.

What, then, to make of the solemn child in figure 42? Photographs of African American boys in Fauntleroy or Buster Brown suits are rare, and this is a touching image for that reason. The boy's clothing, his dog, and the carpet covering the outdoor porch steps all speak of his respectable middle-class background. He is wearing the Buster Brown outfit, a one-piece jumpsuit with a sailor collar, and anchoring his socks are Mary Jane shoes. Buster Brown hats took on a variety of shapes, including the round-brimmed woven hat that we see here. The dog doesn't

look like a purebred animal but, like Myrtle Wilson's dog, it does have "startlingly white feet." Inadvertent as it may have been, it seems fitting that the pup did what dogs often do. It moved just as the photograph was taken, turning its head at the crucial moment, leaving only the child as the direct, eloquent witness to the contending cultural forces that brought him to these steps.

Those cultural forces, documented so subtly in these photographs, are still at large today, and not simply a historical curiosity. During the 2008 presidential campaign, we endured a vigorous national debate about what kind of dog the aspiring White House residents should select. Candidate Barack Obama joked about picking a shelter dog, "a mutt like me," for the family dog, which sparked a nationwide debate over whether the future president should select a purebred dog or an ASPCA mongrel. In the 2012 presidential campaign, candidate Mitt Romney was excoriated for taking a long road trip with his dog strapped in a crate on the roof of the family station wagon. Many voters felt that a man who treated the family dog so callously was not a fit candidate for president. Most of those who hoped that the Obamas would purchase this or that breed were probably just earnest dog fanciers, and yet their marked preference for "pure" breeds has an unsettling historical precedent and is inevitably tinctured with the persistent pain of our classist and racist history, some of which is documented in the body of the dog on the table.

PICTURING DOGS, SEEING OURSELVES

3

THE GAZE OUTSIDE THE FRAME

In a telephone conversation, an elderly relative discussed her plans to hire some-
one to help with yard work at her home. After mulling it over, she announced, "I
was thinking that we would hire a black boy for the yard work. He would need the
money more than a white boy and we could train him to do it the way we wanted. I
thought we could talk to the pastor of a black church to get some names." Having
heard other oblique comments like this from her, I did not misunderstand her
meaning, which is that black people are docile and needy and can be trained like
house pets. The same sentiment informed an image for sale on eBay in 2008. Three
white children dressed in white sit and stand on a capacious wicker chair. At their
feet is a retriever-like dog. Standing behind them, with an arm curving around
either side in a protective-looking stance, is a black youth. Scrawled along the
bottom of the image, which dates from 1904–18, the handwritten message reads:
"Susie-Roy-Vance and their little 'nigger.'" The dog is not black. Even without the
message, I would argue that we are required to consider the likelihood that pic-
tures like this—and there are many—are not benevolent representations of racial
acceptance.

 In this chapter I have isolated a group of images of African Americans and
dogs, not because there is something strikingly different about the ways in which

African Americans presented themselves with their pets but because what is different about *some* pictures of African Americans and dogs demands consideration. In fact, these really are pictures of white people and how they've used dogs for crass purposes. Long after slavery, the condescending association of black people with house pets is perpetuated in photography, making the dog a revealing cultural marker. There is a name for this kind of condescension: *therianthropism.* Therianthropism is the use of animal imagery to discredit or demean other people. It is a form of visual violence, argues Steve Baker, not only because it depicts a person as an animal, but because the person is also depicted as *"less than* wholly human."[1] In this kind of animal representation, the animal is used for evil human purposes, prompting some of the larger questions that emanate from animal studies about the impact of our appropriation of animal lives on ourselves, on others, and on the animals. As we'll see in some of the photographs below, the dog's status is temporarily elevated by the visual postures that shape the image. The African American subject is reduced to petlike status. What is less visible is the impact of this activity on the white instigators beyond the frame. The black persons in the photographs are insulted by the original image and perhaps revictimized by having the images seen again. As with lynching or Holocaust photographs, some observers suggest that viewing these images victimizes the victims all over again. But, following Susie Linfield, I would argue otherwise. Linfield says that viewing photographs of the Jewish victims of the Holocaust is akin to viewing *"self-*portraits of Nazi degradation. Each of these pictures measures just how far outside the realm of the recognizably human the Nazis had thrust themselves; they depict the photographer as much as the subject."[2] These photographs are much more about white people—the gaze outside the frame—than they are about the African American subjects, who comport themselves with stoic and expressive dignity despite the coercive forces brought to bear upon them.

UNCLE TOM AND HIS WIFE

The Victorians loved decorative embellishment, and when a photo album did not have enough images, they inserted print CDVs to fill empty spaces. These CDVs featured a variety of images and themes—travel, nature, celebrity and political portraits, sentimental subjects, and moral instruction. Dogs appear frequently in these illustrations as protective, faithful companions. As we saw in chapter 2, human proximity to a dog serves as an implicit form of character reference. In figure 43, "Grant in Peace," the virtues of Ulysses S. Grant are validated by the support of both child and dog. Almost a century later, politicians were still able to accrue

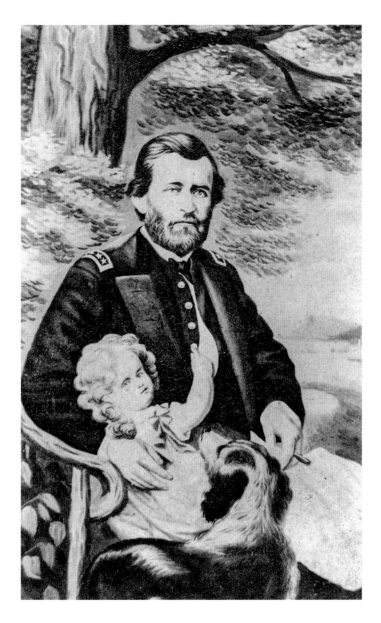

FIGURE 43

Grant in Peace. CDV album
filler, 1870s, 5.5 × 9 cm.

character credits from the dog. "In a desperate attempt to salvage his vice presidential candidacy with Eisenhower," Mark Derr reminds us, Richard M. Nixon
famously invoked both his wife's coat, cut from Republican cloth, and his children's dog, Checkers. The dog had been a gift, and Nixon announced that he would
not return the dog because the children loved it so. "A shrewd man, Nixon surely

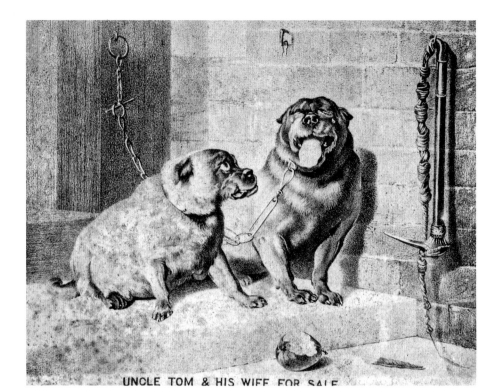

FIGURE 44

Uncle Tom and His Wife for
Sale. CDV album filler, 1860s,
7.2 × 5.9 cm.

UNCLE TOM & HIS WIFE FOR SALE

had Fala and Roosevelt in mind when he prepared his defense against charges that he had . . . benefited from a secret $18,000 slush fund."[3] Another CDV with dogs occupies a different cultural space. "Uncle Tom and His Wife for Sale" (figure 44) confronts us with an eerie moment, as if Lady and the Tramp had been transposed into the antebellum South.

Harriet Beecher Stowe's *Uncle Tom's Cabin* was first published serially in 1851–52 and was subsequently printed as a novel, going through countless editions. It enjoyed further cultural life after being turned into a stage show. Jo-Ann Morgan's careful study of the visual representations deriving from the novel's illustrations, including advertising and handbills for stage and minstrel shows, demonstrates that from the beginning the role of the potentially powerful Tom figure was compromised, with more than one edition of the novel presenting him as if he were a "large, amiable dog," or family pet, on a "leash of flowers."[4] These illustrations reflect Stowe's portrayal of the title character, who is repeatedly described much as the family dog might be: as faithful, trusting, simple, dependent, and loyal. While this depiction may have been part of Stowe's strategy for

generating opposition to slavery,[5] it also became part of a lingering rhetorical and visual prison for African Americans, as well as revealing Stowe's own innate prejudices about black people.

The CDV image in question is an engraving taken from a painting by Sir Edwin Landseer (1802–1873) that was shown at the Royal Academy of Art in London in 1857 and published in the United States in 1860. By allowing engravings to be made from his works, Landseer maximized their distribution and his own popularity. He oversaw the production of the engravings and "took immense pains in touching and retouching proofs to insure the highest quality of reproduction."[6] Landseer visited the United States and apparently read *Uncle Tom's Cabin.* Himself a devoted animal lover, Landseer was affected by the plight of the slaves but created what was even then an ambiguous image.

Landseer is known for his expressive animal portraits and scenes, but the weeping animals in this image exceed even his usual emotional range. The Tom dog is chained and is apparently also shackled to the wife dog, who looks up at him sadly. At first glance, this image could be seen as antislavery in intent. However, even contemporary critics were torn by the contradictory meanings it conveyed, one person commenting that it was "impossible to look at it, and keep from bursting into tears and laughter all at once." This critic, John Brown, a mid-nineteenth-century physician and essayist, thought that the dogs had "'an amazing look of a nigger,' a look defined by another reviewer as 'exquisitely ugly . . . black muzzled, dirty-brown coated, and excessively bandy.'"[7] Diana Donald suggests that the faces of the dogs deliberately resemble the Victorians' racist images of Africans, while at the same time invoking the eugenicist preoccupations of an imperialist culture.[8] Was the image intended to generate as much ridicule as sympathy?

The backdrop in the engraving consists primarily of planes of light and dark, calling attention to the few props included: a half-eaten apple, an elaborate whip, and a smoking cigar stub. The color painting that preceded the engraving shows a bloodstained whip, a detail that underlines the brutality of the moment. Whatever Landseer intended, and whatever his audience saw, the half-eaten apple in the engraving becomes the pivotal prop. While the whip indicates the enslaved condition of these animals and acknowledges the implicit violence of the situation, the apple points outside the frame. The apple suggests the presence of the owner of the dogs, the whip, and the chains, an owner who has taken a bite of a fatal fruit but who tactfully has been made invisible. Despite the seeming appeal to tender emotions of pity for the pathetic dogs, the image begs the question of agency. Who has enslaved these animals? Who threatens to separate and sell them? The image may provoke in the viewer some condescending emotion on behalf of the helpless

animals without suggesting that the viewer abandon his or her comfort zone and identify the white agent lurking on the margins of the image.

When I refer to the "coercive white gaze" in the photographs presented here, I am not talking about a literal white person behind the camera but the perspective that emanates from the lethal crucible of slavery. The white gaze represents a spiritual brutality that violates both the humanity of its subject and the moral integrity of the perpetrator. There is no way to identify the photographers who shot these images, but in one important sense, it doesn't matter. What matters is the wordless story presented in each image, a story that accrues power as these images are gathered together and restored to the cultural narrative that once sustained them. Even when the white gaze is presented as ostensibly sympathetic to black lives, it is not. This point is as difficult for white people to comprehend as it is easy for black people. Claiming not to see or acknowledge racial differences is as hurtful as overt racism, because that universalizing impulse is also self-serving. Not acknowledging racism isolates African Americans, abandoning them to the caustic contexts created by the complicity of white silence. By way of illustrating this point, I mention an image in another eBay listing in 2009, described by the dealer as a picture of a girl and her dog. On the back of this RPPC, mailed from Dallas, Texas, to Brookfield, Missouri, in 1918, someone has written, "study in black and white." I'm arguing here that most white people would see a girl and her dog, just as the dealer did, whereas most black people would see a coerced moment in which a black girl is reduced to pet status by being compared to the white animal. If anything, the dog has higher status, as the photographs in this chapter will demonstrate.

Unfortunately, stories will not provide relief from this insidious visual dynamic. A popular coming-of-age dog story is the Newbery Award–winning novel *Sounder* (1969). This novel, written by a white man, presumes to channel the voice and experience of black people. In *Sounder*, none of the human characters in the book have names, and the black sharecroppers are identified as "the boy," "the mother," and "the father." The coonhound, however, does have a name, and it serves as the novel's title. The illustration for the 1989 Harper & Row Perennial Library paperback edition shows a black man looking at the horizon with his back to us. The hound, however, faces the reader in a full-body portrait. In the mind of the illustrator, the dog is a character in a way that the man is not. I dwell on this point because this novel has been acclaimed as a "tragic story of man's inhumanity to man," as well as an "uplifting tale of courage, human dignity and love," and not as the strangely balanced dog story that it really is.

In many dog stories, a white adult male and a dog are closely identified, and in these masculine coming-of-age tales, the man and the dog are enlarged and

PICTURING DOGS, SEEING OURSELVES

ennobled by their relationship (see chapter 5). In *Sounder*, the black male and the dog are spiritually and physically mutilated together in the descending narrative sequence, and the crippled hound and the father become interchangeable symbols. When the father dies, the dog dies two weeks later, and the novel ends. Sounder has the last word: "And the quiet of the night would fill and echo again with the deep voice of Sounder, the great coon dog."[9] The lyrical writing in the novel is reserved for the dog; the legacy of the father, apparently, is silence and dust. In this pretentious novel, we are invited to feel more for the dog than for the man or his family. And yet this novel has endured for decades as an insightful young adult novel. Why? One answer is that the white gaze that validated the novel continues to dominate the frame, just as it dominates public culture and middle-school reading lists. As with the Uncle Tom image just presented, the owner of the white gaze is excused from considering the source of the delectable torment being presented.

Black people have never been surprised by white hypocrisy. James Baldwin's devastating short story "Going to Meet the Man" shows the white family on its way to a lynching. They pause to make sure the family dog has enough food and water. In *Song of Solomon*, Toni Morrison riffs on the specious humanity of white racists, turning their beloved dogs into instruments of disdain and destruction. When Milkman Dead returns to the big farm owned by white people in Danville, Pennsylvania, the farm that was stolen from his father, he finds the ageless Circe and a pack of purebred dogs. The one-time slave has outlived her owners and lives in the decaying mansion with Weimaraners who are allowed to dig, defecate in, and tear at the house and its furnishings at will. The dogs, once the proud possessions of the white folk, have become Circe's instrument of revenge. In his September 1846 speech "The Horrors of Slavery and England's Duty to Free the Bondsman," Frederick Douglass described the process by which canines and slaves were set against each other:

> [Slaves] are hunted with dogs, kept for the purpose, and regularly trained. Enmity is instilled into the blood-hounds by these means:—A master causes a slave to tie up the dog and beat it unmercifully. He then sends the slave away and bids him climb a tree; after which he unties the dog, puts him upon the track of the man and encourages him to pursue it until he discovers the slave. Sometimes, in hunting the negroes, if the owners are not present to call off the dogs, the slaves are torn in pieces—; this has often occurred.[10]

Here, Douglass vividly illustrates why it matters how we use animals. Slave owners deliberately violated the good nature of dogs in order to violate the

humanity of the slaves, setting one species against another, to the lasting harm of all. Given that African Americans could be treated like dogs, charged with tending the master's dogs, and be hunted down by those same dogs, it would not be surprising if African Americans regarded dog ownership from a different perspective.

I have no photographic evidence that this is the case. Most of the photographs of African Americans in this book partake of the accepted middle-class conventions for documenting relationships and status within the American cultural framework. As it was for white Americans, photography could be a way for African Americans to assert control over their identity and establish their place in middle- and upper-class America.[11] Although such images are relatively rare, it is possible to find pictures of well-dressed African Americans with their dogs, as well as people from humbler circumstances, all participating in the visual documentation of respectable middle-class life.

Juxtaposing figure 45 and figure 46 strikingly illustrates the power of the middle-class portrait, as well as providing a contrast for what follows. The young woman in figure 45 is beautifully outfitted in a stylish, tight-fitting bodice over a skirt that probably dates the image to the 1870s. She wears a bracelet on each wrist and a wedding band on her left hand. The dog on the pedestal is probably ceramic, and the elegant studio setting further confirms her class and status. Thirty years later, her counterpart (figure 46) offers a poignant parallel. This young woman is outdoors. In the background is a house, but probably not her own or she would be on the porch or in front. It appears that she's standing before the side of a barn. Her ill-fitting and obviously homemade dress suggests a nineteenth-century origin, not the 1912–15 time frame indicated by the photo postcard. Yet the modest lace and tucking on the dress, the fabric belt that is secured with two different pins, and the double strand of beads all indicate attention to the photographic moment. Her clothing is augmented by the parasol, the rickety table, and, of course, the dog on the table. There is no way of telling whether this is her dog, but the presence of the dog and the table clearly indicate that she or the photographer is trying to produce a respectable portrait. As argued in chapter 2, and as we'll see in chapter 4, the dog was such an important status symbol that it may have been especially important for people who lacked access to a studio, or the proper clothing, much less the family mansion. Finally, it is clear that the dog was often included because African Americans loved their dogs and were proud to show them off for the camera. The relaxed woman in figure 47 is proud enough of "Taggs" that she writes on the back, "Taggs and me Fans son which makes me grandma to him." While I run the risk here of reiterating the obvious, I'm doing so for the sake of contrasting the images below. Despite the economic and social forces that we see impinging on

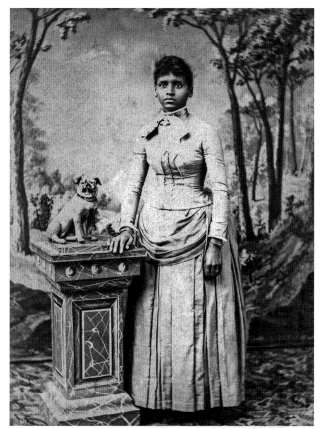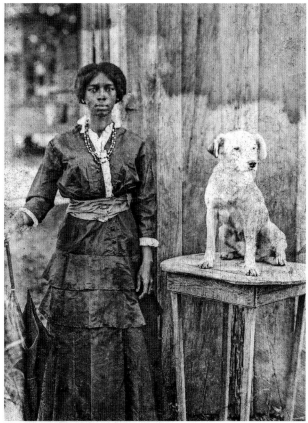

many of these images, the social aspirations and humanity of African Americans are documented in pictures of people with their pets or studio props.

The humanity of the often anonymous photographer or photographer's employer is perhaps another matter, for there is a type of late nineteenth- and early twentieth-century photograph that undermines the conventions of middle-class portraiture and reasserts the degradation of racism. There is still today an antique trade in what is called "black Americana," which is usually a misleading phrase for the many insulting artifacts produced after the Civil War and well into the twentieth century. Among these artifacts are stereographs and RPPCs that are distinguished by a mocking photographic eye. Often captioned in order to underline the insult, these commercially produced photographs retail typical racial prejudices, showing black people eating watermelon, cheating at cards, running around naked, or lolling around on the front porch. African Americans were animalized in

FIGURE 45

[LEFT] Cabinet card, 1870s,
10 × 13.5 cm. Photograph by H.
Houle. Pawtucket, Rhode Island.

FIGURE 46

[RIGHT] Unused RPPC,
1912–1915, 8 × 11.2 cm.

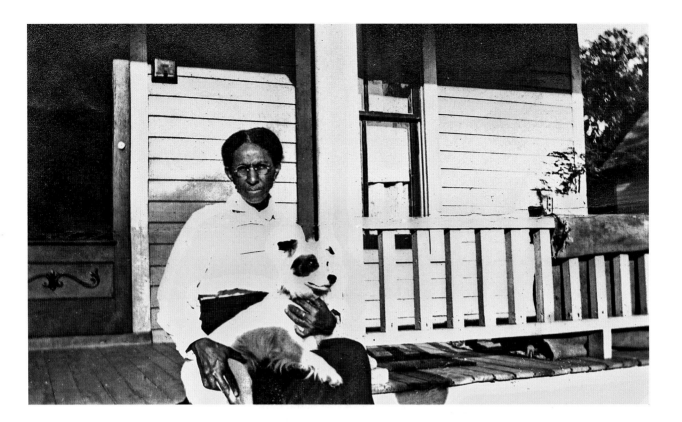

FIGURE 47

Taggs. Snapshot, 1920s,
10.1 × 6 cm.

crude comparisons to donkeys, dogs, and pigs and other livestock.[12] The masculinity of black males was ridiculed in presentations of them as lazy, music-loving buffoons, while black women were fantasized as either the loyal devoted Mammy, whose love was "strangely similar to the love ascribed to a pet," or the sexually prolific "hoochie mama."[13] At the extreme, photography was one more instrument of racial terrorism, as photographers documented lynchings with no apparent compunction.[14]

The poisonous presence of such commercial images illustrates why African Americans would have been wary of photography while understanding its powerful cultural presence. These images also illustrate why African Americans could not trust their own access to the technology. Photography was but one of several emerging technologies that were empowering in the hands of those with cultural clout and potentially harmful to those designated as cultural outsiders. African Americans, along with scorned immigrant groups, for example, were made the butt of jokes involving electricity or the use of telephones, usually through cartoons

and print anecdotes.[15] But the implied verisimilitude of the photographic record made photographs powerful instruments of social control. Shawn Michelle Smith, among others, demonstrates that photography played a key role in "envisioning a racially codified American identity."[16] Unless they found a black photographer, African Americans could not be sure that they had access to a sympathetic photographer. Christian Walker comments that "in every African American family album there is an image that points to what James Baldwin has identified as the 'Negro's past of rope, fire, humiliation, castration, and death.' It is in those aging and fading pictures of relatives, living and dead, that one finds the underlying nature of self-actualization and its antecedent, the internalization of oppression."[17] Eugene Genovese names this internalization of oppression as the paternalism that established a façade of normality around the abnormality of slavery in the United States. In his words, "paternalism in any historical setting defines relations of superordination and subordination," and paternalism as a social system is strengthened when members of the community accept (or are compelled to accept) this system as legitimate.[18] Well into the twentieth century, African Americans were subjected to this paternalistic gaze and the internalized oppression it reinforces, and there are photographs of African Americans with dogs that bring this stealthy dynamic clearly to light.

I have photographs that seem more inspired by the crudeness of this "black Americana" mentality than by a desire to produce a flattering or even a merely documentary image. But rather than reproduce these obvious portraits of American racism, I am directing attention to a less flamboyant class of photographs. In figure 48, for example, what is the relationship of the man in the background to the dog in the foreground? The dog stands assertively, turning an alert face toward the camera. The man, by contrast, his tie askew, lists to the side, his weight, his face, and the rising posture of his hand suggesting a question. Did he just wander into the picture, or was he asked to step into the frame? Either way, he's uncertain about his position, while the dog confidently commands the foreground. Indeed, it seems more likely that the dog owns the man than the other way around. Perhaps the gaze commanding the camera governs them both.

Figure 49 presents a comparable visual ambiguity. It could be from the 1890s into the turn of the century, printed in a CDV size but with cabinet card–style backing. The photographer's imprint on the back shows a location of "Meabville, Miss," but the stamp probably misspells Meadville, a small town in Franklin County, Mississippi. I find the image disorienting and even disturbing, because the framing seems so deliberate. Why bother to print and mount this image; what is being communicated through this preservation? The youth's lower body is in

FIGURE 48

Unused RPPC, 1909–1911,
6.9 × 11.9 cm.

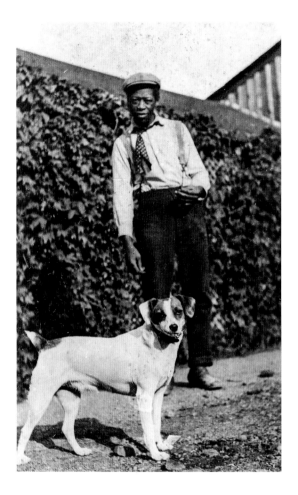

the foreground, but the dog is in the center. Is the male's lower body being com-
pared to the animal? For comparison, the most recent edition of Ann Petry's novel
The Street uses a detail of a photograph by Aaron Suskind from an image that is part
of the "Most Crowded Block" project. The cropped image shows a black child from
the neck down and a woman from the waist down standing in front of a stained
building wall. But both figures occupy the center of attention in that image, and
the cropping seems intended to emphasize the universality of the child and the
woman. Moreover, the cropping is congruent with the leveling, and finally bru-
talizing, effect of the novel's primary metaphor of the street. The content of figure
49, by contrast, seems insidious. It's difficult to imagine a benign impulse behind
the image, and I struggle to make sense of what the context might be. Fortunately,
the figures that follow will seem much more easily readable. But I present these

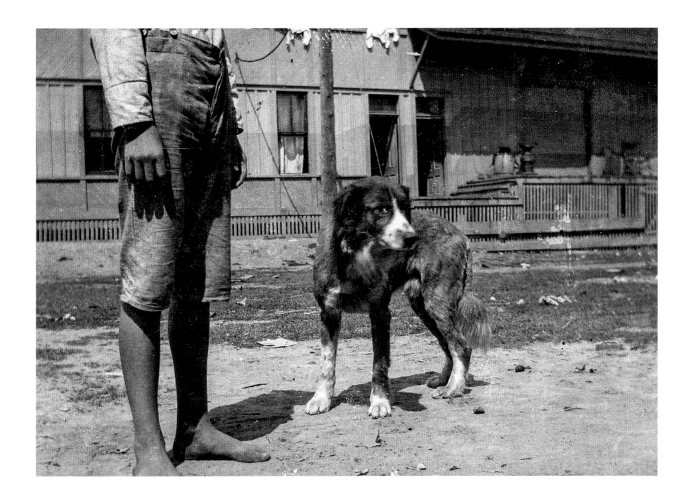

enigmatic images as a reminder of their ambiguity, even as we must acknowledge the inherent intransigence of racism that may indeed form their context.

The pictures I present below might have been authorized and possessed by African American subjects or an African American photographer, but the gaze preserved by the images suggests a different origin. These pictures accrue their significance as a collection, not as individual images. Just as Alan Trachtenberg suggests that a colloquy of images can have narrative and historical meaning, Laura Wexler insists that "photographs have meaning only as elements of a set. Photographic meaning is a system of relations that are established not *in* but *between* images."[19] Although I make this argument throughout this book, the efficacy of this perspective is crucial for grasping what the seemingly disparate photographs in this chapter have in common. My groupings fall into two subject categories: pictures of

FIGURE 49

Small cabinet card or CDV, 1890s, 8.6 × 5.6 cm. Photograph by H. B. Darsey. Meadville, Mississippi.

FIGURE 50

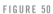

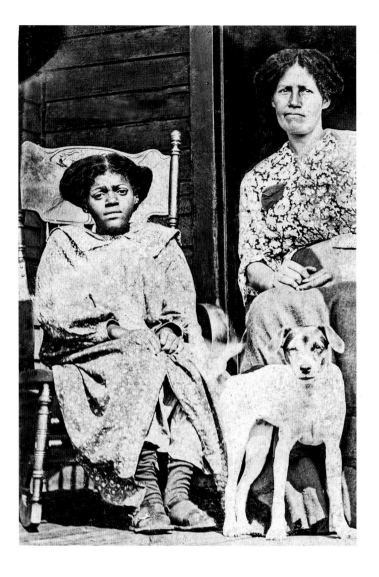

black employees with the master's dog, and pictures of black caretakers with white children.

THE MASTER'S DOG

One group of images involves black employees with the family dog. White families liked to display the fealty of black servants and caretakers, and even when labor-saving devices were part of the middle-class landscape, some families

persisted in employing domestic help. "Americans associated domestic service with serfdom, indentured servitude, and even slavery," Daniel Sutherland reminds us, and it seemed that part of the appeal of keeping domestic help was connected with the social status this seemed to confer.[20] This dynamic might begin to explain the image in figure 50. The surroundings are humble. It is unusual to see a white person photographed with a black child in this way, but it seems unlikely that this woman is the mother of the child in the photograph, even though the same hand has been involved in combing and arranging the hair of both figures. The child's dress is too large for her, as though she is inhabiting borrowed clothing, if not a borrowed position as a pretend equal on the front porch. Her gaze is intense and unhappy. The woman's mouth says that she is either reluctant to smile, would like to smile, or is embarrassed by the moment. What story can we imagine for this image? The woman may have helped prepare the child for the photograph, and perhaps she intended to show her affection for a young girl who is with her as domestic help. Perhaps she was proud to document her status as an employer and homeowner. I'm uncertain about this reading, however, because keeping the dog in view unsettles any conclusion. The alert terrier seems to be announcing or guarding its territory. The dog is wagging its tail, and it's focused on the photographer, so it is also possible that both the woman and the young girl work for someone else and that neither of them wanted the picture taken. It's possible that only the dog really lives there and that neither of the two females is the owner of the dog. Unlike some of the images that I present below, this photo stands alone in its unusual composition, and I have little to go on in providing further context.

Although any number of minorities took their turn within the exploitive system of class and occupational ranking, light-skinned minorities also had more employment choices and could rotate "upward" as the more Anglo-appearing races began to be accepted into the baseline population. African Americans, however, were confined to the employment ghetto by marketplace racism, and African American women found themselves further entrapped by the controlling iconography of the Mammy image, a partner to the image of a servile Uncle Tom.[21] Figures 51 and 52 document the same cultural gesture, although they are decades apart. In the first, a well-dressed black woman holds the dog's head still for the camera, although the Brittany spaniel moved anyway. The little boy looks amused, as if there is a joke in the air. The woman does not look amused. She is there to be seen, in service to both dog and children. This image is related in kind to the older daguerreotype and ambrotype images, coveted by collectors, showing impassive black caretakers with their white charges, a motif I'll discuss further in a moment.

FIGURE 51

Tintype, 1890s, 5.5 × 8 cm.

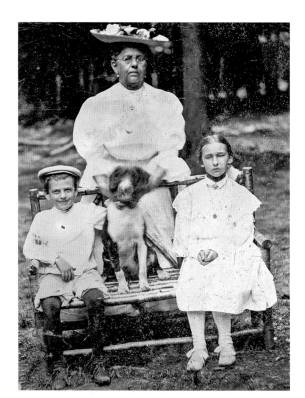

In figure 52 the manservant has been brought out to ensure that the Airedale is properly posed. There is a second purebred dog on the porch, but the dog with its own attendant has the status. The black man, dressed in his startlingly white jacket, is also there to be seen, but not as a person. The black attendant has become the head-grip furniture for the dog.

The presence of the dog in such images is a useful interpretive marker because it represents middle-class status as a valued possession, establishes a claim to wholesome domesticity, and sometimes even takes over the function of the child. It is difficult to imagine that the black subjects in figures 51 and 52 suggested that they have their picture taken in this setting; it is more likely that they were coerced into posing for these pictures. The presence of a white child often clarifies the identity of the African American person, suggesting his or her role as attendant to the child and the pet. But even when the white child is missing, photographs of black subjects with dogs cannot be taken at face value as images of pets and their owners. A rare CDV image dating from the early 1860s features a well-dressed white woman, seated.[22] Her hair is beautifully coifed, her clothing

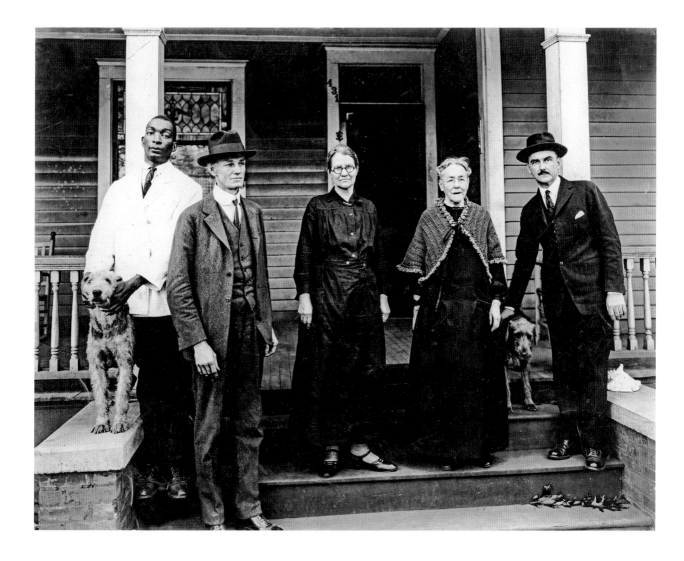

stylish, her hands empty, one resting in her lap, the other on the chair arm. She has a satisfied look on her face. Standing slightly behind her and to the side is an impassive African American servant, probably a slave, given the probable date of the image. She is also nicely dressed. In her arms is a small fluffy white dog that she is holding uncomfortably. The dog's hind legs are dangling and the slave's hand seems to be propping up the dog's chin. The black woman has a graceless grip on the white dog, leaving little question about what she thinks of having to pose for this photo. No one would mistake this dog for hers. The empty hands of the white mistress underline multiple corrosive messages about being a white *lady*,

FIGURE 52

Photograph, 1920s,
24 × 18.6 cm.

FIGURE 53

Glass negative, 1900–1910,
11.8 × 11.7 cm.

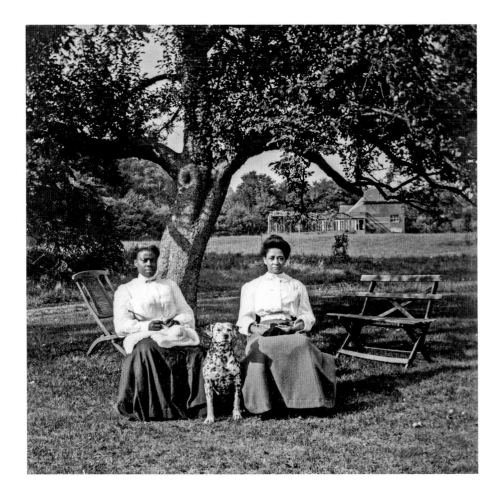

the relative value of work and idleness, and the humanity of African Americans, a message compounded by the presence of a dog that the white woman will not deign to hold.

At first glance, we might decide that the women in the field in figure 53 own the Dalmatian and are having their portrait made under their own volition. But given the paternalistic gaze discussed by Eugene Genovese and the long history of these images, we have reason to be skeptical. These two women are formally dressed. Clothing of this era could look much like a uniform (dark skirt, white blouse), so the sober dignity of the clothing is not enough to suggest that they are employees. But it is odd that such respectable women are not framed by a large house or porch setting, nor are there any other family members in the scene—husbands or brothers, for example—who might suggest that this is a family portrait of

FIGURE 54

Cabinet card, 1920s,
10.2 × 14.9 cm.

some kind. Odder still is that both women are holding some kind of knitting or embroidery in their hands. Knitting is not part of the emblematic middle-class presentation, but documenting one's command of persons who knit might be. The dog, then, might be part of the display of possession and ownership by an unseen white person. We must consider the probability that these two women don't own the dog, and that the person who authorized the picture owns the dog and, by extension, them.

Perhaps easier to read as a descendant of the first image I described is this remarkable portrait of a black maid and a house dog (figure 54). Like the dog, the maid has a decorative cap on her head and a bow at her neck. The dog also has either a studded leather harness or a doggie garter visible on its right front leg. The woman's right arm is hidden behind the bench, probably holding the leash, but

FIGURE 55

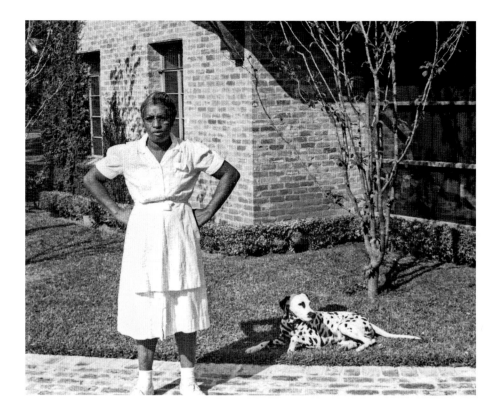

also about as far away from the dog as she can get her hand. But it's her gaze that undoes the image. She is hostile, refusing all sentimentality about the moment, and with her hard eyes and firm mouth, she denies the intended import of the image. She is not owned. She is not a house pet. She refuses to occupy the same cultural space as the dog. She is the defiant ancestor of the maid in figure 55, who has been captured by her employer for a record of his or her status (the maid, the purebred dog, the suburban home). This woman, her arms akimbo and her face set and challenging, makes clear that this is not her dog, not her house, and not her chosen identity.

Some photographs of people and dogs are subtle enough that the ambiguous presentation in any single image could be explained as merely a matter of poor composition, as with figure 48. Excusing the image in this way, however, may be the same as refusing to see what is actually going on. Seen as a group, it becomes obvious that the African American hired help, even well past the Civil War, are accounted for as part of the possessions of the unseen master or mistress. As with paintings, the black persons in the picture are positioned in the same visual

plane as the family pet or livestock.[23] While there are many things we will never know about antique photographs and their white subjects, we do know that what we see can be accepted as an identity authorized by the white subject. We may not have a completely true story before us—perhaps the sitters don't really have a well-appointed parlor but have borrowed a studio to give that impression. Nor do we know if the implied relationships in the image are in fact reasonable representations of the family dynamic or status. Portraits are, after all, all about appearances and improving reality. But when white people appear in photographs before houses or astride cars, or with the dog in tow, it is reasonable to think that they chose that setting. Perhaps they even own the setting.

None of these things can be assumed with photographs of African Americans, who were economically and socially excluded from many of the accoutrements of the American dream, and who were often denied any agency in having their picture taken. Instead, those same economic and social forces coerced black subjects into the frame of a racist gaze, presenting them as accomplices and participants in a power charade, where everything from the clothing to the dog could be manipulated in order to document the continuing subjugation of the black race. Alongside these images of black servants attending the master's pet is a second group of pictures: the highly sought-after photographs of black caretakers and white children.

THE FAUX FAMILY

One of the most persistent of enslaving sentimental myths is that of the benevolent Mammy or Uncle Tom. The fiction of the black caregivers who love to take care of white children and dogs persisted well into the twentieth century. The idealized figure of Mammy was a post–Civil War construction,[24] and many of the black nurse/white baby images hail from during or just after the Civil War, a handy visual rhetoric designed to reinforce the idea of the willing submission of black persons to their racialized responsibilities. These photographs establish the rightful hierarchy of the white patriarchal domestic sphere. Laura Wexler's discussion of George Cook's "Nursemaid and Her Charge" (circa 1865) demonstrates that these images have much more to do with racial hegemony than with fondness for the black subject. The young woman of "Nursemaid" is presented like a piece of furniture, with a black cloth draped over her shoulder in a way that frames and accents the white-gowned baby.[25] Most unsettling, to my mind, is that the nurse's hands are hidden, as is most of both arms, as if seeing the body parts that do most of the work might be too much. The baby, however, has full agency and has waved one hand. Along

FIGURE 56

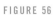

Snapshot, 1930s, 7.9 × 13.5 cm.

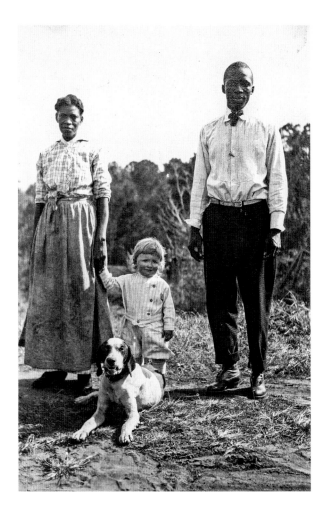

with the black nurse's oblique gaze, it's the disappearance of the hands that reinforces her utter stillness as a piece of human furniture.

Wexler speculates that the unidentified nursemaid in the Cook photograph may have had her own baby, enabling her to serve as a literal nursemaid to the Cook baby, but of course her own child gets obliterated in the faux photographic realism of the moment. The unseen white mother is magnified by her ability to command servants to her child, and by her economic ability to render work unseen. Wexler points out that for many families, the parlor was not part of a home until the family photograph album and family photos were displayed. Images of domestic tranquility were part of the prescribed method of enforcing what the photographic image declared to exist. A picture of a respectable family must be

PICTURING DOGS, SEEING OURSELVES

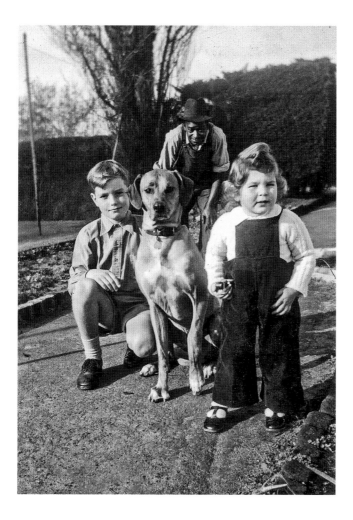

FIGURE 57

June. Snapshot, 1950,
5.4 × 8.2 cm.

the same thing as a respectable family. In light of these perspectives—the erasure of the black subject's family and the necessity of presenting the visual convention for a happy family—perhaps it is understandable that we would read the image of figure 56 with skepticism. This image of impassive black adults with a white child could be read literally, as a depiction of a mixed-race family, but that seems highly unlikely for the period. While the woman is the party responsible for the tow-headed toddler, the presence of the young man suggests some conflicted purpose behind this image. Is he married to the young woman? Are we supposed to think that they are a family, or "just like family"? This is not their child, and yet some off-margin authorizer wanted something that resembled the family portrait, so of course the dog is included. What the picture suppresses, however, are the real

FIGURE 58

Unused RPPC, 1910–1918,
7.8 × 11.4 cm.

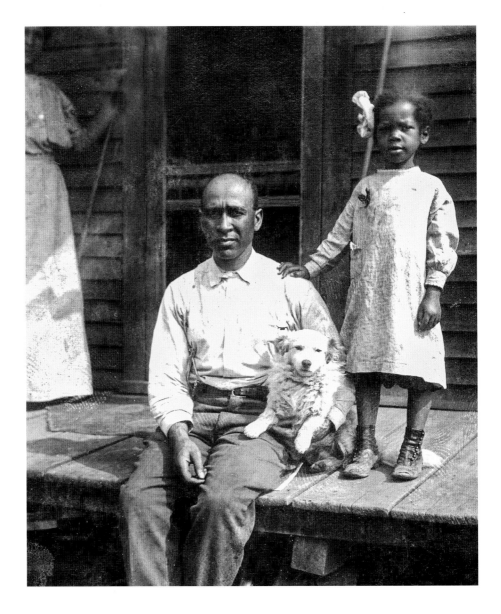

children and the real family, for if this is a young married couple, they probably
have children of their own. Their children are erased by this faux family moment,
because acknowledging them would force us to contemplate the slave system that
made these twentieth-century images possible. Thus figure 57, almost iconic in its
composition and the latest of this sequence, enshrines the ultimate white fantasy.
The precious children and dog are in the foreground, but they are watched over

tenderly by a kindly black man, whose stance and demeanor bring him and the children into yet another variation of *Uncle Tom's Cabin*, as popularly embraced by white audiences. We prefer to think of Uncle Tom as forgiving and benevolent. Figure 57 is not an image produced for a black audience, which long ago repudiated the idea that black men and women enjoy being submissive and tender toward white people and their children.

In figure 58 a man, child, and dog sit on the edge of porch. The man holds the dog comfortably, so this might be his dog. The child, dressed in shapeless sacking and sporting a large floppy hair bow, stands with his or her hand on the man's shoulder.[26] They are connected. They might be a family. But this might not be his house, because lurking in the background is the figure of a woman whom we cannot see clearly. A marginal figure is usually a parent, hovering to make sure that the child and dog sit still. But it's reasonable to assume that if this woman were related to the figures in the foreground she would have been included in the composition. We must suspect that she is white and that these black subjects are employees. Her lurking visual presence insists that we read this image differently, which means also that we must acknowledge that the dog may not be theirs and that all are being displayed as possessions. At the very least, the suggestion of the white gaze robs both white and black observers of any pleasure in what could be simply a record of a relaxed father, child, and dog.

This coercive marginal figure is part of the legacy of African American images. Even when no white person is visible, the racist gaze that is the product of white people's bigotry still commands the image, while all the while denying what it really is. In the pictures I've just presented, the dog is sometimes the reason for a black person's presence in the photograph, and in most of them the dog functions as an interpretive marker, often adding to our sense of the palpable insult to the African American participant. The images of black attendants to purebred dogs and white children remind us how deeply the prejudicial language of breeding and race extended from the canine to the human world. Americans thought it important to make social distinctions based on race and breeding, and they borrowed liberally from the lingo of dog shows to enforce these standards for the Victorian elite.[27]

In *Regarding Animals*, Arnold Arluke and Clinton R. Sanders consider the enigma of Nazi behavior, for the people who engineered the methodical killing of more than six million human beings also enacted strict animal-protection laws. Indeed, the authors tell us, "anti-Semitic rhetoric in Germany suggested that the persecution of Jews was sometimes put forward as revenge on behalf of aggrieved animals. Jews were identified as enemies of animals and implicitly of Germans." Certainly, this paradoxical stance can be explained in part by the interest in breeding and

eugenics, an interest that could generate nativist responses to immigrants in the United States, as we've seen in chapter 2, and, at the extreme, the wholesale extermination of human beings. For the Nazis, "the intent was to breed Aryans as if they were pedigreed dogs," an impulse that prized animal lineage and savaged the weak. More important, however, "by animalizing human life, moral distinctions between people and animals were obliterated, making it possible to treat animals as considerately as humans and humans as poorly as animals."[28] Clearly, there is more at stake than idle curiosity in the ways in which we use and represent animals. The profound ambivalence with which we encounter the animal world gets expressed through some remarkable hypocrisy toward the human world, and vice versa.

In Toni Morrison's novel *Song of Solomon*, Macon Dead reminisces about working on the big farm in Danville. "White people did love their dogs. Kill a nigger and comb their hair at the same time. But I've seen grown men cry about their dogs."[29] The deeply ingrained and paradoxically expressed racial prejudices that fueled the Nazi genocide are not that distant from the deeply ingrained white gaze implicit in the images presented in this chapter. Given the way African Americans were hunted down with dogs, it's not a stretch to see these images as trophies of the continuing assertion of racial dominance. Indeed, trophy taking provides a significant connective webbing in the construct of white male masculinity, as we'll see in chapter 5. These images document the stern truth of Christian Walker's comment, quoted earlier, that every African American photo album contains images that preserve the horror of slave history and the shape of internalized oppression. Many of the images presented here carry the shape of that internalized oppression. In them, we are forced to acknowledge the shadowy presence that unravels the Edenic fiction of the middle-class family—the menacing gaze of the out-of-frame master or mistress who has eaten deeply of the fatal apple.

4

<div style="text-align: right">FAMILY PORTRAITS</div>

Several years ago, we had our family portrait made. I met my husband and children at the studio, so I was surprised to discover that Todd had brought our greyhound, Kelso (figure 59). Kelso was a rescue animal from the track and, like many greyhounds, was reserved in extending his affections. He tolerated us, and we did our best to appreciate the subtleties of his personality, but he hadn't charmed us as we had imagined he would. I didn't want the dog in the picture. But my family insisted that Kelso belonged, so our record from 1997 has a large, handsome dog front and center, ears uncharacteristically perked. He is centered in the family portrait in a way that falsifies his importance to us and our affection for him. In fact, when we moved across the country two years later, Kelso seemed to fall apart, and despite our efforts to understand his problems, we had to admit that we were now failing with this dog, who was urinating in the house and howling every night. If we were dismayed by him, he clearly wasn't enchanted with us, either. With relief, we returned Kelso to greyhound rescue, where he found a better home with a woman who could give him the attention he needed.

While I'm embarrassed to admit that we failed with this dog, the experience provides a commonsense backdrop for a discussion of the dog in the family portrait. The private motivations that compose any family portrait are not available to

FIGURE 59

Morey Hedinger family.
Photograph, 1997, 20.3 × 25.4
cm.

us, especially not with a collection of images that have no common family histo-
ry. Annette Kuhn notes the cultural theory that "tells us that there is little that is
really personal or private about either family photographs or the memories that
they evoke: they can mean only culturally."[1] Eventually, even within families, pho-
tographs lose their significance when they are not labeled and there is no longer
living memory to support a meaningful viewing. Rendered anonymous by their
loss of immediate family context, then, family photographs have only their partic-
ipation in a larger context and our re-viewing to bring fresh life to their presence
as cultural artifacts.

The term "family," of course, is laden with political and historical import, and
I am appealing to common sense in my usage. We are talking about the persons in a
biologically related domestic unit, and in this chapter I am usually looking at groups
of people who seem to be related. Philippe Aries, however, offers a definition that
may also be useful on a conceptual level. At the end of his magisterial *Centuries
of Childhood: A Social History of Family Life*, Aries arrives at a description of what
we commonly call today "the nuclear family," although not before he thoroughly

debunks the notion that this family structure has existed for all eternity. He concludes his study by linking class, family, and race, saying, "the concept of family, the concept of class, and perhaps elsewhere the concept of race, appear as manifestations of the same intolerance toward variety, the same insistence on uniformity."[2] Not only does this observation underline the middle-class homogenization we see in so many family portraits, Aries also reminds us how family is an exclusivist conceit. Family is not just a way of identifying members. It is also a way of repelling outsiders and refusing space to cultural interlopers. Laura Wexler suggests that the Victorian culture of sentiment was firmly anchored in the middle-class display of family in relation to the well-appointed home, and that middle-class sensibility aimed "not only to establish itself as the gatekeeper of social existence, but also to denigrate all other people whose style or conditions of domesticity did not conform" to this model.[3] The photographic protocols of the white middle class were a powerful tool for documenting membership in that class, and once again the enticing presence of the dog assists our reading of this collection of photographs.

In addition to their role in confirming middle-class attainment, dogs claim further cultural meanings, becoming visual shorthand for a wholesome childhood and family life. According to Katherine Grier, the presence of animals in the family household provided opportunities for children to learn an ethic of kindness—an essential building block in creating a civilized individual. Undoubtedly, this emphasis was nurtured by the popularity of such books as Anna Sewell's *Black Beauty* (1877) and (Margaret) Marshall Saunders's *Beautiful Joe* (1893), novels that intersected with and supported the growing visibility of humane societies in both Britain and the United States. *Beautiful Joe* is an autobiography, narrated by an abused and then reclaimed mongrel who argues that "many schoolteachers say there is nothing better than to give [children] lessons on kindness to animals. Children who are taught to love and protect dumb creatures will be kind to their fellow men when they grow up."[4] Thus pets—and dogs in particular—became a center of gravity for an emerging sense of family meaning, for the ethic of kindness was "grounded in a broader set of cultural concerns about defining good relations within families, between men and women, and between the powerful and the powerless," in Grier's words.[5] Feminists in dialogue with animal studies perspectives are rightly uneasy about this view of women's role in the family dynamic. It plays to a sentimentalizing impulse that obscures the reality of who is powerful and who is powerless, although Grier's parallelism (men and women, powerful and powerless) should make it clear that as women are to animals, men are to women. "Women are the animals of the human kingdom," Catherine MacKinnon tells us,[6] so if women are better at inculcating kindness, that ethical quality might be

attributed not to their superior humanity but to their inferior animality. Women understand animals better than men do because they are closer to them. Arluke and Bogdan note that pets were increasingly regarded as significant others and as "members of the family," and they comment pointedly that family photographs are an important source of information about a social inclusivity to which social scientists have not given much thought.[7] The family photograph that includes a dog offers visual communication about power relationships in families, and suggests the multiple compromised meanings of that most political of terms, "family."

I discuss several elements of the family portrait in this chapter, including the most basic of family units, the child and the dog, and then look at how interior and exterior uses of the house enhance our understanding of the image before us. Finally, I examine the ways in which the family portrait may covertly reveal within the captured moment the dynamics of race and gender. As noted in the introduction, it is also important to keep in mind that the efficacy of these readings depends upon assenting to a common understanding of the cultural context, and that we cannot validate any reading with absolute certainty. What we can say, however, is that while many of these photographs show how people were trying to meet certain social expectations, some of the choices revealed in these images also suggest how people contested or acquiesced in the heavy hand of social judgment, if not the heavy hand of their own families.

CHILD AND DOG

The basic visual unit for establishing a claim to "family" is the child and dog. We still live in an era that romanticizes childhood, the legacy of our Victorian predecessors. From the vantage point of the early twenty-first century, the loyalty, faithfulness, and affection of dogs are as necessary for family life as the picket fence, summer sandlot baseball games, and Mom's cherry pie, although few of us have picket fences or bake our own cherry pies, and if there is summer baseball, it's likely to be the highly organized spectacle of Little League. Today, free-form childhood play is discouraged by both educational and marketing strategies. Toys must be educational, games must be organized, and gizmos must be sold if children are to be happy.[8] This was not always the case, and much of our nostalgia flows backward around the regimented play of our times, to a time in which we imagine there were less complicated toys and freer play. Along with bicycles, baseball bats, and dolls, the dog is a stable reference point for this nostalgia.

This view of childhood, like prevailing notions of what it meant to be a "lady," takes its definition from the middle-class frame of reference. The status of "lady"

was not attainable by working-class women, black or white. Similarly, the notion of precious childhood was extended only to upper- and middle-class white children. Steven Mintz tells us that until the mid- to late twentieth century, the majority of families living in urban working-class neighborhoods and most rural areas of the United States depended upon their children's labor and earnings to keep the family afloat. Schooling for these working children was highly variable, and depended on ethnicity, social class, and geographic location. That is, despite child labor laws, most children in the nineteenth and early twentieth centuries did not lead sheltered lives of structured discovery and carefree playtime, and it was not until the mid-twentieth century that child protectionists were able to enforce the middle-class ideal of a sheltered, extended childhood.[9] Nonetheless, the middle-class norms for family presentation both construct the images we see below and instruct us as to how we will read them.

Figure 60 is an effective piece of visual rhetoric for everything that white middle-class people know and believe about American family life. There are fruit trees and flowers in this well-tended backyard. The quaint wheelbarrow evokes pleasant images of honest labor and life in harmony with the domesticated earth. The barrow supports a boy whose frank gaze and stately collie companion signal the inherent integrity and wholesomeness of good breeding. Implicit is the assurance of a sound family life. Behind them, the clean white sheets snap like flags of the American way, suggesting the presence of a happy housewife and mom, while the gardening tools point to the unseen father. Some readers will find this image reminding them of the *Lassie* TV series, which ran from 1954 to 1973. Marjorie Garber documents how the show burnished the nostalgic association of home with "a boy and a dog—it's always there, like Mom's apple pie."[10] Eric Knight's *Lassie Come Home* (1940) is the ur-narrative for the return-to-home theme so closely associated with dogs. This is one version of a modern Eden, where a dog is always a boy's best friend, and where the child is the center of that family dream. And we know that gardens are enclosed by walls, or fences, and that this child, like every child in a garden, is enfolded in a protective boundary. The space depicted in figure 60 is safe and exclusive, in spite of being outdoors. This snapshot is relatively late, but many such images precede it.

For example, in a formal studio portrait from the 1890s (figure 61), we find the same impetus, but presented differently. Here again, the child is at the center of the picture, and only she engages the viewer directly. The triangulation of the figures, enhanced by the angle of the father's guardian leg, puts the focus on the patriarch, the pug dog below functioning as an embellishment. The maternal figure has an implied energy in the set of her arm that creates motion from her arm to

FIGURE 60

Snapshot, 1940s, 10.3 × 6 cm.

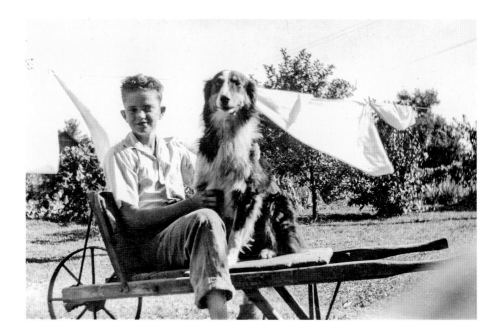

the paternal arm, and she is appropriately focused on her daughter. The mirrored arms of father and mother frame the family unit. The viewer is not invited into this world; the child is secure behind its gates. It is unfortunate that neither the photographer nor the subjects are identified, because the lighting, staging, posing, and printing have created a painterly photograph. Its subjects are remote but beautiful in the confident modeling of light and dark. Like its mid-twentieth-century counterpart, all the elements of family as an Edenic refuge are accounted for, although more literally. Mother and father are visible bulwarks in their beautifully appointed private world.

These images present an Edenic account of family, one in which "family," "home," and "childhood" occupy an almost paradisal space available only through retrospective reverie or advertising. In this account, the family is in perpetual danger of erosion and invasion, and may already have slipped irrevocably beyond any reasonable security. The threat to family is a periodic boogeyman in American life. In the nineteenth and twentieth centuries, immigrants and generic foreigners, most of whom lived in unwholesome cities, were stigmatized, as were African Americans. However, while white-looking foreigners who adopted English as their language joined the cultural mainstream, they often did so by adopting the racial prejudices of the white middle class, understanding that African American families were barred from the intended lexicon of the middle-class family. As

PICTURING DOGS, SEEING OURSELVES

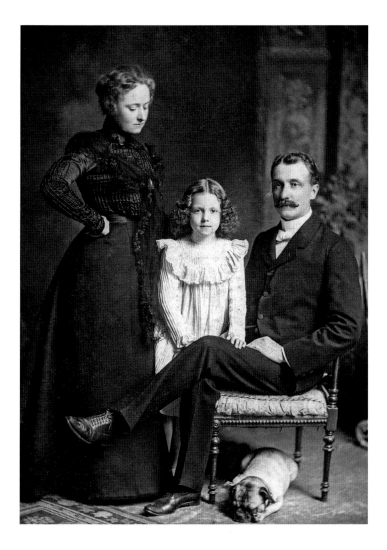

FIGURE 61

Cabinet card, 1890s,
9.9 × 14.1 cm.

Toni Morrison has commented, "it is no accident and no mistake that immigrant populations (and much immigrant literature) understood their 'Americanness' as an opposition to the resident black population."[11]

The family portrait, then, plays an important role in either repelling outsiders or laying siege to the castle of the white middle class. Laura Wexler observes astutely that "photography was part of the master narrative that created and cemented cultural and political inequalities of race and class," but at the same time, the photograph became a powerful tool for resisting cultural oppression.[12] Whether vernacular or formal, people made use of the middle-class portrait in ways that

FIGURE 62

Cecil and Fido. Cabinet card,
1900–1910, 10 × 14 cm.
Waxahachie, Texas.

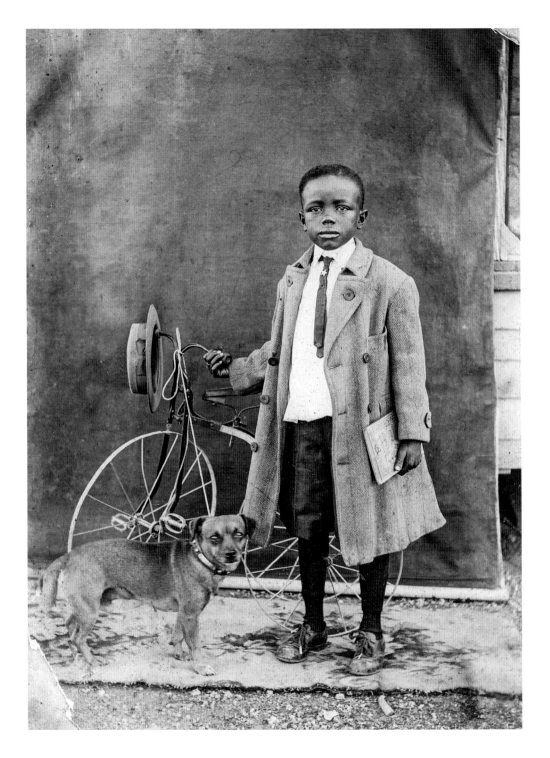

finally democratized the image of family. Of the many elements that define the middle-class studio portrait, the dog is arguably the most versatile and enduring, and the child and dog together become a basic unit of significance that points to the implicit meanings of "family." Thus it is important to acknowledge all portraits of children and dogs, and not simply the ones that fit the white middle-class template.

In a cabinet card hailing from Waxahachie, Texas (figure 62), young Cecil is posed outdoors against a makeshift backdrop. He is surrounded by the implements of middle-class childhood: tricycle, book, tidy school clothing, a piece of carpet to stand on, and the dog. This photograph is anchored by the house, as are many family portraits. On the front border of the card someone has written, "Cecil and Fido." The adult Cecil writes on the back of the card: "Hadn't entered public school. But could read, write and spell thanks to Mother and auntie (Ada). When I entered public school I was assigned in the 3rd grade. Age? I don't know." His writing is an additional treasure, for it confirms that he had a family (Mother and Auntie Ada) and that they cared about him. But even without this notation, the photograph tells us that this child had a loving family, because they have assembled all the ingredients necessary to present him in his well-appointed childhood, and there is no need for the adults to be present.

The dog is not essential to this photograph, but it is noteworthy, and we see why more clearly when we turn to the next image. In figure 63 the dog stands in for all of the middle-class accessories. In this RPPC, a mother props up her infant in front of a blanket or tarp of some kind. Behind her, an entrance opens onto a dirt floor. There are two tilted timbers, perhaps holding up a roof, and in the back, daylight is visible between the planks of worn lumber. Is this a barn, storage shed, or the woman's house? The image is faded, but it looks like she is wearing an apron, and her sleeves are rolled up, so perhaps a working woman or servant interrupted her chores to take advantage of a traveling photographer. She kneels, looking fondly toward the tiny baby, who shares the wooden chair with a small white puppy. The mother's look would have sufficed to tell us that this child is cherished, but the dog underlines the message. Additionally, the photograph itself bears that message on its surface, for the borders of the image are punctuated by three thumbtack marks, each hole faintly rusted, suggesting that this picture was tacked up for viewing, and the back shows the remnants of paste and black paper, showing that the picture was once part of a family album.

Not all of these images originated with black people, of course. Poor white people occupied the same space of resistance in documenting their lives. Can there be any doubt that the children in figure 64 are living a hardscrabble life? The two boys wear caps and jackets, as if they are in school clothing, but they are

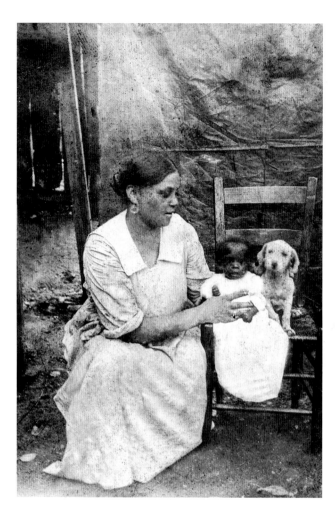

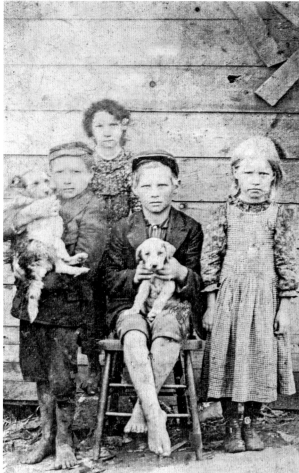

also barefoot, and it's likely that the photograph has recorded that these are dirty feet and legs. The girls have not been prepared in any obvious way. Their clothing is serviceable at best. The background is a building with lumber patches, perhaps a barn or shed, or it could be the side of the shack where they live. But again, their lives as family are affirmed not only by the photograph itself but by the puppies they clutch as part of the picture.

Many of these images are not well preserved. They've been roughly handled or they were not processed carefully, so they have faded. Neither the infant in figure 63, nor these shabby children, nor even young Cecil (figure 62) meet the middle-class definition of family. They are the wrong color and the wrong class.

And yet the very presence of these images contests the tyranny of the middle-class studio portrait, using what is at hand to affirm the lives of the subjects. When not much else was available, the dog stood in for all that might be materially missing to validate a proper family and childhood.

THE FAMILY AT HOME

In *VanDerZee: Photographer, 1886–1983*, Deborah Willis-Braithwaite discusses a photograph by the well-known Harlem Renaissance photographer in which a young man in uniform sits looking down at a dog. Beside him is an American flag. Invoking all the compressed cultural meanings that we take for granted about the dog, Willis-Braithwaite concludes that "through the use of simple props, VanDerZee suggests how important the patriotic notions of home, country and family were to this African American soldier."[13] Although Willis-Braithwaite doesn't note that the dog is artificial, she effortlessly identifies the dog as an icon of home and family. The dog—the fake dog—summarizes just about everything that could be said about the respectable family portrait—its sincere presentation of a dignified public self, the calculated iconography of scenery and prop. To paraphrase Marianne Hirsch, the family photograph occupies a space between the idealized public construct and the partially hidden private reality, and it is the implicit tension between these ever-present elements that can draw us into the family photo. In addition to the dog, the groupings, the furnishings, and the site for the photograph are readable elements in a picture that has become detached from the private historical moment that once gave it meaning.

"Home" is so much a part of the rhetoric of "family" that it is not surprising that houses themselves are an important part of the iconography documenting family life. Once considered a private refuge from the harsh and harrowing public world of work inhabited by men, "home" became a tangible symbol of the meaning of family. A beautiful home, both exterior and interior, was synonymous with "intelligence, refined taste and prosperity," advised a suburban advertisement from 1884, and such a home would help provide "morality, good sense and culture" for the inhabitants. Correspondingly, tenements and slums would produce brutality, poverty, wretchedness, and crime.[14] Home was protected by men, who shielded women and children from the economic demands of the public world, and by women, who safeguarded the family home as a place of peace and refuge from the ruthless energy of the workplace.[15] "The suburban home, how it was furnished, and the family life the housewife oversaw," Gwendolyn Wright tells us, "contributed to the definition of 'middle class' at least as much as did the husband's income."[16]

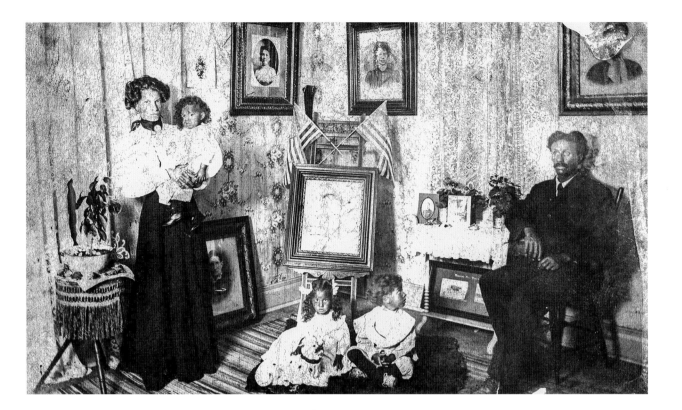

FIGURE 65

Corrothers family. Used RPPC,
1906–1908, 14 × 8.9 cm.

Figures 65 and 66 show us how the interior family portrait could be used by
different families for the same purpose and same message—to signal wholesome
family and social attainment. According to Grier, the Victorian family parlor was
the site for a social signaling system so complex that it's possible we will never
fully comprehend its multiple messages. Wallpaper, rugs, furniture, staging, bric-
a-brac—all were part of the communication that was itself an essential piece of
sacred social ritual. The parlor, or what Grier calls the "memory palace," was a
place for designating the identity and history of the family, and this included vi-
sual rhetoric about what it meant to be civilized and cultivated participants in the
world at large. Objects were felt to take definition and power from the associative
thoughts they engendered, and were part of a visual rhetoric "meant to persuade
others (and, it can argued, also ourselves) that we actually are what our posses-
sions claim us to be."[17] Thus the cluttered Victorian parlor was a visual testimony
to both the laudable income of the family and also the identity that income could
purchase. Consumers were not just purchasing goods; they were establishing a so-
cial identity—an identity based not only on literal wealth but also on the aesthetic,

PICTURING DOGS, SEEING OURSELVES

spiritual, and educational wealth that inhered in parlor organs, paintings, family photographs, natural history collections, hunting trophies, women's handiwork, plants, and the Bible and other books.

According to Grier, the "memory palace" reached its apex in the 1890s, but the effect of the multimedia parlor communication lasted at least two decades beyond that. The two figures reviewed here are dated 1906–8 (figure 65) and 1910 (figure 66), and both exemplify the coding of the interior messaging system. The Corrothers family is the subject of figure 65, and the handwriting on the back identifies the young mother as Minnie Berry Corrothers, who is holding Muriel. Mother Berry's picture is on the floor next to Minnie. Mildred and Norman are seated on the floor together, and Norman Senior is seated on the right in the chair, a convention in turn-of-the-century family portraits. This RPPC is not in great condition, but some salient details are evident. The walls are papered with a floral design, and several photographs of persons hang on the parlor wall, although we don't know how they and the family are related to the person who wrote notes on the back of the card. Still, the framed pictures at least partially document family members, although two of the portraits seem to be of white women. Either the family is of mixed ancestry or this is not their room and was borrowed for the portrait. Two small tables are crowded with signal artifacts that include plants, photographs, and seashells. At the center of the photograph is an easel adorned with two American flags, and what now appears as an empty canvas. The children and parents are neatly dressed, and the little girl (Mildred) has her hand on a large ceramic dog figure. Because it is white, it blends in with her dress, but it looks like a representation of a bulldog.

The Corrotherses, then, have visually communicated their key identity as a family in which multiple generations, denizens of the worlds of nature and art, are joined in patriotic affirmation. In this home, obedient children will learn the protocols of civility and good manners. Visually, their claim to wealth is modest. No specialized or heavy, ornate furniture is visible, no fireplace or central family table (symbols of warm family life or the family circle), and it's possible that this room was not simply a parlor but also a bedroom or sitting room. Middle- and working-class families often made one room serve multiple functions because space was at a premium. Nonetheless, they showcase in this portrait their ability to generate a respectable setting and goods to confirm their claim to middle-class status. For African Americans, this moment would have been particularly meaningful. The dwellings provided by slave owners were not home; to the contrary, home consisted in the fragile social kinship of memory and support created outside the shanties and apartments they inhabited.[18] Moreover, as we know, African

American family heritage was defined in part by lingering homelessness, as social and kinship groups struggled to find one another, at the same time seeking the educational and economic foundation necessary for well-being after emancipation. The ability to document a family home in the white, middle-class sense of the word was empowering.

The Dickinson family in figure 66 also does not present the overflowing parlor of an earlier era; the bed suggests that they used this room for multiple purposes. Wright tells us that "bedrooms were usually large enough to serve as sitting rooms"[19] where a mother could spend the afternoon with her children, and a family of modest means who lacked a formal parlor might well use the bedroom as a sitting room and location for family display. Albert "Bert" Dickinson, age thirty-five, the most important person in the family, is seated, while Emma Dickinson, age twenty-four, stands with a proprietary wifely hand on his shoulder. Velma, age six, Jud, age two, and Tip, the dog, complete the family unit. Everyone is dressed neatly, although no one displays the current high style, just as with the Corrothers family. The most smartly dressed family member is probably the two-year-old. Jud is wearing a Fauntleroy-inspired collar with his "little fellows" suit, a later version of the Buster Brown suit with a low-belted waist over a tunic top and bloomers. Velma, Emma, and Bert are wearing acceptable but slightly outdated styles for the end of the decade.

Like the Corrotherses, the Dickinsons want their patriotism to be seen, as they signal with the centered American flag throw rug. The wallpaper is Victorian ornate, as are the lace curtains, which are accented in various places with hanging decorations that I would associate with Christmas but that may have been ordinary embellishments. The shelving on the wall behind the family displays various painted china and seashells. Along with the plants near the bed, the seashells bespeak the family's interest in and appreciation of the natural world. Velma's dolls are displayed on the daybed behind her, along with a stuffed pillow in the form of a chicken and various embroidered pillows, which we might assume are the work of Mrs. Dickinson, good homemaker that she is. And how else do we know that she is a good homemaker? In this carefully presented room, the Cottolene stand-up poster to Emma's right could not be an accident. Respectable housewives were urged to distinguish their homemaking skills, including their cooking and the ingredients they used in it, from lower-class methods of keeping house. Commonplace lard became associated with immigrant ignorance and filth. Cottolene, by contrast, made from a manufactured combination of cottonseed oil and beef tallow, was considered a pure and healthy type of shortening. "Shorten your food, lengthen your life," says the printing below the picture of the happy, donut-eating girl. The

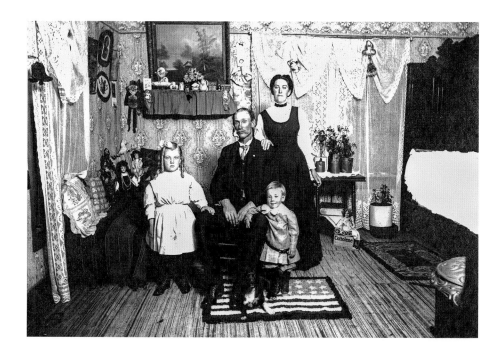

FIGURE 66

Dickinson family. Cabinet card, 1910, 17.5 × 12.4 cm.

Cottolene visual announces that these people are knowledgeable consumers, and that Mrs. Dickinson in particular is taking admirable care with her family.[20]

Neither of these families present themselves as wealthy, but, like many other working- or middle-class families, they participated in the "powerful urge on the part of ordinary families to give social ceremony its due" by staging a well-accessorized family photograph.[21] In these photographs, the dog is only one iconic element, but one that arguably is the most powerful child-related item in the room. As we have seen, when a family had no accessories for their children, the dog could stand in for what was missing. The dog says that these children are loved; they have a home and a pet to grow up with that will ensure successful adulthood. Tip, the Dickinson dog, is not a purebred, but he's obviously comfortable with the group and appears to be settled companionably on Albert's foot. The Corrotherses' ceramic pooch is a replica of a purebred dog, probably chosen to emphasize good breeding and social class. It's the sort of embellishment that was supplied by the photographer to aid in the middle-class presentation (as we saw in chapter 2).

In addition to a carefully controlled interior scene, the exterior of a house was another popular location for a family portrait. The exterior shot had the virtue of displaying the grandness of the family's property—Victorian display writ large—and the house structure itself is part of the middle-class credentialing that

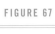

FIGURE 67

Unused RPPC, 1906–1908,
7.7 × 11.1 cm.

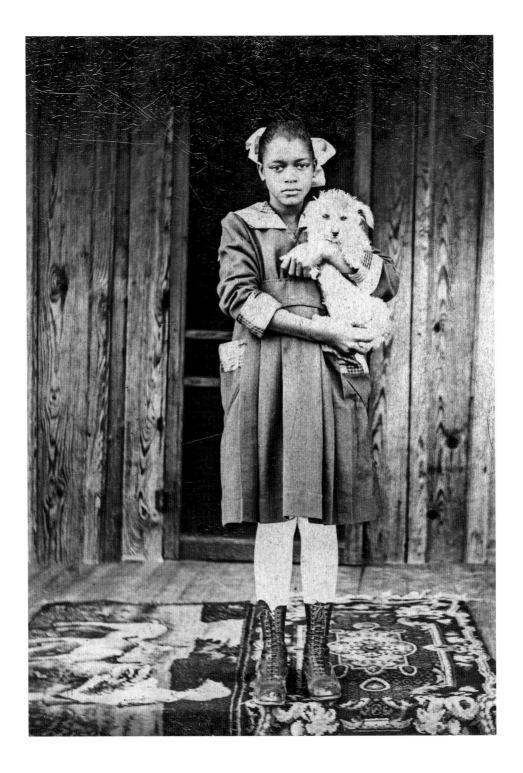

undergirds the family portrait. The looming house in the portrait symbolizes the financial success of the family. So important is the house that the effort to document it sometimes renders the humans in front of it unrecognizable. While practical considerations, such as lighting or sufficient space, certainly played a part in the choice of setting for a family portrait, the decision to frame the family standing outside the house—sheltered on the porch, blocking the steps, or grouped about the garden gate, for example—may also tell us something about the psychological territory being claimed. Houses, and especially childhood houses, are not simply containers for our lives; they are profound structures for our dream lives, and their various privileged spaces may be sites of comfort and imaginative travel, or imprisonment and anxiety.[22] Bloomer and Moore amplify this idea, suggesting that the power of the American single-family home derives from "its being the one piece of the world around us which still speaks directly of our bodies as the center and measure of that world."[23] There is, in other words, an intrinsic relationship between the boundaries of a house and the boundaries of our bodies. The house *"becomes a single body metaphor for one or more persons."* Moreover, the authors argue, there is significance in the relationship of front and back entrances to the public presentation of family life. Like the human face, the façades of houses face forward and the windows are symmetrical, in contrast to back entrances, which "seldom exhibit symmetry and which serve the private and earthy functions of family life."[24] Porches, doorways, back doors—all thresholds—are interesting locations, because they present the subjects in a liminal space, one that hints at the private life within without disclosing much.

Figure 67 offers a haunting example of the possibilities of thresholds. This girl is positioned on the middle-class signature carpet, and she is clutching a small white dog. Behind her looms the dark doorway of a house, which could be either a sanctuary for her or a place of imprisonment. As we've seen in chapter 3, an African American pictured alone with a dog does not necessarily mean that the subject owns the dog or chose to have that picture taken. It's possible that the look on this girl's face reflects a coerced moment. In any event, her troubled expression and her position on the threshold of adulthood, on the threshold of the house (is she leaving, or will she retreat back through that dark opening?), give this image a remarkable tension and emotional ambiguity.

But the house also serves another purpose, for it is symbolically much like the body itself, built with levels and openings that mimic the symmetry and functions of the body. Porches, like smiles, may welcome desired guests, and photos of families on the front steps or scattered about the porch are common. Back porches, back doors, and cellar stairs, on the other hand, hide the private functions of the

family, just as we tend to keep the lower and back regions of our bodies secure from public view. In figure 68, five young men have staged a portrait despite the severe physical limitations of their setting. This looks like a back porch abutting a steep hill; the couch must be positioned sideways in order to accommodate the shot. The post of the porch awkwardly bisects the group; the men are squashed together in a space too small for them, and they are all wearing hats. The hats suggest a sense of moment for the picture and may also indicate that they are in a jaunty mood. The dog is being held and displayed as an important part of the composition. It's possible that this is not a group of biologically related individuals; they might be a team or a musical group who are displaying their mascot in the visual tradition of the early twentieth century. Well into the twentieth century, African Americans were still banished to the servants' entrance, the back door, and the side entrance, and yet these young men have used every convention of the family portrait at their disposal—the house, the porch, the furniture, the clothes, and the family dog—to declare their bond. We don't know if they are biologically related, but their portrait tells us that they are united. In the visual rhetoric of the time, it is the dog that confirms this message.

In addition to the setting, the postures and groupings in a photograph are also helpful guideposts. The Victorians were acutely conscious of rank and class status. Not only were their homes arranged so as to provide the appropriate markers of breeding and sensibility, but even their furniture, and the use of that furniture, was part of a gendered and class-based value system.[25] We have inherited many of these conventions from our Victorian forebears. In my family portrait (figure 59), our presentation is defined by a marketed construction of "family" so pervasive that Holland, Spence, and Watney can argue that the ideal family unit "constitutes the central sales pitch of our capitalist economy." This family image is "always smiling and happy, untouched by the vicissitudes of economic and social change."[26] Dad, given a seat of honor in the nineteenth-century photograph, looms protectively over his family in the twentieth-century version. If the children look just a little scruffy, well, Mom apparently didn't take the same care with their clothing that she did with her own, suggesting an unhealthy vanity. Or perhaps each person is dressed in a way that is comfortable and speaks of his or her identity as a family member. The children are dressed in play clothing; Dad, who was the stay-at-home parent, is dressed casually, and Mom just came from the office. Moreover, the children have the last name of their mother, while Dad's last name stands alone, unanchored by the tradition of male possession by name. Of course, neither Dad's occupation nor his last name is visible in this image. Our portrait thus falsifies something else about our lives. It suggests

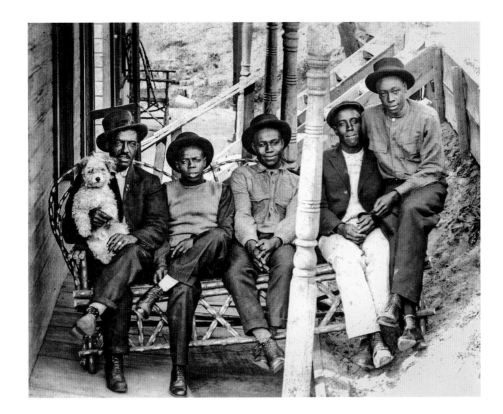

FIGURE 68

Cabinet card, 1920s,
10.2 × 7.2 cm.

a traditional family hierarchy that in fact we did not honor. That is, the conventions of family representation override the private structures of our lives, and we are homogenized in that moment. As I am suggesting here, our homogenization has tenacious antecedents.

Julia Hirsch demonstrates how the well-appointed photographer's studio of the nineteenth century could erase the private individuality of the sitters, presenting them as interchangeable figures in a common cultural setting—presenting them, in fact, as distinct from the private spaces of home and family life and allowing them to inhabit a different public identity that pretended to be a private identity.[27] In *Culture and Comfort: Parlor Making and Middle-Class Identity*, Katherine Grier reveals the ways in which parlors became a formative location for establishing social identity and photographers' studios staked their business on being able to provide a superior parlor setting.[28] Apart from peering closely at the quality of the garments—are the women's clothes well made, or obviously homemade?—you can't tell from studio images whether the borrowed setting is congruent with the sitter's private world. Similarly, we can't be sure that the dogs in studio portraits actually have a

FIGURE 69

Irvin Young. Cabinet card,
1890s, 9.8 × 14.2 cm.
Photograph by Warmkessel.
Allentown, Pennsylvania.

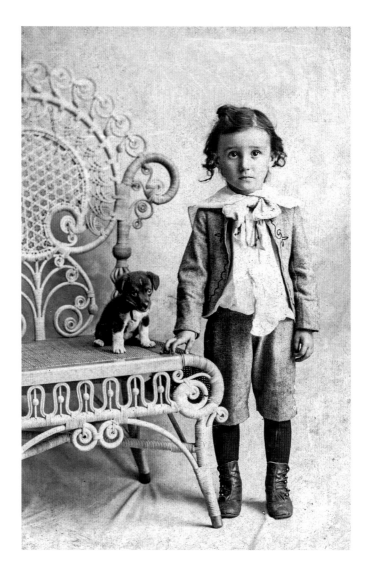

relationship to the sitters. In many studio portraits, we assume that if a dog is in-
cluded, it is the family pet, but given the facile use of dog statues, as we saw in chapter
2, we might well assume that the really perspicacious studio owner may sometimes
have provided a living animal. This might be one way of explaining the sitter's ap-
parent detachment from the canine in some instances. For example, photographs of
children and puppies usually show the children cuddling the pup, or in some kind
of physical contact. But consider figure 69, in which the puppy and the boy seem
united solely in their apprehension. Has the boy ever seen this pup before?

PICTURING DOGS, SEEING OURSELVES

Philip Stokes suspects that the staging of family portraits includes an important kind of social mapping, although he is not sure what to make of images where family members are scattered across the visual field, in contrast to images where people are bunched together; he simply comments that, for whatever reason, the clustered group became a convention in the twentieth century and that it marked some kind of cultural shift.[29] Following Philippe Aries's lead in *Centuries of Childhood*, one explanation may be that as the family came to be defined by biological and dwelling exclusivity, it seemed natural to present the group visually as tightly knit, erecting a formidable barrier to intruders. The relationship between individuals in a portrait, whether they are seated or standing, centered or on the margins, scattered or bunched together, is part of the communication; and the conventions born in the efflorescence of Victorian culture reach well into the twentieth century and even the twenty-first.

The wide visual field of some family photographs might be attributed to the cultural importance of the frontier, where the expansiveness of the natural setting seems to command the sense of frame. Additionally, the frontier ethos required hospitality to visitors and travelers, whether the occupants of a prairie home were related to the guest or not. Visually, then, a casual gathering of persons may reflect that frontier generosity, as well as giving a capacious view of the proud landowner's holdings. In figure 70, the staging may serve multiple purposes. The homestead is open to outsiders, and the wide perspective shows off the property and other elements that suggest a hopeful prosperity. The young saplings and the cans of potted plants along the side of the house suggest the intention to establish a civilized environment. Thus the horses are intentionally included as part of the holdings, along with a man who is separated from the main group of people, who are standing in proximity to one another but have no physical contact. The male we would take as the husband, but the child and the dog are centered, which doesn't suggest which males are married to (or related to) which females, or if the man with the horses is a hired hand, although that is often the case with group portraits like this. A hired hand would be a status symbol.

In contrast to the scattered group above, the family in figure 71 is already positioned as if anticipating a cultural shift. The family is still spread out, but they are standing along a fence and gate, with the family home looming behind them, secure behind the fence and the line of human beings. Again, the children and the dog are near the center of the image, while the adult women are distributed farther along the margins. Unlike the frontier portrait with its generous spaces, we are not invited to step closer in this image. And if the frontier image is typical for a portrait hailing from the 1880s, by the 1890s we typically see a tight cluster of individuals

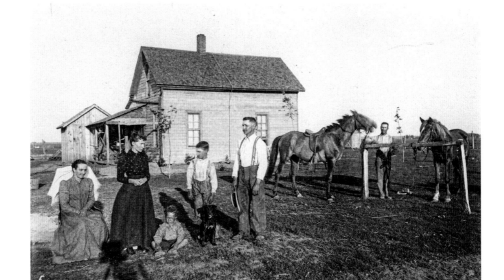

FIGURE 70
Cabinet card, 1880s,
19.5 × 12.3 cm.

FIGURE 71
Cabinet card, 1890s,
19.5 × 11.5 cm.

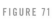

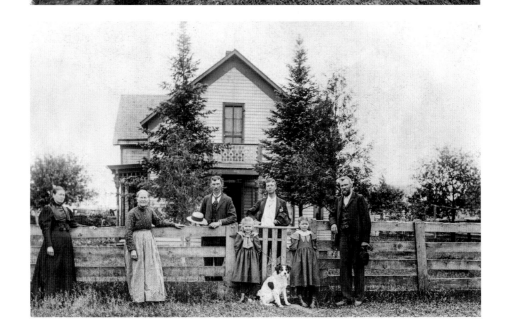

presented for viewing, sometimes in a studio setting and sometimes on the porch, in the garden, or in front of the house.

The clustering pose need not always be forbidding. In the charming portrait of "cousin Jake and family" (figure 72), both dogs have been coerced into the picture

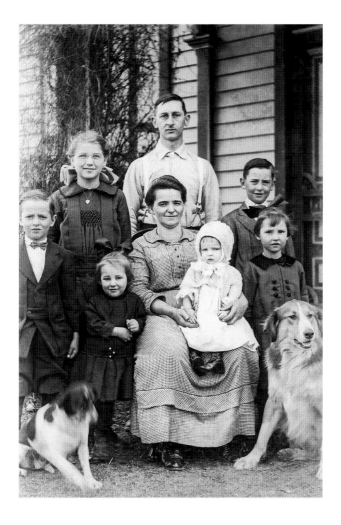

FIGURE 72

Cousin Jake and family. Used
RPPC, 1910–1918, 8.6 × 13.2 cm.

with varying degrees of success, and the children have all been polished and
primped for the camera. Part of what makes the portrait so appealing is the infor-
mal setting—it appears to be a garden area near the door of the house. In addition,
most of the children and the mom are smiling, and the little girl at her mother's
knee is leaning against her mother in a way that reminds us of the amiable bodily
relationship between a parent and child. This is what a young child looks like even
when she is dressed up. It is also easy to imagine that the dogs are beloved parts of
the family, and that the hound got scolded later for moving.

As a movable marker of social import, the dog may speak about different as-
pects of family identity. Purebred dogs were a matter of middle-class pride, and
were displayed as evidence of material and personal accomplishment. Similarly,

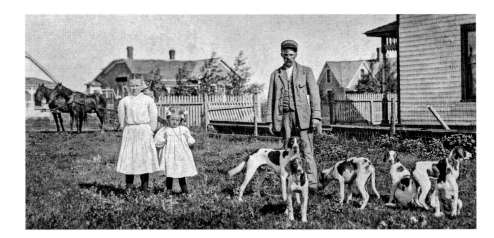

FIGURE 73

Elsie Frank. Used RPPC,
1907–1908, 13.9 × 7.9 cm.

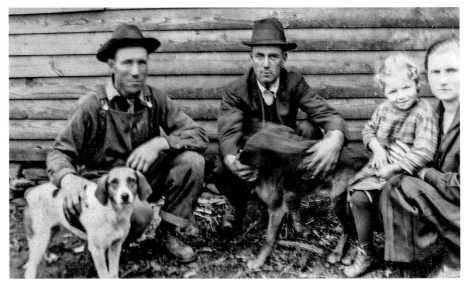

FIGURE 74

Unused RPPC, n.d.,
11.8 × 7.2 cm.

hunting dogs are possessions indicating hunting prowess, and the proud hunter often displays the corpses of his quarry along with the dog. As we'll see in chapter 5, numerous RPPCs and cabinet cards feature men, boys, and dogs exclusively. In figure 73 it is difficult to tell whether the children or the dogs were the occasion for the picture. It's not exactly a full family portrait, nor do the children seem to be the center of attention, although a handwritten note on the back identifies one of the children as "Elsie Frank." In these kinds of images, even when the rest of the family is included, the dogs seem to upstage the people. Perhaps it was only careless printing or framing that pushes the woman and child in figure 74 to the margin of

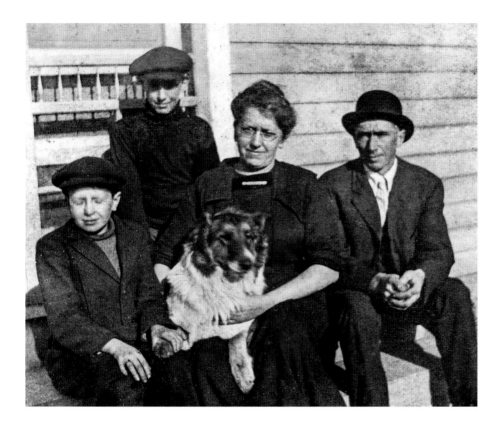

FIGURE 75

Used RPPC, 1910–1918,
12 × 8.7 cm.

the image, but the men and dogs seem to occupy the center, suggesting that they were the reason for the photograph. Additionally, all of the people have to squat in order to bring the focus to ground level, rather than expecting the dogs to adopt a pose or setting unnatural to them.

While clustering around the children is one way to suggest family relationships, the dog seems to bring a finalizing solidity to the implicit statement. In contrast to figure 74, where the central group seems to put the mother on the margin, figure 75 shows us the father on the margin, with children and mother as the primary group and the dog cradled in the middle of that grouping. The canine centers this image, and the son on the left is holding paws with the dog.

FAMILIES JUST WANT TO HAVE FUN

Not all families took the family portrait very seriously. Some families had a good time having their picture taken, and they generated some goofy images, including

FIGURE 76

Cabinet card, 1890s, 11.5 × 9.7
cm. Photograph by Goodrich
Palace Traveling Studio.

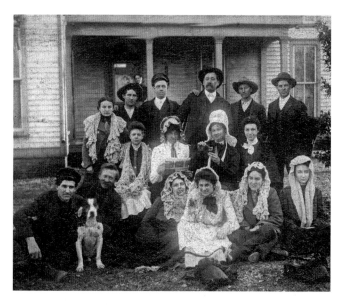

FIGURE 77

Unused RPPC, 1910–1918,
12 × 8.6 cm.

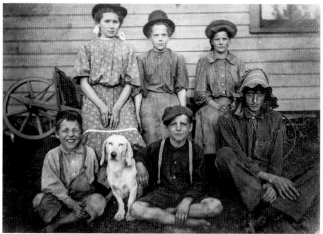

a motif that must have been something of a counterconvention in the late nine-
teenth century—the silly hat picture. In figure 76, the women seem to be wearing
head coverings that are not natural to them but seem similar. The woman in the
second row in a tall, bonnetlike affair is holding a pipe, as though to light it, and
the person next to her is peering up from a newspaper. This person may be a man
in women's clothing, so that the two central figures are enacting a humorous role
reversal. Several others in the group display barely suppressed laughter. The pho-
tographer imprint for this cabinet card says that it is the product of the Goodrich

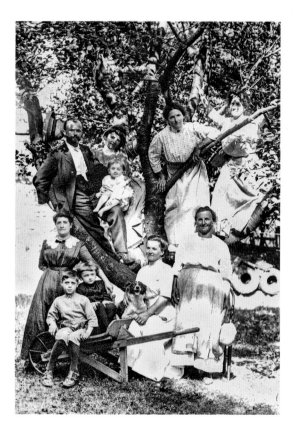

FIGURE 78

Unused RPPC, 1907–1923,
8.7 × 13.9 cm.

Palace Traveling Studio, which suggests that the participants took advantage of the photographic props to enliven their portrait. In a similar grouping (figure 77), we see again a cross-dressing theme in the headwear, so that the gender conventions displayed with such seriousness in other images are deliberately undercut and spoofed in these. The dog is not critical for reading either image, but in both pictures the dog is included in the family joke, and the only surprising thing about the dog in these pictures is that they didn't dress it up as well. Nineteenth-century photos of dogs occasionally feature the dog with a pipe, or wearing glasses, hats, or other such humanizing items. Another kind of whimsical presentation involved putting the family in a tree, a presentation that pretty much obliterates the class-based pretensions of the studio portrait. The group in figure 78 isn't guarding the gates—they are issuing a playful invitation. Again, the dog isn't especially important for reading the image, but it was included as a centered part of the family portrait. This family doesn't need the house, the well-appointed parlor, or the purebred dog. Their natural good breeding is evident in the family tree!

FIGURE 79

Snapshot, 1931, 10.4 × 5.8 cm.
Louisiana.

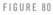

FIGURE 80

Unused RPPC, 1910–1918,
13.1 × 8.1 cm.

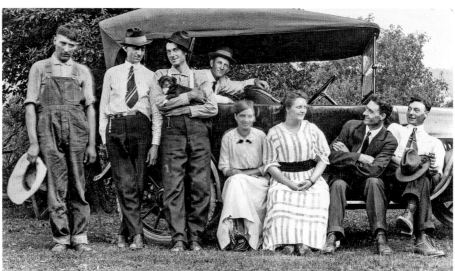

Finally, as we move into the twentieth century, the family car rolls forward as another desirable setting for the family portrait, and sometimes as a suitable replacement for the ancestral mansion. As with all status symbols, the car joins both the class and racial signaling system. In figure 79 three possessions are being displayed—the car, the dog, and the driver. But people also used the car for having fun. It's common to find people perched all over a vehicle, sometimes with the dog on the front, like a hood ornament. Like the tree family, the group in figure 80 is having a good time. The dog is a cute addition, but not essential to the spirit of the image. However, there is an added social dimension to this image. Note that while

PICTURING DOGS, SEEING OURSELVES

most of the people are wearing formal clothing, however informally positioned, the man on the far left is wearing overalls, and he holds his hat in his hand, as one would when in the company of one's social superiors. Unlike all the other men in the party, he is neither jaunty nor sharing in the joke. So even in this lighthearted presentation, it's likely that social class commands the scene. The hired man has been included in the photograph, but as Laura Wexler demonstrates, this inclusivity is more apparent than real.[30] High-minded notions of philanthropy suggested that the well-bred family would treat inferior others with kindness, hence the pretense that domestics and hired help are "part of the family." At the same time, the presence of the help signals a certain middle-class attainment, so including the hired hand in the photo is doubly self-serving.

Figure 81 is another illustration of Wexler's point, this time inflected by race. Several generations of family have been gathered together for a casual outdoor portrait. Their names are faithfully recorded on the back of the card: this is the Jeffreys family. The only creatures not identified are the two dogs and the kneeling black man. The two dogs are doing what only they can get away with—ignoring the camera. The black man, however, is more captive than even the dogs. He looks as if he has been commanded to face forward, and his posture on his knees suggests that he was not allowed to stand with the Jeffreys clan as an equal, nor could he sit comfortably, as if he belonged with the two seated members. Apparently, he can't even be as comfortable as the family dogs, although he occupies the same space. He is clearly not part of the group, but he is definitely part of their documentation. In these kinds of images, it becomes clear just how pervasive class and racial distinctions can be. Domestics, servants, and hired help may have been included in the frame, but they were not invited to dress for the moment or to step from the shadows and join in the fun as welcomed peers. They are acknowledged, but just barely. Their presence is inherently contradictory, confirming the economic and social status of the family while undermining the homogeneity of the middle-class family presentation.

GENDER IN THE FAMILY PORTRAIT

With these conventions for family portraits in mind, I'd like to turn to several photographs that offer unusual opportunities for contemplating family relationships. Unlike some of the examples above, the dog in these photos is a vital element in completing the visual statement offered by the family portrait. Figure 82 shows a middle-aged couple in a plain setting. There is a tarp or blanket as a backdrop and three chairs, two for the people and one for the dog. In addition, there's a footstool

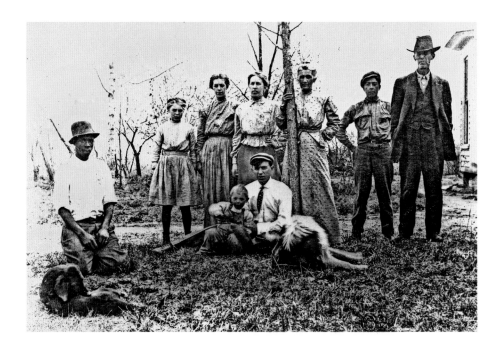

FIGURE 81

———

Jeffreys family. Used RPPC,
"approx. 1909," 12.4 × 8.6 cm.

for the cat, an unusual addition. The inscription on the back identifies "Herbert W. Parker," from somewhere in New York. Mr. Parker looks up from his newspaper, while the nameless woman attends to the animals. Given the side-by-side staging, she is probably his wife. The dog could be shared by the couple, but in this staging it has its back to the man, and the woman looks tenderly at the dog. It isn't difficult to imagine that she has a closer relationship to the animals than to her husband. The presence of the dog, and its position, in other words, gives this portrait an interpretive angle that would not be available if the dog were erased and the two people were simply sitting side by side.

According to Holland, Spence, and Watney, "power relations are cemented as firmly in photographs as they are in the institutions of the state and industry," created by a "careful orchestration of consent" that reinforces social norms.[31] Figure 83 makes this observation distressingly concrete. Both women have prepared for this photograph, and they stand like attendants behind the dominating male in the center. The younger woman has rolled and puffed her hair and adorned the whole with a big bow. She's wearing a pearl necklace or a collar with pearls, and a metal bracelet and a small ring with a stone. The older woman is less adorned, but she's clearly wearing her nice clothing, which dates this photo as late as 1919, although the hair might put the date as far back as 1905. Neither woman looks very happy.

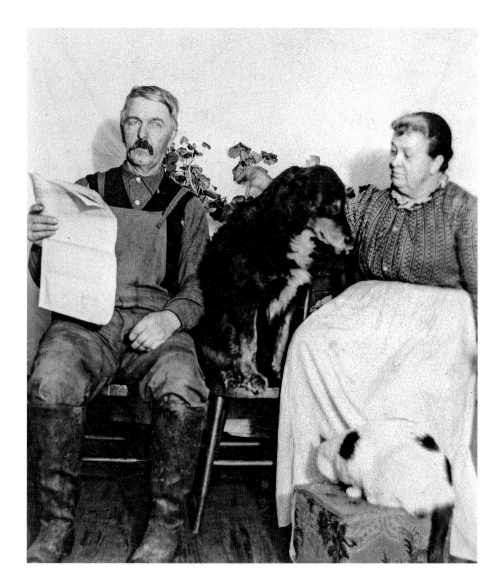

The man looks pretty satisfied, however. Wearing his work clothes, he's tilted back
in his chair in the dominant, crotch-first positioning of the old West. While tilt-
ing back in the chair may sometimes be read as a sign of informality or of the un-
pretentiousness of working-class subjects, Kenneth Ames notes that "often the
point was to demonstrate masculine behavior in a masculine sphere," and he links
this posture to specifically male-identified purposes. The tilt creates distance and
controls connectedness, allowing one to survey a situation and assume the role of

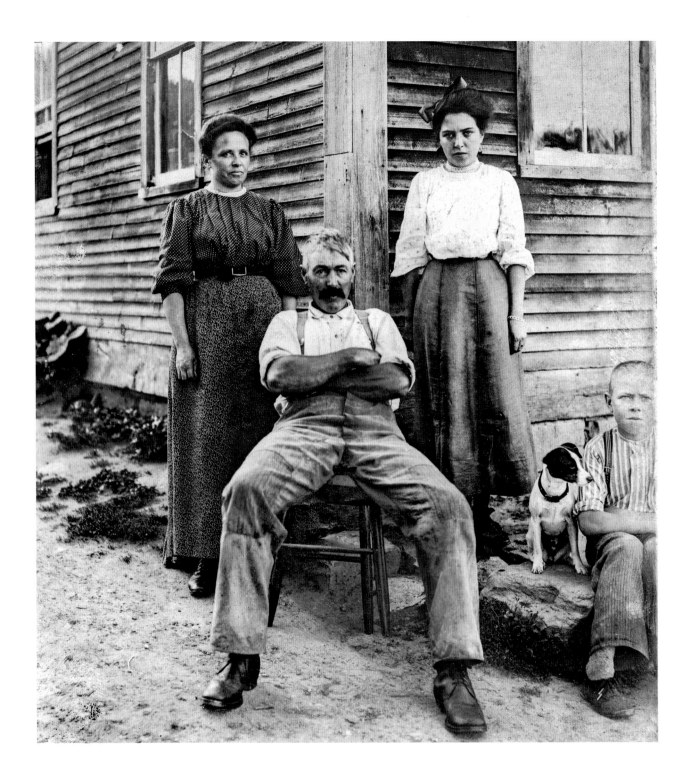

spectator or voyeur. It is an implicit pose of assessment and evaluation, in other words, where the command of the male gaze is reinforced by the physical communication of the tilted chair. In addition, "the tilting behavior, so aggressively uncourtly, ungracious, unfeminine, was a way in which males revealed and affirmed their politics and their gender."[32]

The decision to position the subjects at the corner of the house is unusual as well, and adds force to the man's presence, with the ramrod-straight timber seeming to issue from his seated figure. In this image, although the bulk of the house looms behind the subjects, the house is dominated by the male owner. Given the man's phallic presence, it seems inevitable that the boy is edged out of the picture, having even less of a place than the dog. If the dog were missing, it would still be obvious that either a terrible job of cropping or a tantalizing psychological perspective helped compose this family picture. But the dog underlines the dynamic, for even it is more a part of this centered portrait than the hapless boy.

The outdoor staging may also be important in situations such as this one. The photographer Nicholas Nixon says that the porch is a "bridge between private and public space," a space that can act as both an invitation and a refusal. People behave differently in public, Nixon observes, and there is more potential for violence in public. "Something can always happen outside."[33] Although this comment may seem light years away from a turn-of-the-century family portrait, the family portrait can in fact hint at just such possibilities. The Vermont patriarch in figure 83 probably could not have dominated a portrait taken in a contrived studio setting in the same way he does in this outdoor setting, and perhaps even a front porch would have been too close to family domesticity to suit the purposes of his image.

In figure 84, the elimination of the house as an element of the portrait, in combination with the positions of the family members, suggests the erasure of any notion of "home," further compromising the portrait's message. While some families did choose outdoor settings, the context was usually a hike or a picnic or some other pleasurable activity. It is rare to find people dressed up, standing in a field. The absence of the house is striking. Striking also is the downcast face of the little girl, who doesn't seem to be merely looking down. The family is looking into the sun, and there is a cat lurking just under the skirts of the woman on the left, so the girl's downcast look may be directed toward the cat, or it may be an attempt to shield her eyes from the sun. Yet her whole body seems slumped into a submissive downward posture. The man is separated from the group. What should have been a tight family cluster is not, unbalancing our expectation that this man is related to the women and children. It's also not an expansive or generous-looking presentation. The man's stance might suggest that he has commanded or herded them

FIGURE 83

Photograph, 1910s, 16 × 17.4 cm. Vermont.

FAMILY PORTRAITS

[135]

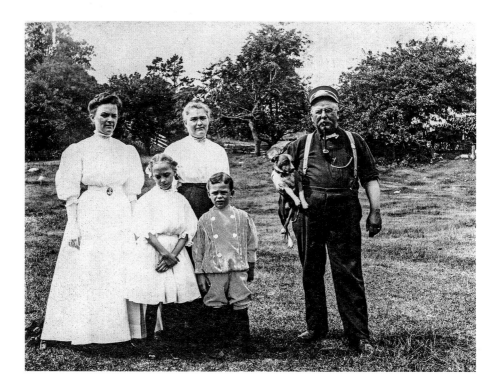

FIGURE 84

Cabinet card, 1910s,
12.2 × 9.4 cm.

to this moment. He is wearing an official-looking cap, as if he were a conductor or fireman, and it appears that he usually wears long sleeves, for his arm is very white from the wrist to the elbow. The women and children are dressed nicely, but the man is not wearing an equivalent costume, and the pipe suggests that this is a casual moment for him. Perhaps most telling, however, is the dog, which has been grabbed up for the picture. Legs dangling uncomfortably, the dog hangs from this man's beefy arm, a possession on display. The uncomfortable canine completes the impression of a domineering male father or grandfather figure in command of his chattel.

The forceful male presence in these last two images underlines the implicit gender dynamics in the concept of family, and in the homogenizing conventions of the family portrait from the nineteenth to the twentieth century, we see the effect of social conditioning on the public personas presented for the record. At once nostalgic shelter and coercive construct, the imperatives of the family portrait may conceal much and yet still reveal the tangle of private lives documented in the photographic surface. The social pressure to present a respectable family (nineteenth century) or a happy, united family (twentieth and twenty-first

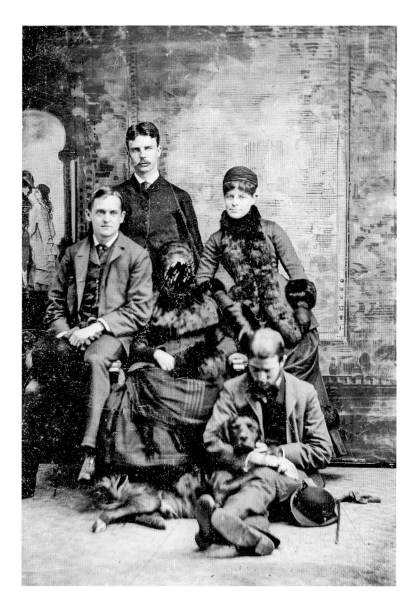

FIGURE 85

Tintype, 1880s, 6 × 8.5 cm.

centuries) implicitly sets up expectations that no real family can meet, and the photograph may solidify family tensions in ways that become troubling to the participants. This apparently was the case in figure 85, where the woman in the center has had her face scratched out. We'll never know if one of the other participants vandalized her face, but given the relative scarcity of images, the vandalism of this one makes a powerful statement about the hidden passions of the family

portrait. In the defaced image, the hidden private world has erupted into the public face of the photograph.

During my lifetime, American sanctimony about "family values" has been sustained by religious and political dogmatism that seems unparalleled until we review the family profiles of Victorian America. The "middle-class Victorian family," Stephanie Coontz tells us, "depended for its existence on the multiplication of other families who were too poor and powerless to retreat into their own little oases and who therefore had to provision the oases of others."[34] The comfort of the white middle-class family has always depended upon the degradation of those who lack the same economic and social advantages.

As we saw in chapters 1 and 2, the conventions of the middle-class portrait were part of a class-based signaling system. Paradoxically, the homogenous visual rhetoric of the middle-class portrait erased individuality and offered "outsiders" a way to invade the sanctum of social hierarchy. Those outsiders—in this book they are African Americans and poor white Americans of any ethnic origin—did finally acquire the clothing, the house, and the car. But even when they didn't have those things, there was always the dog, who appears in these portraits no matter how luxurious or how desperate the physical surroundings.

Enzo, the canine narrator of Garth Stein's *The Art of Racing in the Rain*, tells us that dogs are potentially dangerous to humans because someday dogs will evolve an opposable thumb and a smaller tongue, which would make them more dexterous than humans. Enzo also feels that dogs possess superior spiritual insights that humans are afraid of. *"All dogs are progressively inclined regarding social issues,"* he concludes.[35] This is why, Enzo tells us, dogs must be constantly supervised and are immediately put to death when found living on their own. Today, we still see isolated but horrifying efforts to enforce cultural and sometimes literal death on those who violate the norms of family life. Dogs, however, do not willingly participate in these aberrant human activities. In these family photos, the dog is used as a marker of family and cultural power, but that marker is not entirely within our control, because we know that dogs love unconditionally in ways that we humans refuse to do.

PICTURING DOGS, SEEING OURSELVES

5

HUNTING PICTURES AND DOG STORIES

Hunting pictures are occupational photographs that have enjoyed a long cultural shelf life. Like big fish pictures, their purpose is to document the size and quantity of the hunter's victory over animals and the natural world. In this chapter, I look at hunting pictures and dog stories about hunting to probe further into the cultural meanings of the hunt and its documentation. These pictures have meaning for our understanding of race and gender. For example, the solemn young boy in figure 86 grasps a 12-gauge shotgun that is taller than he is. Although the image is faded, it appears that he is a wearing a boy's suit with a long, low-belted jacket, white, high-collared shirt, and bloomer or knickerbocker pants. The shirt includes a detachable "shield," which is embroidered with an anchor and cross. Images from the 1912 Sears catalogue show a number of these shirt-and-shield arrangements, which must have been a decorative item that also protected the shirt from the results of being worn by an active boy. In this photograph the shield has slipped to the side, so the rest of the embroidered design is not visible. The boy is dressed in good clothing, not play clothing, for his hunting picture, and the portrait is completed by the faithful dog.

This photograph and many like it indicate the importance of grooming young boys for their roles as civilized killers of animals, if not as lady-killers. Thinking

FIGURE 86

Unused RPPC, 1907–1912,
8.7 × 13.8 cm.

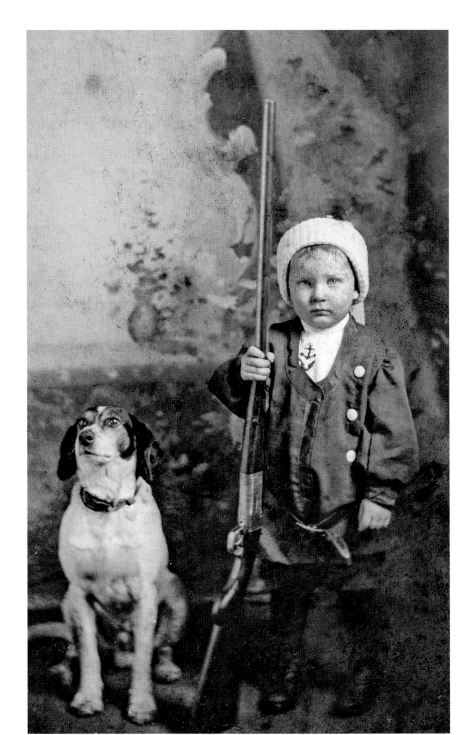

about the boy, the dog, the weapon, and, finally, the hunt opens up a fascinating narrative about manhood and womanhood that I'll unroll in this and the next chapter. While photographs and dog stories were essential tools in establishing proper public identities (chapter 2), they were also key elements in confirming a culture of masculinity that was defined by a male's uneasy relationship to civilization (women) and wilderness (men) and the constant balancing tug between the two.

All of these elements are rehearsed in hunting pictures and dog stories, although the visuals and literature can be quite different for women, black men, and white men. As we have seen, girls and boys appear in pictures with dogs, and we have no reason to think that girls didn't love their family pets. And yet cultural wisdom still speaks about "a boy and his dog," as if that bond between white male children and canines was especially important. Perhaps it was. Dogs are an essential part of American hunting culture, and that hunting culture became a way to establish gender and racial territories. The dog stories that were so popular in the early twentieth century crackled with gender-inspired anxiety, reinforcing cultural concerns about manhood and documenting acceptable rituals of passage by which the modern white male could assert his masculine identity against the claims of women and dark-skinned males.

BEAUTIFUL WHITE BOYHOOD

In *The Great Gatsby*, Daisy sighs over her beautiful white girlhood in Louisville, but the implicit racial subtext of the novel indicates that beautiful white boyhood is also at stake in the figure of the über-masculine Tom Buchanan. Anxious nostalgia about boyhood and manhood has relatively recent roots in American culture. It seems that the more civilized we became, and the more the inspirational frontier eroded before the onslaught of civilization, the more masculinity became of national concern. Given the social rigidity of our gendered visuals in the United States, it's difficult to imagine why this is an issue. Anyone who has been in a Walmart knows that the aisle of girls' toys is a flood of pink packaging, as is the section of clothing for girls. The section for boys is filled with blue and other dark serviceable fabrics, and toys are for building, driving, or killing. We are so habituated to the extreme visual distinction between the sexes imposed from infancy that it's surprising to discover that Americans were not always so concerned about locating sexual difference. It seems that our age of anxiety is all about sexual and gender identity, and some historians describe this as an obsessive preoccupation with cultural and economic changes in the late nineteenth century.

In the 1850s, children of both sexes were put into short dresses once they were released from the long gowns of infancy. Boys and girls wore cotton "trowsers" underneath the dresses from about age three. This practice of unisex dressing continued well into the 1880s.[1] By 1912 boys ages two and a half to nine were wearing long, suitlike jackets and bloomers, knickerbockers, or long pants,[2] long pants having appeared for older boys as early as the 1860s. Boys typically were transitioned to long trousers somewhere around the age of five or six.[3] The apprehensive toddler in figure 87 is wearing typical clothing for a boy his age, and the skirt and the large bow put the image in the early 1890s. His short hair identifies him as a boy, although some doting parents cultivated long Fauntleroy curls in their young sons well into the 1890s. His sibling is dressed in the long gown that was used for infants of both sexes, and the infant's short hair is typical of a young child of either age. The sleeping dog appears to be an English setter, which, along with the studied studio furnishings and the carefully dressed children, establishes the respectability of these middle-class or upper-class children. Apparently, no one was worried about whether the viewer could distinguish a boy from a girl.

However, while in the 1880s little boys might still be dressed in skirts, by the turn of the century children of both sexes were increasingly subjected to gender-stylized cultural pressures,[4] although those pressures could be conflicting. Girls were essential laborers inside the home and often outside, especially in the country and on the frontier, and yet, as females, they were endlessly coached on how to preserve their delicacy and feminine charm, virtues that were best exercised behind the front door, safely away from the rough-and-tumble of the natural and public world. Boys, however, were treated like a peculiar and challenging species in need of domestication. At the same time, cultural pundits worried about the emasculating effects of civilization on manhood.

The late nineteenth-century novel *Beautiful Joe*, which is narrated by a sympathetically presented mongrel dog, identifies girls as naturally unselfish but isolates little boys as having special needs when it comes to basic human empathy. Beautiful Joe approves of the ways in which people offer their boys a "heart education, added to the intellectual education of their schools," by teaching them to be kind to animals.[5] Katherine Grier reviews a number of nineteenth-century artists and essayists who agree that "the boy who tormented animals would in time become the man who tormented other people," and thus the natural inclination of little boys to throw rocks and pester needed firm rechanneling into more empathetic pathways.[6] This critique of casual violence against animals had broader implications than simply civilizing rude boys. Grier argues that violence against animals was a real issue at the turn of the century—was in fact a motivating force

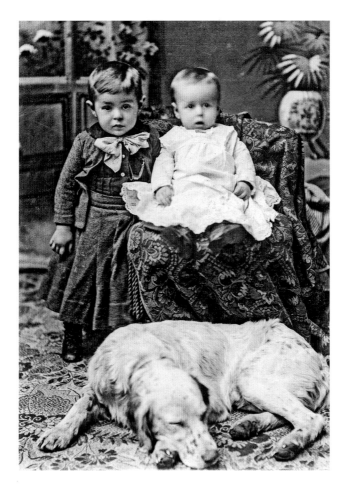

FIGURE 87

Cabinet card, 1890s,
10 × 14.3 cm. Photograph by
Mackey. Superior, Nebraska.

that galvanized humane societies into existence. As Grier comments, "the violence perpetrated on animals . . . was individual and casual, reflecting a rough world of male privilege that regarded the suffering of the powerless as a joke."[7] Hunting was an accepted and well-defended ritual for exercising these privileges in defiance of womanly scruples.

The ardor of hunting culture is essential to understanding boy culture and the topography of masculinity.[8] According to Gillian Avery, writers waxed ecstatic about an eternal summer of boyhood, one that contained bare feet, plunging into the swimming hole, fishhooks, watermelon, and guns. Boys all "coveted guns and thought them the 'most valuable and enjoyable personal property on earth. We pitied boys, and even men, that lived before firearms were invented.'"[9] The boy culture of the mid-nineteenth century and beyond describes a world in which boys

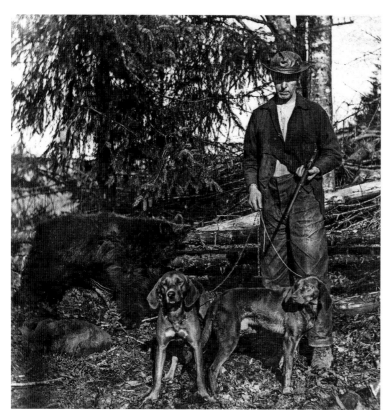

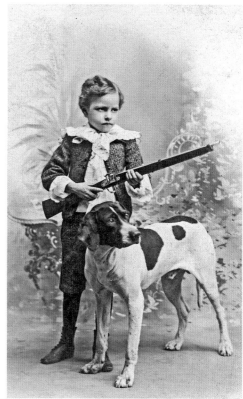

FIGURE 88

[LEFT] Geo Johnson.
Used RPPC, 1906–1908,
12.2 × 8.7 cm.

FIGURE 89

[RIGHT] Cabinet card,
1900–1910, 9.9 × 13.9 cm.
Photograph by Speake.
St. Joseph, Missouri.

alternately tormented and teased one another in physically crude ways or turned their irrepressible spirits onto the animals in their path. Like a litter of hound pups, boys could be frisking amiably one minute and snarling savagely the next, and both moods were typical of boy culture. Boys hunted birds and squirrels, and they set traps. In rural cultures, hunting would have been a natural way for men to exercise their masculine identities, and for rural families, hunting also would have been an essential contribution to the family's sustenance.

But beyond that, the hunt "was associated with the power and status of grown men," a status as compelling for city boys as it was for their country counterparts. For southern boys, owning a gun was more than simply acquiring the right equipment. They desired what it represented—entrance into the brotherhood of white masculinity.[10] It's likely that this comment was as salient for youth in the West and East as it was for southern youths. Poor boys might have to make do with traps, but any boy worth his salt wanted that gun. In *American Manhood: Transformations in Masculinity from the Revolution to the Modern Era*, Anthony Rotundo notes that city

PICTURING DOGS, SEEING OURSELVES

boys took the same "lusty pleasure" in the kill as did their country cousins, and the culture of these youngsters is notable for the "extravagant sadism" they exhibited toward their prey. They weren't just hunting to put food on the table; they took pleasure in inflicting pain and enjoying domination over helpless creatures.[11] This pleasure in taking life is not restricted to boys; those enthusiastic killers of small animals become men who enjoy inflicting harm on larger prey as well. In figure 88, for example, a hunter has documented his kill of a bear in a real photo postcard. The laconic writing on the back says, "Geo Johnson. Slautered animals for fun." It seems that this is not an unusual motivation. If the immense piles of animals or the rhapsodic prose in which hunters justified the activity are any indication, boys and men hunted precisely because it gave them pleasure. Rotundo goes on to comment about the inherent conflict for boys, who at the end of the day would be returning to a home where civility and self-restraint were expected. "The world that they created just beyond the reach of domesticity gave them a space for expressive play and a sense of freedom from the women's world that nurtured them early in boyhood—and that welcomed them home every night."[12]

Figure 89 provides a visual record of these contradictory impulses, for this stern and focused youth is dressed like a foppish aristocrat, but he is clutching his rifle as if he were going hunting in that improbable Fauntleroy outfit. For every youth who was made to dress for a contradictory role, we have a homespun counterpoint. On the RPPC in figure 90, the youth on the card has written on the back, "Lee says he will make some more on soft paper so these cratches won't show but Sampson look cute don't you think." Sampson has been given a chair to sit on, which we recognize as a sign of honor. With his hat, his prey (a squirrel) stuffed into his overalls, and his colloquial communication, this adolescent presents us with the dog that Mark Twain forgot to give Huck Finn. As we know from any number of examinations of the American ethos, women represent civilization, a desirable but imprisoning construct for young men, if not for young women. Like Huck Finn, the white American male is always poised to light out for the territories, just ahead of Aunt Polly's domesticating claw. The inexorable process of civilizing boys has long been in tension with potent cultural definitions of masculinity that yearn toward unfettered savagery. It seems that grown men weren't too far from this matrix of masculine savagery and its puzzling relationship with the world of civilization, given that, as adults, these youthful hunters settled into the domesticated role of husband and father. Young men, schooled in the language of the hunt, saw women as lures, as bait that would trap them in the cage of domesticity; "from one place in their hearts, young men regarded women with the vigilance and fear that the prey feels for the predator."[13] Boys were affirmed as adults by crudely translated Darwinian

understandings of human biology. This included recognizing the impulse of the fittest to survive and triumph. In their celebration of masculine vitality, grown men in both the city and the country grew comfortable identifying themselves with primitives and animals, and this identity was variously celebrated and reinforced in athletic clubs, lodges, and hunting groups.[14] According to Michael Kimmel, men at the turn of the century were overwhelmed by cultural changes, and a resort to hunting culture was a way to reestablish the practice as both sport and proving ground. The call to manhood was echoed by Theodore Roosevelt, who organized the Boone and Crockett Club to encourage big-game hunting. Others insisted that eating red meat was also a male-building requirement.[15]

Katherine Grier's work on the cultural dynamics of pet keeping and its implications for our understanding of hunting culture is reinforced by recent animal studies scholarship, which pushes the meaning of hunting far beyond the casual and enjoyable cruelty that seems to be its point of origin. The activity of stalking and killing animals is found to have deliberate and deep-seated cultural meanings, from southern culture to the cross-cultural meaning of manhood over the centuries. At its heart, the predation of men in the woods establishes the critical distinction between white men and white women—men kill in order to maintain dominance and demonstrate their ultimate mastery over the world and their control over themselves. Their prowess depends upon their ability to subjugate, or feminize, nature and all other humans.[16] Any number of commentators present variations on this perspective, although perhaps the most aggressive is Brian Luke's *Brutal: Manhood and the Exploitation of Animals*. Luke admits that men are conflicted about their role as hunters, but the erotics of killing—the sheer pleasure and ecstasy of the moment—override their psychic scruples. Apparently, the white hunting male must kill what he loves in order to fully possess the beloved, and the automatic feminization of the kill only enhances the romantic valences of the activity. In a remarkably candid set of passages, Luke quotes hunters who talk with passion and longing about the erotics of the hunt, one of whom says that "telling you about hunting is like trying to explain sex to a eunuch."[17] As Matt Cartmill says, "many hunters deeply and sincerely love the animals they kill and they identify that love as one of their reasons for wanting to kill them."[18]

With language like this circulating, it's small wonder that the relationship between men and women is colored by an implied and apparently inevitable danger. Brian Luke suggests that "eroticized animal hunting may be a sexual expression of *normal* men in hunting communities,"[19] and he concludes that in addition to the sexual charge of the violence of hunting, "men kill animals in order to communicate a threat to other people." Hunting, in other words, is not simply a way to get

PICTURING DOGS, SEEING OURSELVES

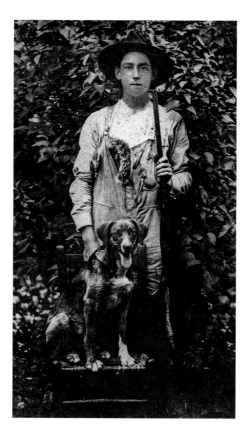

FIGURE 90

Sampson. Used RPPC,
1904–1908, 8.3 × 12.8 cm.

a meal or control animal populations; "it is intelligible only as symbolic behavior" designed to keep white men in one place and white women in another.[20] Hunting is a way to assert masculinity and male bonds, and it is also a way to perpetuate male bonding through the initiation of boys in the rites of manhood.

The kicker, however, is that the sexual charge and domination being explained are often homoerotic and depend upon the literal convergence of sex and death in order for consummation to be complete. Men flee the company of women in order to hunt, drink beer, and talk about sexual conquests. The psychological intimacy is profound. Moreover, male bonding is created through the blood ritual. The animal has to die, blood has to soak the ground, and the hunter must penetrate and destroy the mystery of the creature's beating heart in order to complete the act. Every creature hunted is feminized in that construct, and so hunters often imagine that the animal, male or female, willingly opens itself to the hunter's lethal thrust. The overlap of sexuality and lethal possession that animates this conceit is at the heart of animal studies concerns, which point to how the edible bodies of animals

become the feminized body for conquest and consumption in the bloodthirsty logic of domination.[21]

HUNTING PICTURES

Photographs confirm that in some family social systems, hunting dogs were as important as the women and children, as we saw in chapter 4. The existence of the hunting picture is a confirmation of the cultural and technological synergy between the male-dominated domain of the hunt and the photographic enterprise. Mark Seltzer sees a connection between the American machine culture and our drive toward nature. Naturalizing the American male becomes part of the discipline of technological culture, so that any enterprise that involves technology, equipment, or machinery and is combined with an intent to claim, conquer, and rule the natural (human) body will become a supreme moment for man making. This is what Seltzer refers to as "naturalist skin games," a phrase that suggests the ironic play of nature, conquering nature, superficiality, and ritual, if deadly, play. The appearance of natural masculine vitality is actually the product of multiple disciplines and technologies and is of paramount importance.

Seltzer buttresses his argument with a remarkable quotation from Oliver Wendell Holmes. Writing in 1859, Holmes described photography as the means of divorcing form from nature, saying "We have got the fruit of creation now, and need not trouble ourselves with the core. Every conceivable object of Nature and Art will soon scale off its surface for us. Men will hunt all curious, beautiful, grand objects, as they hunt cattle in South America, for their skins and leave the carcasses as of little worth."[22] It's so easy to read this passage as if the immediate referent were hunting that the relationship between the act of hunting and the act of taking a picture is well underlined. Thus, as Susan Sontag argues, photography is a predatory act that transforms the subject into a symbolically owned object.[23] We sight, we aim, we shoot; we capture a moment, figuratively killing the subject into a deathlike state of permanence, embalmed within the bounds of the physical print image. Not surprisingly, men were the instigators of photographic culture. Only later did Kodak articulate the necessity of photography as a playful, domestic form of record keeping, so that the woman of the house might be encouraged to take up the practice on behalf of her family not as a professional but as the person responsible for insuring and documenting wholesome family life.[24] This did not mean that women were encouraged to hunt with guns or cameras. As we know from both histories of the hunt and histories of photography, they were not. Both technologies belonged to maleness. Seltzer comments on the quoted passage from

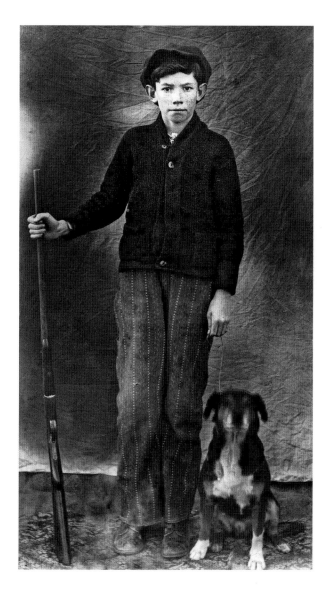

FIGURE 91

Unused RPPC, 1910–1918,
8.7 × 13.8 cm.

Holmes that "if photography is the realist form of representation, taxidermy is the form of representation proper to naturalism" (i.e., men's hunting culture).[25] In this context, taking skins or displaying corpses in photographs is indeed part of a continuum of the male's desire to immerse himself in bloody nature in order to display his temporary triumph over that chaotic self through the technology of gun and then camera. It's a doubled shot, a doubled victory, in which the victim gets to die twice.

FIGURE 92

Uncle Fred. Cabinet card,
1900–1910, 14 × 10 cm.

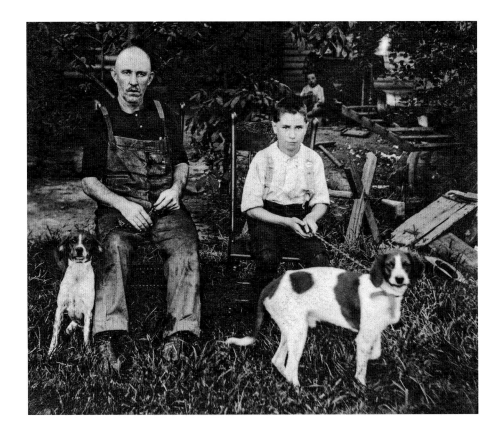

While occupational photographs gave way before the capacity of the studio portrait to present a formal, polished image, hunting pictures remained a popular form of social and occupational documentation. The convention is to show the proud hunter with his gun, his prey, and his dog, although sometimes the prey, or the gun, is missing. The dog, however, is almost always present. Families took pride in documenting the emergence of a son as a skilled hunter, and figure 91 (like figure 90) is a typical presentation. In a makeshift studio setting (tarp or curtain for backdrop, the piece of figured carpet on the ground), this solemn young man gazes intently at us, rifle gripped in one hand, his dog at his side. He's holding the dog by a piece of string or twine, and he might be a little uncomfortable, for one leg is bent as if he were uncertain of his stance.

Even without the guns, the father and son in figure 92 can be identified as having composed a hunting picture. The inked notation on the back identifies this as "Uncle Fred in Mo. he had 10 children." Having your picture taken wasn't an everyday occurrence, so the decision to document the dogs and the son

PICTURING DOGS, SEEING OURSELVES

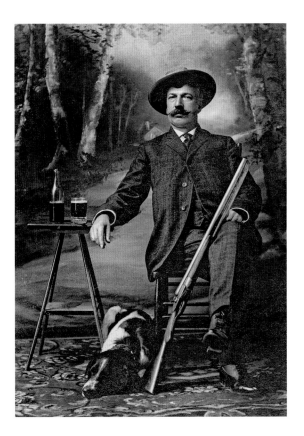

FIGURE 93

Cabinet card, 1900–1910,
10 × 14 cm. Photograph
by Schmidt. Middletown,
Connecticut.

suggests the locus of pride for this man. Far in the background, almost part of the detritus that litters the yard, there are two younger children. The only surprising thing about this image is that they didn't include the guns, because usually the guns are displayed even when the dogs and the slain animals are part of the picture.

While some hunting pictures clearly issue from rustic, if not impoverished, settings, others document class identity. The fellow in figure 93 would not be keeping company with Uncle Fred from Missouri. This gentleman is announcing his double identity as a man of refinement and a man's man. The dog is lined up as one of the accessories, positioned between the beverage table and the chair, and the man's casually draped right arm claims the table and the dog under it, while the left arm forms a visual embrace of the double-barrelled, muzzle-loading shotgun. The Oriental carpet under his feet belies the painted landscape behind him, which is not a wilderness setting but something more domesticated, like a country lane with a cottage at the end. The implied killing that will commence off-road is

FIGURE 94

Cabinet card, 1890s,
10 × 13.9 cm. Photograph by
J. H. Hayden, 1029 O. Street,
Lincoln, Nebraska.

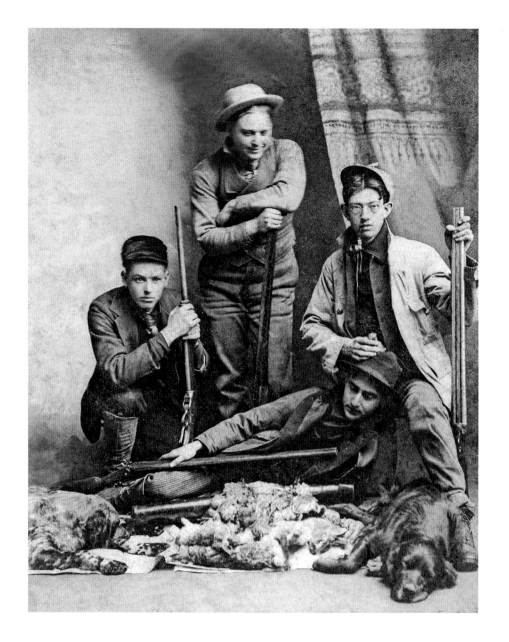

prettily decorated. Refreshments are provided. As with all studio portraits, we are permitted to wonder which part of this image is authentic.

Figure 94 shows four young men who are documenting their hunting prowess but assuring us that they don't take things all that seriously. Shotguns at hand, one looks down with a smile, while the other has a pipe clenched between his teeth

and rests his hand on the head of the youth who is lying prone, contemplating the carcasses up close. The two dogs flank the scene, having determined that sleeping through the photographic event was their best gambit. Whatever joke the men are sharing is lost to us, but what we can see is that they had to plan to document the kill, and perhaps make arrangements with the photographer ahead of time. What is interesting here is not only the playfulness in evidence but the seemingly unconscious revelation of desire that our commentators suggest animates the hunt. The prone man is lying with the corpses of his prey, gazing at them as a man might gaze at his sleeping lover. It is a surprisingly intimate moment, with the other hunters either connected by touch or as voyeurs. And just to conclude with the obvious, his head is in close proximity to his companion's groin. Only the prone hunter's weapon is at rest. This staging is not anomalous. I have seen several hunting group pictures choreographed with some members lying down with the animal bodies and dogs.

The pile of prey is a typical and telling feature of a hunting photograph. Size, as in the physical proportions of the prey and its quantity, matters. As Arluke and Bogdan comment, these images confirm the "prowess of the hunter but also served to foster the impression that the land and water provided an endless bounty of wildlife."[26] Sometimes the carcasses are imported into the studio, as in figure 94, and sometimes they are neatly arranged, as in figure 95, where the partridge are strung like beads on a necklace for the admiring view of the audience and the hunter. But it is just as likely for the photograph to be staged in the outdoor setting, as in figure 96. What is common to all these images is that the quantity of the prey is part of the visual message. These are trophy pictures. The handwritten message in figure 96 reads, "Wouldn't you like to go hunting and have luck like this." Unfortunately, the wanton slaying of animals also created a resource issue, and civilized hunters referred disparagingly to "pothunters," a term that once referred to people who hunted for supper but later came to refer to the same low class of "market hunters who supplied urban markets with wild game."[27] Certainly in the South, their "reckless prodigality" with regard to slaughter became the distinction between the sportsman and the pothunter, yet another way in which class became an active term. However, despite professed upper-class scruples, "most hunters simply blazed away at any targets that presented themselves, just as they routinely slaughtered more game than they could carry or use . . . [and] because most hunters remained fixated upon counting the number of their kills, the slaughter continued."[28]

The photograph documenting the impressive pile of kills carries on a cultural argument about masculinity and manhood such that the importance of hunting for food takes a backseat to its importance as a validation of masculinity. Savvy readers

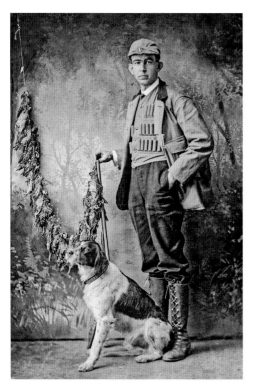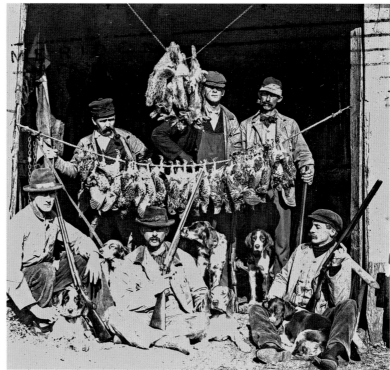

FIGURE 95

[LEFT] Unused RPPC,
1910–1918, 8.7 × 13.7 cm.

FIGURE 96

[RIGHT] Used RPPC, 1907,
11.5 × 8.6 cm. Meriden,
Connecticut.

probably haven't missed the implications of multiplied corpses and their relation-
ship to sexual instrumentality. Uncle Fred, after all, did have ten children, which
is a record of a different but analogous sort. While prey was often hung, or strung
up along walls for viewing, some kills were documented more intimately, as we've
already seen in figure 94. The triumphant youth in figure 97 displays the pump
shotgun and the dog that assisted in the kill, but he has also propped the buck's
head up on his knee, as if it were resting. He's probably trying to show the number
of points, but the effect is peculiarly familiar, suggesting an unspoken intimacy
between the vanquished male animal and the young man.

In addition to showing off quantities of prey or unusual specimens, such as
a first buck or a black bear, taxidermy was another popular way of documenting
one's skill in the wilderness, and again, photographs preserved the proud moment
of achievement. I suppose we could say that if the animal is killed, skinned, stuffed,
and then photographed, it actually gets to die in triplicate—a perpetual multior-
gasmic effect for the hunter, who gets to relive the kill in print and in skin at will.
The practice of taxidermy documentation was largely a masculine pursuit, a way of

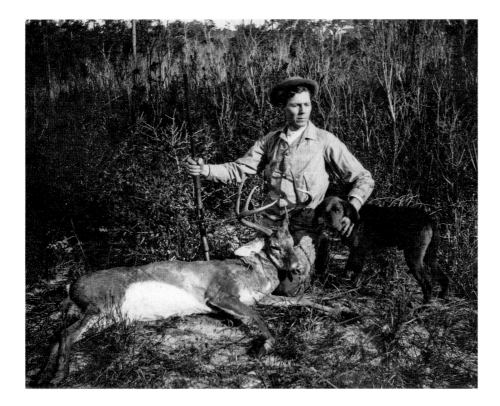

FIGURE 97

Unused RPPC, 1911,
10 × 7.7 cm.

asserting "evidence of the hunter's virility."[29] Not surprisingly, it was also common practice to display the slaughter so as to maximize its size. Arluke and Bogdan reproduce a photograph of a man between two huge mounted deer heads, which are probably not as large as they appear. "Placing an object in the foreground with a person in the background is an old sportsman's trick to increase the catch's dimension," they explain.[30] The photo in question is unintentionally funny, because the formally dressed man also looks stuffed and mounted in this setting.

THE GREAT WHITE HUNTER

In all of these hunting photos, the dog would appear to be incidental, but as with the class-distinguished pictures of chapter 2, this is not the case. Men of all classes and regions took pride in their dogs. Through their valuable assistance in the hunt, dogs are part of the process of amplifying masculinity. A good dog can make a white hunter look larger. Ted Owenby suggests another connection and attachment. He's speaking about southern hunters and southern men, but this comment

doesn't seem regionally specific: "No standards for upright behavior governed humans' treatment of animals; . . . dogs gave loyalty and friendship without expecting self-control or respect in return." Given the constraints of respectable family life, perhaps southern men might appreciate the physically exuberant affection of a dog.[31] It does not escape Owenby's attention that the slavish affection of the dog is naturally wedded in the southern, if not the national, imagination to the slavish affection of black people. As Jennifer Mason comments, "more than any other slave-animal comparison, portrayals of slaves as faithful dogs complemented the depiction of slavery as benevolent, masters as paternal, and slaves as content with their servitude."[32] Many hunting narratives so seamlessly blend the description of dogs and slaves that one is "indistinguishable from the other."[33] Despite the fact that owning a good dog was a matter of social prestige, hunters were capable of treating their dogs with the same casual cruelty and thoughtless affection that they might extend to their slaves.[34] The ambiguity that pertains to the dog, previously remarked in chapter 1—it is at once valuable and worthless, gutless and courageous, dirty and pure in spirit—is lent to African Americans.

Therefore, in addition to the class and gender dynamics we can see in hunting pictures, it's important to note that we have few photographs of black hunters. It is rare to find an antique image of a black man showing off his guns, dogs, and vanquished quarry. African Americans in the South would have been used as guides or beaters. They were responsible for tending to the dogs and horses, and, with the dogs, they helped find and drive the prey into view for the white shooters. They could handle the dogs, but guns and dogs were forbidden to them. "Because state laws prevented slaves from legally owning guns and tradition restricted their use to men, guns acted as talismans of white manhood. They represented the dominion of white men over slaves, animals, and the natural world," Nicholas Proctor tells us, not to mention their dominion over women and children.[35] Not only were African Americans prohibited from owning weapons, but in many states after the Revolutionary War, they were forbidden to own or run their own hunting dogs. A provision in the Virginia code in the nineteenth century "mandated thirty lashes for any slave caught hunting on his own with dogs in the forest."[36] When black men appear in hunting photographs, they are often situated as hunting guides or dog handlers, if they haven't already been relegated to the status of pets themselves, as we saw in chapter 3. Additionally, the white male model of masculine success was not extended to African American men, who for their part saw little reason to emulate the standards of their oppressors. Instead, African American writers and magazine editors coupled their ideas about masculinity to "a strong advocacy for citizenship and basic manhood

rights."[37] For these men, being masculine involved standing up for voting rights and refusing to submit to white racism.

Unfortunately, there is yet another way to explain the presence or absence of the black male in a hunting picture. He was the prey. Here is a powerful example of why we must attend to our history in photographs as well as in prose. I was stunned when I made the visual connection between hanging deer and proud hunters and the lynching photographs I sometimes use when teaching literature. For my students, who think James Baldwin's short story "Going to Meet the Man" is an exaggeration, one lynching picture puts doubters in the quiet. As Amy Louise Wood says, "The visual association between hunting and lynching photographs . . . underscores the ways in which lynching photographs bore within them both white supremacist ideology and the gendered elements of that ideology."[38] Hunting pictures and lynching pictures originate from the same domineering white masculinity that has generated so many other gender and racial practices. Michael Kimmel argues that the call to manhood was rooted in a rearguard action by white men who were concerned they were not enough of either.[39] Gail Bederman emphasizes that at the turn of the century, "civilization was seen as an explicitly racial concept." Advanced civilizations could be identified "by the degree of their sexual differentiation. . . . The discourse of civilization linked both male dominance and white supremacy to a Darwinist" outlook.[40] Thus the bellicose definitions of manliness that were tied to the hunting culture were reserved for white men only. White men not only hunted animals for sport and sustenance; they hunted black men well into the twentieth century, and seemed to enjoy it, as James Allen et al. have documented in *Without Sanctuary: Lynching Photography in America*. Much like the hunting photographs in which the hunter has hung the deer or bear from a tree, the corpses of African American males are displayed singly and in groups, hung from ropes as a group or presented as a charred pile.

One photograph in Allen's collection is labeled "The Hounds" and shows the law enforcement officials and bloodhounds who were used to track the African American quarry. The victims of these hunts were largely black men. In this case, the culture that turned African Americans into house pets turns on those same creatures by granting real dogs a change in status. By associating dogs and black men as similar kinds of domesticated animals, the condescension of domination exerts itself. When black men are turned into wild animals that have to be hunted down by the dogs they were once related to, the savagery of that condescension rips into view. The dogs now become more like a cultural male than the black male does, and so too the racism of the white male is lent to the animal, which participates in the hunt willingly, because the dog's participation is always guaranteed.

In some of these lynching photographs, the victim's genitals have been exposed, and castration was the implied or actual conclusion to this torment. Their brutalized bodies are pointed at and prodded by the white hunters and their admiring audience, many of whom smile for the camera. All the latent homoerotic features of the "men-in-fur" dog stories are rehearsed in these pictures. Capturing the sexual organ of the black man apparently transfers the awesome power of that organ to the white hunter. These lynching photographs are hunting trophies of white domination. In them, the edible bodies of animals have become the sexualized bodies of black men, who in turn are killed twice, thanks to shooting the death on film. As Wood notes, photographing the brutalized dead is also a way of domesticating and trivializing the death so represented. Pictures were to remind and display and document. Were lynching photographs, like animal hunting pictures, displayed in parlors and sitting rooms? Women and children were not too delicate to attend lynchings, so perhaps there would have been no compunction about displaying the visual reminder of the celebratory day in the home.

The suggestion that civilized people might have relished displaying these photos is difficult even to contemplate. We would like to think it a wild speculation. But it is also difficult for us to think about what "dog" and "animal" mean when the canine in question is used to hunt a human being. Typically, we think of dogs as loving and servile pets. But dogs trained to hunt slaves brought us "the Cujo effect," as Paul Youngquist so aptly names it, referring to the 1983 horror film in which a rabid St. Bernard becomes a human-flesh-eating monster. Youngquist offers a brief history of how dogs were employed by the British to hunt and devour black people, and only black people, to defeat the Maroon uprising in Jamaica in the 1790s. The carnage was so terrible that witnesses couldn't bring themselves to describe what they saw when the savagery of the dogs was loosed on women and children. The dogs were, in other words, terrorist instruments that racialized the attacks by animalizing the human victims.[41] It was not so different in the American South. In a succinct and hard-hitting chapter, Marjorie Spiegel affirms that hunting was not simply a literal activity; it was a social metaphor applied literally against black people, an expression of the power that the "ruling race or species exerts over the powerless. Prior to 1863 it was recognized that hunting down black people—'slaves'—was a sanctioned act."[42]

The visual force and metaphorical power of images and stories clearly suggest how our use of animals as cultural symbols is never neutral in its consequences for ourselves, for the animals, or for others. Arluke and Bogdan, for example, note the "dreaded comparison" (Spiegel's phrase) between animals and African Americans that African Americans reject, but they continue their discussion in a way that offers

sympathy for the plight of the animals.[43] Their intent is probably to call attention to animal suffering, but they do so at the expense of the human beings trapped within the comparison. In commenting on this lapse, I'm not suggesting that human beings are of more importance than animals. I am suggesting that such a lapse favors animals over humans, and in such a way as to perpetrate a microaggression[44] against African Americans that will not assist animal studies advocates who ask that we reconsider how we value different forms of life. Calls within animal studies for exploration of "animality," as well as concern about the integrity of animal life, must take cognizance of the ways in which white racism has so compromised a concept of "animality" that it may not be recoverable for dark-skinned or homosocial people.

DOG STORIES

As I've suggested in earlier chapters, photographs can join in cultural storytelling when a group of seemingly unrelated images are reconnected by their thematic relationship to a cultural narrative. In this discussion I've rewoven hunting pictures back into the larger cultural narrative, and in this final section I am strengthening that connection between cultural narrative and photographs by turning to the supply of dog stories that once were a reading staple for American adults and children alike. In the Fauntleroy pictures, it is clear that the story preceded and constructed the visual image, but then the image goes on to tell its own story about class and race (chapter 2), so that the synergistic relationship between image and text is apparent. The subliminal gender and racial agendas of the hunting pictures might have been obvious on their own, given a sufficient collection of these images in colloquy with each other, but the process of understanding those cultural forces more directly is greatly enhanced by dog stories. We have an abundance of literature about boys, men, and dogs that tells a story of cultural anxiety about masculinity and manhood well into the twentieth century. As in hunting pictures, the dog is an important element.

The Adventures of Huckleberry Finn is considered a classic American coming-of-age story, and it has served as an inspiration to countless American readers, and male literary critics, as well as providing an iconic reference point for American childhood. I commented earlier that Twain forgot to give Huck a dog in what is otherwise a perfectly calibrated boy adventure. But that's only literally correct. In fact, given the discussion of how slaves were animalized by their owners, it's now possible to see that Jim functions as the loyal dog in the story. Twain didn't forget to give Huck a pet after all. Huckleberry Finn rehearses the white male fantasy of escape and mastery, using an idyllic raft trip and the anguish of an escaping slave

as the backdrop for boyish adventures. Indeed, much of the pretext of the plot is the escape of Huck and Jim, and the hunt for Jim, which concludes with the satisfyingly servile man being reenslaved by Tom so that the whites can pretend to free him. Jim sometimes protests his treatment, but in the end he plays his part as the faithful companion to the white boys. Huck has a moral epiphany without actually having to act on it, and it turns out that Jim was free all along, so everybody lives happily ever after in the end. More to the point, the whiteness of white people is reaffirmed, if not the proper masculine and feminine roles for men and women.

All subsequent dog stories use much the same template. In Twain, real men want to remain boys. In the work of his contemporary Jack London, real men want to find themselves far from women, testing themselves against the wild and often exulting in that wild. Dog stories celebrate the instinctive animal nature that is either unleashed or vanquished in the brute encounter between man and the elements. Some of these stories are about sledding and hunting on the Alaskan frontier, and they overlap with later stories about boys coming to manhood through the hunt and a relationship with a good dog. Photographs of sled dogs and handlers became common commercial images issuing from the Alaskan frontier in the 1920s and 1930s, and they all look much the same—a long sled line of tiny dogs, surrounded by whiteness—probably because of the perspective necessary to document the activity. Dogs were essential at the turn of the century during the several gold rushes that swept from California northward, and the sled dogs became transitional transportation as the cold frontier was slowly settled.[45] Anthony Rotundo comments that "Jack London's 1903 novel *The Call of the Wild* drew much of its immense popularity from its message that beneath the veneer of all human training lurks a wild animal." London's Alaska stories were consumed by readers of both sexes, although even a casual reading of a Jack London dog story makes it clear that London is not calling women to exercise their wild selves. Rotundo underlines the masculinist nature of London's perspective, commenting that "the mere fact that an animal could be the hero of a book so eagerly read by men was revealing in itself."[46] *The Call of the Wild* and *White Fang* both invite us to an awareness of the "men-in-furs" narrative,[47] where the human-to-animal erotics reside explicitly in a relationship between male humans and other males, human or otherwise, what Lundblad would call an interspecies romance.[48] London was followed and imitated by a slew of "man-in-the-wilderness" novelists, among them Jack O'Brien, James Oliver Curwood, Thomas Hinkle, and even William Faulkner, whose portentous prose in "The Bear" carries the same erotic freight as his writing counterparts.[49] As Leslie Fiedler so famously exposed in *Love and Death in the American Novel*, the core American narrative is that of love between men, or, in London's case, between men and their wolfish dogs.

PICTURING DOGS, SEEING OURSELVES

As with hunting pictures that include or feature dogs, most of our dog stories are coming-of-age stories that instruct the male reader through the agency of dog love about how best to realize maturity and manhood. In the hands of cultural critics, many of these tales yield up their homoerotic charge, showing how the male canine body becomes the furry love object for the naturalized white man. Dogs cross back and forth between the human and natural worlds, and they guide the traveler between wilderness and civilization. They are bilingual, so to speak, and we follow them to learn that language and because we think there is something intrinsically wholesome about being in a relationship with the communication that a dog offers. By bonding with the dog, the white male gets to cross into his own animality and his own homosexuality.

In the Alaska and frontier dog stories, the dog and the man are interchangeable, at least spiritually speaking, and that dynamic is obvious even in so domesticated an adventure as Laura Ingalls Wilder's *Little House on the Prairie.* Pa is trying to keep vigil against an Indian attack, but he dozes off. "Don't let me do that again," he admonishes, to which Ma replies, "Jack was on guard," one of several instances where the alert dog comforts and protects the family in the absence of the father. Fred Gipson's most famous dog story is the tearjerker *Old Yeller* (1956), set on the Texas frontier after the Civil War. Travis learns to care for his mother and brother in the absence of his father, with the aid of a rascally but courageous yellow mongrel. Yeller stands in for the absent father as Travis grows into manhood. Not as well known, but a better book, is Gipson's *Hound-Dog Man* (1947), another Texas-inspired narrative about a boy and a dog, this time set in the early twentieth century. *Hound-Dog Man* plays all the key themes visible in hunting pictures in a way that normalizes the sexualized and racialized text, presenting a tender and complex view of the young man coming of age. In this way the novelist reaffirms why stories about "a boy and his dog" are such an important index to American cultural perspectives. I'm closing with *Hound-Dog Man* because it is a surprisingly complex rendition of the man-dog relationship. For all the savagery revealed in the photographs and the fiction, some people were undoubtedly motivated by a genuine love for dogs and boys in telling their stories, and there is a lingering sweetness in that telling. *Hound-Dog Man* is an exemplar of this bittersweet paradigm.

The hound-dog man of the title is one Blackie Scantling, and the narrator is twelve-year-old Cotton Kinney, who wishes his white hair were black and slick and smooth like Blackie's. Blackie just isn't the marrying kind, because a woman won't put up with what a hound will, and Cotton finds that he agrees with Blackie. "Give me my choice of a good coonhound or a woman, and I knew for certain which I'd take. Couldn't any woman start a coon trail."[50] More than anything, Cotton

wants a dog, and he has grown up on his father's stories about his legendary hunting dog, "Nigger." Here, black people are associated with something good, the beloved hunting dog. Late in the novel there is discussion about whether the famous hunter Mexico Jesus should get to eat using the same tableware as white folks; Fiddling Tom announces that "a man's a man . . . irregardless of his skin color" (207), thus ending the discussion. Still, the characters' names are saturated with the casual racism of the era. Towheaded Cotton is the innocent white boy, Blackie Scantling is the renegade bad boy, and it's appropriate that "Nigger" is the name of the hound from Papa's childhood. Blackie joins the hound and the black man on the wrong side of the class divide. Gipson reflects typical usage of the time in the same way that he reflects the coercive truisms that women are the domesticators of boys and that black people are more like dogs than women are. You can't treat women mean and get away with it, Blackie comments, whereas you can do all manner of horrible things to a dog and it is still "ready to lick your hand or warm your feet of a cold night" (12). Naming a favorite dog "Nigger" would have been a natural gesture in this cultural context.

Blackie shows up at the Kinney homestead with his coonhounds and invites Cotton's Papa to go on a hunting trip, but Papa is "tied hand and foot" by his domestic responsibilities to his wife, Cora. Over Cora's protests, Cotton and his best friend, Spud, get recruited for the big hunting trip. Cora delivers the arguments of the "civilizer": "You want our boy to grow up to be nothing but a no-account fiddle-footed rake? . . . What's [Blackie] ever done? Has he ever married and tried to make a home? Has he raised any children and done a lick of work to feed and educate them? What's a man good for if he dodges that kind of duty?" Papa's response is simply that "a coon hunt now and then ain't going to ruin him. I was on a few myself and got over it" (19–20). He agrees with Blackie that Cotton needs to get out and "prowl the river banks" and learn how to take care of himself in the woods.

Spud brings his fiest dog,[51] Snuffy, who will prove himself the courageous equal of the rangy coonhounds, and the great boy adventure begins. Blackie wrestles with an armadillo, challenges a bull, swims with an enraged boar coon, and then confronts the scariest of creatures, the man Ed "Hog" Waller. Waller will later prove Blackie's observation that "they's varmints prowling these woods . . . that's a damned sight more decent acting than some humans I know" (53). In between, Blackie and the boys dress their kill and cook up fireplace feasts, and Spud and Cotton drink in Blackie's outrageous hunting stories. "We felt wild and free, 'way off out here at the back side of nowhere, a million miles from schoolbooks and face washings" (51).

And yet the story quickly evolves a second narrative, one that offers more than the "boys-will-be-boys" trajectory that seemed imminent at the start. Blackie and

PICTURING DOGS, SEEING OURSELVES

the boys come upon Dave Waller, who is breaking a horse by riding him in the creekbed. Assisting him is his pretty sister, Dony. Blackie gives her a look and commences a conversation that makes Cotton feel that he may not know Blackie as well as he thought. "You reckon a man could stir out something if he was to come a-hunting down in your part of the country?" Blackie asks her appraisingly. "He might," she replies, "providing he knows how to go about it" (47–48). Cotton suspects that "she and Blackie had been saying one thing and meaning another," and in fact, as the narrative proceeds, the double text builds, tacking back and forth between hunting language and courtship language. Through the hunt experience, sexual experience comes to occupy the foreground, as Blackie and the boys cross the line between civilization and wilderness, moving back and forth from camp-sites to homesteads in their travels.

In the process, the term "bait" takes on multiple meanings. Cotton laments that he never got "a full bait of hunting talk" (14), and Blackie shows Spud and Cotton how to bait a trap for a coon using empty mussel shells. "Old Coon's curious about play-pretties as a woman," Blackie explains to the skeptical boys (50). Grandma reports that she's doing mighty poorly, and tells the boys that it will be "the Almighty's mercy if I last to eat a bait of poke greens come spring" (101), while Hog Waller shouts at his wife, "I'll learn you to go spread your bait around" (234). When Blackie finally decides to marry Dony, he says, "The slickest kind of an old fox'll keep fooling around a bait till he finally gits caught" (242–43). Blackie's courtship of Dony commences through hunting metaphors. "You've hit a cold trail," Dony tells Blackie, who responds, "Chickabiddy . . . you sure got a fancy bait laid out, but this old fox has robbed too many pretty sets to stick his foot in a trap now" (150–51).

As a verb, "bait" means to tease, torment, lure, or entice. It is also a noun, referring to literal or figurative sustenance, as when Cotton wants a full "bait" of hunting stories. "Bait" can take on a gerund form, as when my dad used to speak of "baiting the horses," meaning to give them grain or hay. But the noun can also refer to anything that serves as a lure or snare, and in this world women are prey, bait, and the providers of bait—appealing but dangerous creatures. By the end of Gipson's story, Cotton is ready to go home, having had enough of the menacingly charged world of adult passions. He has proved himself in the hunt. More important, Cotton gets his dog at about the same time that Dony gets her man. She had begun taming the wild black pup, who finally takes up with Cotton. Dony gives him the dog, saying, "A boy and a dog go together. Like pepper and salt. Like—husband and wife. If I ever have me some fine boys, they're all going to have dogs" (231). Like heterosexual marriage, there is a natural marriage

between a boy and his dog, which is what all these pictures and stories have been talking about.

Thus *Hound-Dog Man* dramatizes a number of the themes that animate the hunting picture. In the hunt, boys aspiring to manhood escape civilization, at least temporarily, and test their mettle against the wilderness. Hunting and killing animals is great fun and sometimes thrillingly dangerous. This coming of age is for and about white boys, and the best kind of woman approves of it and understands how a boy and a dog need to grow up together. Men of color occupy an uneasy position in this 1947 rendition, which records the casual racism of the time. But the novel also critiques hunting culture as well, which is why I think it is such an interesting story for our purposes. Much of the shallow circus appeal of Blackie's way of life evaporates against the reality of adult jealousy, drinking, lying, and spousal abuse. Cotton gets to see how a real man behaves when his father intervenes in a drunken brawl, and the loving, responsible relationship between his mother and father restores his own sense of security. The hunt, as it turns out, is about more than evading women and celebrating one's animal passions. It is also about entering into maturity and responsibility.

The pleasures of stories like this are multiple. They celebrate the innocence of childhood and the maturation of a boy into a man. They advise right-minded women how to be good mothers and wives to their adventuresome men. They also celebrate a culture where bonding occurs through tall tales and physical adventure, in natural settings that many readers could only dream about. There is a "paradise lost" quality to them, as writers recall sparkling forests where the water was always pure, dogs were always loyal, and a boy could grow straight into some old-fashioned values. As a girl who loved dogs and horses, I read them all and loved them, never realizing that I was supposed to be the shrewish wife waiting at home in the cabin.

6

WOMEN CROSS THE LINE

The emergence of masculinist ideology at the turn of the century is documented and illustrated by hunting photographs. Men were urged to emulate the activities and postures of the rugged outdoor male. Some men and boys did this of necessity, but for others the imperative was less clear cut. If the visual inspiration wasn't sufficient, or if their own memories of what was entailed were vague, men and boys could consult a burgeoning literature—biographies (perhaps closer to hagiographies) of pioneers and backwoodsmen and tales of the wild life, in particular, dog stories. Larger-than-life dogs became love objects for the rugged outdoorsman or boy coming of age. As we've seen, these stories articulate the same cultural preoccupations with racial breeding and gender that are visible in the hunting pictures.

The romance between men and dogs is long-lived in photographs as well as in narrative. In a recent dog story by W. Bruce Cameron, *A Dog's Purpose: A Novel for Humans* (2010), the canine narrator is reincarnated into the lives of a series of dog owners, only to return to his "boy," Ethan, at the end. Now a very old man, Ethan recognizes the essential soul of the animal as his first childhood companion and he dies peacefully with "Buddy" at his side. The entire novel encapsulates that fond sentiment that there is something special, if not downright mystical, about a boy and his dog. Of all the dog stories I've read, I can't recall a single one where the

story involved a girl who loved dogs. As she concludes her discussion of the *Lassie* TV series, Marjorie Garber notes the few culturally visible places where the relationship of girls to dogs has been acknowledged: Dorothy went to Oz with Toto, while Little Orphan Annie had her dog, Sandy. That's it. What makes this glaring omission so inexplicable is the nineteenth-century view that women were the appropriate domesticators of children and pets; you'd expect that fancy to have been fodder for any number of fictional explorations, both in children's literature and maybe even in adult literature. However, the invisibility of women (and girls) in the world of words is long-standing, as we see in annual articles that review how many books by women are published by major publishing houses, and how many women are asked to review books in major cultural venues.[1] While this is not the place for an in-depth discussion of this issue, it is certainly grounds for reinspecting the visual records in an effort to restore balance to our cultural narrative and history. Take figure 98, in which a teenager kneels with a rangy hound dog that is chained up near a kennel. The smiling girl is nicely dressed in a skirt and a white blouse, her arm draped affectionately over the dog's back. She doesn't seem worried about getting dirty, or about the smell that emanates from the doghouse straw that surrounds the kennel. Yet according to fiction, she really doesn't exist, and she assuredly does not exist if we ask the question: does she hunt with this dog?

In this chapter, I argue that literature lets us down but that pictures tell the story, and in fact are essential to a fuller view of the story of women and dogs. While we have an abundance of dog stories articulating male culture, we have very little that suggests the importance of dogs and animals—or the importance of the natural world—for women. In order to get a more realistic view of women's lives, we literally must turn to pictures, which show us women in what could be construed as occupational settings with their dogs. Hunting pictures of women and dogs are a subset of these photographs, where women clearly cross the line between the traditionally defined masculine and feminine worlds.

To further complicate the discussion, the visual evidence of women hunting also challenges the emergence of feminist perspectives in animal studies. To summarize briefly, ecofeminism suggests that there is something essential about women, or the feminine, that inclines toward a holistic and nurturing view of the world. From this basis, feminists have argued that our treatment of animals is symptomatic of a culture of death that is sustained by masculinist impulses. Animals and women are together subject to domination in a continuum of violence that shatters interspecies trust, falsely elevating human power into a license to subdue, exploit, and kill creatures for pleasure and profit. Hunting, to be specific, is a symptom of

PICTURING DOGS, SEEING OURSELVES

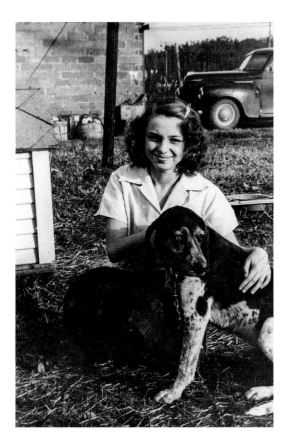

FIGURE 98

Snapshot, 1940s, 6.2 × 9.8 cm.

this masculine thirst for blood power.[2] As we saw in chapter 5, when viewed through the hunting scope, all prey is feminized and all hunters are male.

But while this dynamic may ring symbolically true, and while real men may have tried to make it literally true, it is not. In addition to my historical pictures, recent scholarship on women and hunting argues that women have always hunted and still do. Nicholas Proctor says that in the South, bestowing a boy's first gun was a coming-of-age prerogative reserved for fathers or male relatives. Women "never presented or received guns themselves. They could not bestow manhood." But when young women did take to the field as hunters, they tended to be unmarried and "at the dawn of sexual maturity . . . so they did not pose a threat to the dominant paradigm of gender duality," Proctor concludes.[3] Arluke and Bogdan note the presence of women hunters in the RPPC record, and they include a picture of a young girl holding a gun, although they note that the woman hunter was unusual in the male-dominated landscape.[4] At the dawn of the twentieth century, the number

of women hunters was estimated to be around 10 percent, up from 3 or 4 percent, and that number is apparently still accurate today.

In addition to several recent volumes about women and guns that take for granted women's hunting,[5] Mary Zeiss Stange confronts contemporary feminism and contemporary masculinism with the historical and present-day reality of women hunters. In *Woman the Hunter* (1997), Stange argues that we must courageously acknowledge that "the central paradox of hunting is the painful paradox of life itself: some of us live because others die."[6] Stange, who doesn't tolerate any silliness about hunting as a male-only activity, considers it as natural for women to hunt as it is for them to give birth or suckle a child. She sees women's hunting as part of a healthy participation in ancient, mythologically rendered life forces. The vigor, and sometimes defensiveness, of Stange's presentation suggests that the meaning of the hunt, as with the meaning of women, is as culturally contested now as it was in the time frame I'm covering here, 1860–1950. When dog stories were not simply a form of adolescent literature but something adult men read for encouragement and instruction, writers could not bring themselves to write about women hunters with anything but a sneer, hence the absence of dog stories that valorize the emergence of a young woman as huntress. For example, in Thomas Hinkle's *Bugle: A Dog of the Rockies* (1929), reckless Mary decides to track a bear on her own, but she foolishly forgets her rifle at a crucial moment and has to be rescued by her lover and her dog, at great peril to them all. In *Baree: The Story of a Wolf-Dog*, by James Oliver Curwood (1917), a young Native American woman comes of age through attempted rape and then rescue by a nice white man. In *The Call of the Wild* (1903) there is a stupid woman named Mercedes whose vanity and ignorance are the lethal elements that destroy an entire dog team, as well as herself and her brothers. The Mercedes automobile was first marketed in 1901, so it's possible that London named his repulsive female deliberately. She insists on riding on the sled even when it's obvious that the starving dogs are incapable of pulling her.

As I hope is clear, the determined appearance of the woman hunter is a challenge both to traditional cultural myths and to animal studies perspectives on the ethical treatment of animals. Hunting pictures and dog stories are presented in the previous chapter as occupational cultural artifacts. They document the proper role and relationship of males and the natural world. While women and men often occupy the same space in a photograph with a dog, sometimes they do not, and the differences help us further understand the versatility of the dog and the rigidity of our gender role expectations. Not only does the dog cross from canine to human, but dogs have another boundary-crossing talent. They fit into both the masculine world of the outdoors and the feminine world of domesticity. They can move from

boys to girls and speak both languages. So, still watching for the dog in the picture, what do we find when we look specifically for women in relationship to that dog?

OCCUPATIONAL PHOTOGRAPHS

Occupational photographs usually show the subject in his or her work garb, holding the tools of the trade, or posed for a moment in the work activity to have a portrait made. Sometimes the product of the work is visible, even proudly displayed, as we've seen in the hunting pictures. For example, in *As We Were: American Photographic Postcards, 1905–1930*, Rosamond Vaule offers an engaging range of photos that document activities indoors and outdoors. It is much more common to find images of men than of women at work, from industry to agriculture, although as the twentieth century progressed, women appeared more frequently—as nurses, telephone operators, or factory workers. But because women transitioned slowly from a home-based economy to the workplace, the variety of images of women is somewhat different from those of men, simply because women were engaged in different activities. It's rare to find a picture of a white woman cleaning house or cooking, although those might have been typical occupations for her, depending upon her social and economic status. Moreover, those kinds of images would have required an interior shot, and while the home was a place of work, it was not necessarily considered the kind of work that one would proudly document, unlike logging, butchering, or building construction. But just as young boys were posed for their proper male role, so were young girls. Instead of an oversized shotgun, girls might be carrying an oversized doll, as in figure 99, where the dog seems like a natural accompaniment to child play. In fact, it seems that a girl with a doll is as common a visual trope at the turn of the century as a boy with a gun. Family pictures of women, children, husbands, and dogs, then, would have been a natural outcome of early domestic explorations with dolls, and we might want to consider them as a form of occupational image for women.

We can find women positioned with dogs in some familiar and characteristic settings that might indicate their domestic vocation. In figure 100, a group of merry women are sitting on a front or side doorstep with an amiable-looking black and white dog. "Tippir is sending u his picture. He says Blanche come out and make us a visit. Tippir." They brought out a chair for the picture, but otherwise the moment looks spontaneous because they are all wearing housedresses, and one of them has a pinafore apron over her dress. It's easy to imagine that they interrupted their chores in order to send their playful message to Miss Blanche Makley of New Carlisle, Ohio. In the staged but unstudied photo in figure 101, Sarah Mitchell sits

FIGURE 99

Unused RPPC, 1910–1918,
8.3 × 6.1 cm.

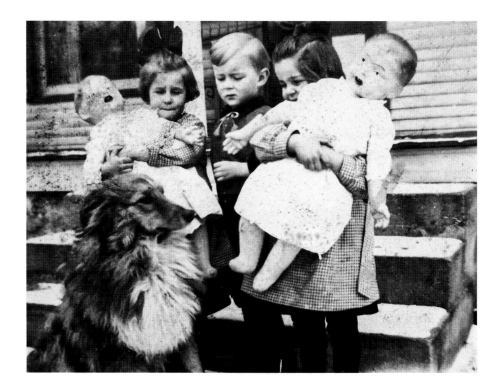

on her back steps, gazing fondly at a stately dog. She has put a pansy in her severely drawn-back hair, and the basket of apples has been tilted so we can see the harvest. Sarah holds an apple in her right hand, while her left embraces the dog. While the kerosene can (?) on the step may suggest an improvised moment, the dignity of the woman and dog override the extraneous detail. Sarah's gaze makes it clear that the dog is central to the picture. Behind her, running diagonally on either side, is a taut string that supports a morning glory or sweet-pea vine on her left and possibly also on her right. Despite the three-quarter sleeves of her serviceable calico dress, we can see that her arms are sun-tanned. This woman worked outdoors as well as indoors. Women not only gathered the harvest; they were responsible for preparing and "putting up" that harvest against the winter. Whatever flowers are about the home are also likely to be her doing. Her occupation as mistress of the home is gently indicated in the picture, and we have all the essential elements of the American dream here—the home, the dog, and the (implied) apple pie, as well as photographic confirmation of her womanly identity within the confines of that dream.

Women who worked in the public sphere also had their pictures taken, and, like men, they sometimes displayed the tools of the trade in the photograph. As

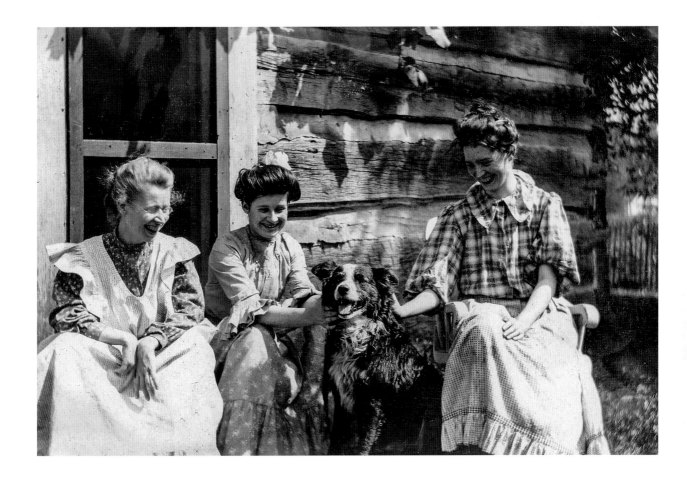

FIGURE 100

Tippir. Used RPPC, 1907,
13.8 × 8.3 cm.

Joan Severa demonstrates, working women made every effort to dress fashionably, even when the actual workplace militated against delicate lady garments.[7] But until women became a regular part of the world of commerce, most women seemed to opt for a photograph that, if it did not verify her role as a wife and mother, established her credentials as a lady, a refined woman free from economic necessity, redolent of decorative accessibility. Women of all economic classes usually went to some trouble to present themselves fashionably, and with the accoutrements that would suggest a status of gentility and good breeding. In figure 102 a proud young woman from Kansas City poses with a dog that is given equal, eye-level billing with her. She is neatly dressed, her lace collar embellished by a pretty brooch. Her dark dress with its slim sleeves suggests a date in the 1880s. But the wicker chair for the dog is more typical of the 1890s or 1900s, as is the brooch at her collar and her hair. Maybe she updated her wardrobe for the picture, perhaps adding the lace or a detachable

FIGURE 101

Sarah Mitchell. Cabinet card,
1890s, 11.3 × 10 cm.

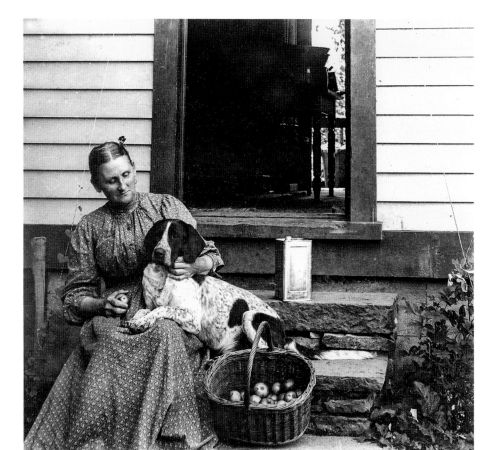

lace collar to what otherwise might have been a housedress. Her hands tell us more, however. They look darkened and chapped, as if she is used to rough work indoors or outdoors. The same is true of the tight-laced young woman in figure 103. She is smartly turned out in a white lawn shirtwaist that is cut in the Gibson Girl "pigeon breast" style, and she wears a crisp dark skirt that is short enough to show her button-up boots, which are well shined. Her elaborate hat is anchored with a huge bow at the back of the neck and acts as a frame for both her puffed-up hair and the artful strand that curls over her shoulder. Everything she is wearing can be found in the Sears catalogue of 1909,[8] so she really is fashionably up to date. Her dog leans comfortably toward her and, posed on the threshold of the house, clearly seems an important part of her self-presentation as someone with a good home. Her hands, however, are working hands. They are stained and rough looking. Like the proud girl in figure 102 she has a job—mill worker? tobacco harvester? dairy farmer?—but

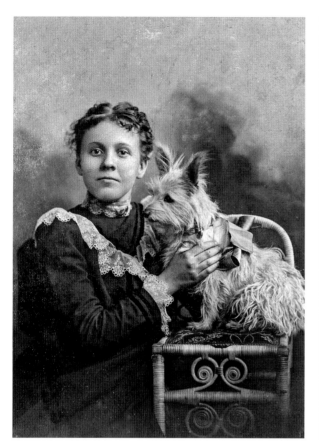 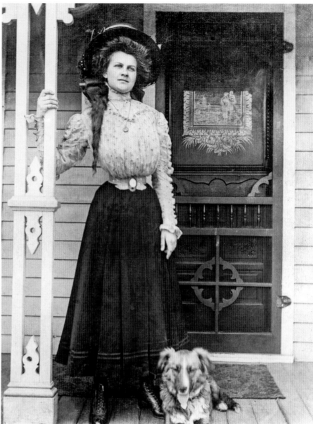

this is not an occupation she wants to document. Neither she nor her Kansas City counterpart is wearing work clothing, but both women's carriage indicates the class and status they wish to occupy. The Kansas City girl has a purebred dog and seems quite comfortable with it, if not plainly proud of it, although we don't know if the studio lent her the dog or if it's hers. Either way, in both pictures the dog appears as a companion and character reference for these women.

A more jarring image is presented in figure 104, perhaps because it brings the world of women into collision with the world of men in such a visually awkward way. Here we are, back in the world of women's domestic work. These women are plucking the birds that have been delivered by the hunt. There is a pile of birds at their feet, and a little boy watches intently. Two of the women are not plucking but are simply sitting with the birds draped across their laps. The women's expressions don't suggest a cheerful or happy activity. The woman on the right looks

FIGURE 102

[LEFT] Cabinet card, 1890s, 9.9 × 13.9 cm. Photograph by Mitchell, S.W. Cor. 10th and Main Street, Kansas City, Missouri.

FIGURE 103

[RIGHT] Unused RPPC, 1907–1912, 8.3 × 11.3 cm.

FIGURE 104

———————

Cabinet card, 1880s,
14.2 × 10 cm.

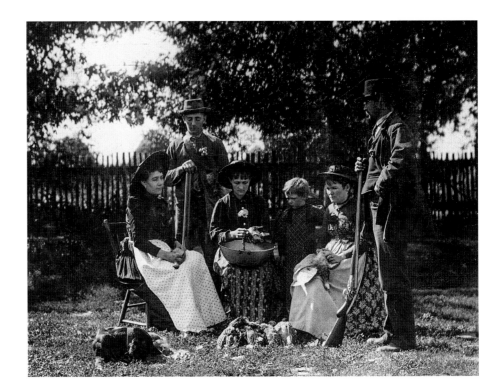

stunned. The woman in the middle is looking down, intent or sad, it's hard to tell. Only the woman on the left looks mildly comfortable. There is perhaps a slight smile playing about her lips. What is jarring is the presence of the men with their shotguns, as if the preparation of the birds needed monitoring somehow. Dogs can add warmth to an image, but in this case the dog is asleep in the foreground, nearer the women but not engaged with any of the figures. It's possible that the entire group in figure 104 was happy about the game and the future suppers it represented, and that everyone is posed to look serious because it is a serious moment for them, and that that's all there is to it. Still, the picture is quite unusual, bringing the triumph of the hunt back to the world of women and almost into the kitchen. The effect is all the more striking when we consider the various ways in which hunters displayed their catch in the photographs of chapter 5. They stand proudly with the kill; they string it up for view; sometimes they lie right down with the carcasses and grin about it. In figure 104 there is an air of coercion about the picture precisely because the males are standing and two of them still have their weapons in hand, and because they encircle the sitting women, who in their postures look more like captives than happy housewives.

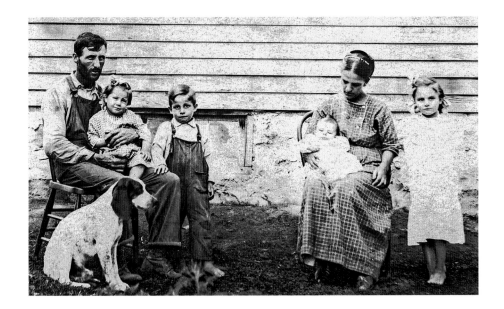

FIGURE 105

Unused RPPC, 1907–1912,
13.7 × 8.6 cm.

The position of the dog or its absence can be telling. The family photo in figure 105, for example, suggests that the dog belongs to the world of the men and boys, and there's a space between the male and female adults that produces an odd visual staging. This space could be accidental, or it could be a way of distinguishing gendered realms that some photographers and subjects adopted. Gender-dispersed staging is not uncommon, although in the case of figure 105, the child in the father's lap appears to be a girl. In figure 106 there is a similar gap between the participants. The woman and dog stand to the left of the open front door, while the husband stands alone on the right. She is dressed in the "uniform" of the Standard Church of Canada, while he is dressed in a black suit without a tie, the prescribed garb for that religious community. So they have put on good clothing for this snapshot, taken in the early 1930s. Here is another divide, but it's probably a product of the practical, if not hardscrabble, life these people led, rather than any particular sign of estrangement. Sentimental public display of a personal relationship would have been uncharacteristic for this or any couple in this setting.

And where is the dog? Well, the dog's head is partially camouflaged by the flowers, but it has voted with its feet about where it belongs. This is Sailor, the farm dog who helped my dad train calves to lead, and these are my great-grandparents, Ida Melissa and John White. In this photo the Whites are standing behind a remarkable bank of flowers, which look like dahlias. These are part of the domestic artistry of Mrs. White. In the evening, after a long day that started before dawn of

FIGURE 106

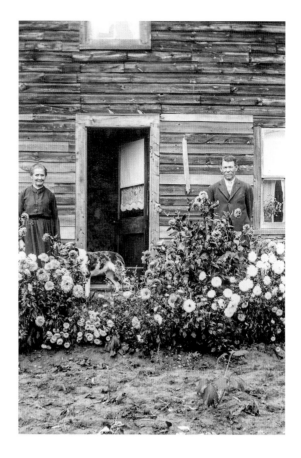

The Whites and Sailor.
Snapshot, 1930s, 6 × 10.3 cm.
Photograph by Ibra F. Morey.
Harlowe, Ontario.

cooking, chopping wood, washing clothing, and cleaning house, she carried buck-ets of water to her flowers, and there was nothing practical about that labor, but she loved flowers and willingly added to her workload to have them. She also fed Sailor, grained the cattle in the winter, and tended the chickens. Dad went woodchuck hunting with this dog, and probably my great-grandfather did, too, and the dog did what dogs do. It crossed back and forth from male to female worlds, from human to canine, and in the moment of the photo, stood with the human it felt closest to. Sailor, my Dad reports, was attached to Ida White. Why are this man and woman standing so far apart? It may just be an accident, or maybe they wanted the open door to be visible, as a gesture of welcome and to show that they had wallpaper, which might have been an item of decorative pride. What is probably more im-portant in the picture is where the dog is standing, which is why I commented on the position of the dog in figures 104, 105, and 106. The dog can tell us where the relationships are.

By the same token, the absence of a literary tradition about women, dogs, and the natural world is telling. Images of girls as future mothers, or of women pausing in their routine chores as homemakers or as occupants of a world of ladylike fashion fit nicely with the literary version of domestic womanhood, and they also reflect how many women spent the days of their lives. It's a true story. But it's not the entire story. Clearly, dogs were part of women's lives. Yet, although women founded and ran humane societies, if from behind the scenes, and now make up the primary workforce in animal rights organizations,[9] and although women were largely responsible for the care of pets in the home, there is no body of fiction about girls and dogs. Far from reflecting life, or extending an imaginative critique of the conventional expectations for women and girls, the literature offered to young women at the turn of the century and well into the twentieth century reinforces traditional social and psychological roles.

In his study of childhood, Steven Mintz uses Huck's raft as a symbol of childhood, assuming that that literary moment both reflects and expands lived experience. However, that raft also symbolizes the escape of white males from white women. Some of the comedy extracted from Huck's adventures features Huck uncomfortably cross-dressed as a girl. He's not very good as a girl, and thus his bona fides as a real boy are reinforced by his awkward efforts to imitate the prissy domestic gestures that define femaleness. No girls are allowed to cross-dress as boys, however, and enter into the adventure. Later in *Huck's Raft*, Mintz makes clear that while Americans were worried about boys being "overcivilized," girls were taught through literary and other cultural means that their job was to transform the beast and redeem "adult curmudgeons." Mintz unselfconsciously comments that the girl characters featured in books like *Anne of Green Gables* (1908), *Pollyanna* (1913), and *Rebecca of Sunnybrook Farm* (1903) were not passive. They used their "ingenuity and charm to alter adult behavior."[10]

Mintz is accurately reporting what was offered to girls as models for childhood and early adulthood, but his own choice of symbolic moments in literature replicates the dominance of the boy's adventure story as the site of evocative articulations of American childhood. The childhood literature for boys encourages them to develop manly strengths and skills completely apart from relationships with women, whose literature confines them to roles that will support rather than challenge male identity. As *Little Women* has famously taught generations of girls up to the present, a girl's biggest challenge is to conquer her own pride, ambition, and creativity, so that she may enter into the gracious service of others. In real life, girls have rooted for stalwart, headstrong Jo, only to see her subdued and married off to a man old enough to be her father. Firmly enchained by the

romance plot, women are ceaselessly instructed by fiction and expository writing that their greatest adventure will be courtship and marriage, and that a woman's greatest test will be to sublimate her emotions and imagination in order to serve her family. Her virtues are best exercised in the home, behind the white picket fence that shelters her and her domesticated flowers from the rude world beyond. As Nancy Cott observes, equating the public sphere with men suggests the possibility that women spent their entire lives behind closed doors, an absurdity "easily countered by pictorial evidence." Cott points to genre paintings depicting women working outdoors as peddlers or farmers, noting that such visual evidence directly contradicts the "many contemporaneous texts in which women dwelled only at the private domestic hearth."[11] As I will demonstrate, photographs also provide visual evidence of the wider, richer lives of women.

WOMEN, GUNS, AND HUNTING PICTURES

We might suspect that this relentless advice from literary sources was, in part, a response to alarming trends toward female independence. Women who crossed the prairie and settled the western frontier were hardly the shrinking flowers depicted in fiction and popular magazines. Frances Cogan makes a spirited case against the hegemony of the "cult of true womanhood," suggesting that literary critics and historians have done us a disservice by overstating the impact of this "cult." A model of real womanhood was offered to mid-nineteenth-century women who may not have been radical feminists but who eschewed the frail flower of "true womanhood" for a more robust and independent persona. Although some daring souls pioneered what came to be called the "bloomer" in the early 1850s, and the National Dress Reform Association created its charter in 1856, most women adapted their clothing to their own circumstances, attempting to address practicality and fashion at the same time. Women settling the frontier shortened their dresses or wore bloomers; they wore work boots, Indian moccasins, or went barefoot, but once they came back into contact with civilization, "proper and up-to-date modes of dress were known and respected and were followed as soon as conditions made it possible, even though it was sometimes a year or two in newly settled territory before this could happen."[12]

Cross-dressing women in the Revolutionary and Civil wars challenged the conventions of femininity, proving themselves utterly capable of self-defense and warlike behavior. But they—and photographs documenting cross-dressing—are relatively rare. Figure 107 is labeled on the back as "Ruth Williams & Fritz, 1878." With her hair parted on the side and slicked closely to her head, and her practical

PICTURING DOGS, SEEING OURSELVES

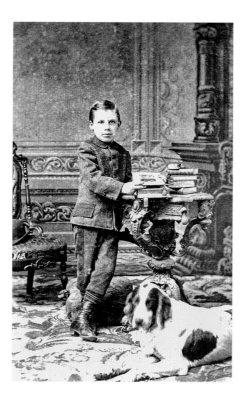

FIGURE 107

Ruth Williams & Fritz.
CDV, 1878, 5.9 × 12 cm.
Photograph by Barr & Wright.
Houston, Texas.

pants, boots, and jacket, unrelieved by any telltale lace or jewelry, Ruth can easily pass for a boy. She is posed in a typical cross-legged style we usually see only in men and boys, and her setting is the library, not a bowery garden, thus emphasizing her educated mind. The dog appears to be purebred, possibly a setter, and would be a natural accompaniment to a young person of breeding and education.

Despite its relative scarcity, the image of the cross-dressed woman warrior was a source of titillation as well as anxiety. A woman who could handle a gun and herself in wartime might very well have a compelling claim for full citizenship.[13] At the turn of the nineteenth century, several women became famous as sharpshooters. As Laura Browder notes, the most outrageous of these women were suspected to be of questionable morals or of mixed race. Calamity Jane (Martha Jane Cannary), for example, was white, but she dressed in men's clothing, bragged about her exploits, and apparently discarded husbands and lovers as quickly as she dispatched liquor. Annie Oakley, however, presented herself as a Victorian woman who happened to be a great shot. She eschewed women's suffrage, rode sidesaddle, never wore pants in public, and made her own costumes. But Calamity Jane actually lived that tough, hard-bitten life, while Annie Oakley was a performer in a Wild West show. Not surprisingly,

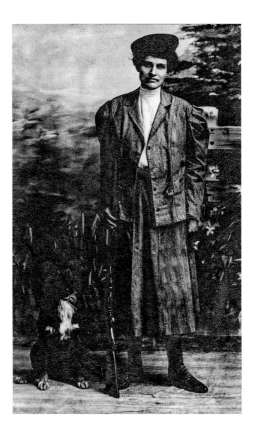

FIGURE 108

Mrs. Henry Hasselton. Cabinet card, 1910s, 9.6 × 14 cm. Peoria, Illinois.

Oakley was often compared favorably with the several reckless and racially tainted female sharpshooters who preceded or were contemporaneous with her. While the gun was the crucial piece of costumery in this cross-dressing, Oakley's presentation so domesticated the weapon that she could be regarded with pride, not alarm.[14]

These daring women, however, did not inform fictional presentations for girls about how to become a woman. They were the exceptions, and the most successful of them, like Oakley, took care with appearances that would not violate the expectations for womanly modesty. Most women in hunting pictures look womanly despite the weaponry. Here, for example, is Mrs. Henry Hasselton (figure 108), who took to the studio for her hunting portrait. Holding a shotgun, she appears to be wearing an oversized jacket, but her skirt is relatively short, revealing sensible flat-heeled shoes and spats or leggings to conceal and protect her legs. Interestingly, she is not accompanied by a hound dog but seems to have a spaniel sort of mutt with her. The scarcity of photographs of cross-dressed women hunters in the late nineteenth and early twentieth centuries suggests that no matter how daring their inclinations and

PICTURING DOGS, SEEING OURSELVES

activities, most women hewed to a modest middle line in choosing their attire, even when the long skirts and white blouses were not particularly practical or helpful when on the trail. Hunting attire for women migrated slowly toward practicality.

The jaunty young woman in figure 109 is wearing a long skirt girdled with her ammo belt and holding her shotgun. Observing the conventions of studio portraiture, however, she has brought out a chair for her dog as they pose in front of the evergreens. Scribbled on the back of the unmailed card is a largely unintelligible message to a friend: "These are the last three one I got. One have to take the old darke. Ha! Ha!" Despite the deliberate and overt hostility of men toward women in the field beginning in the early twentieth century, pictures of hunting groups from the late nineteenth century occasionally include women. In these group pictures, several persons may hold a weapon, while others may not. If a woman is holding a weapon, it seems reasonable to assume that she is one of the folks who will go into the field as a hunter. Or, at the least, her prowess may be part of the explicit iconography of the photograph. Figure 110 features a group that would bring a smile to any stalwart member of the National Rifle Association. Wobbly writing on the back of this RPPC identifies this as Mr. and Mrs. Snider from Wood County, Ohio. In this carefully staged shot, the family weapons are propped up against a length of sturdy rope that is secured across the front of the group. The assembled firepower is impressive. There are two small-caliber single-shot rifles, three pump shotguns, one lever-action rifle, and two revolvers. Mother and son are wearing ammunition belts. The dogs are alert and well cared for, and because they could be bear-hunting dogs, there is an added charge to the portrait. Every family member wears a hat, and, to judge from that along with Mr. Snider's attire, it seems clear that this family was assembled for a formal, dynamic hunting picture showing every member as armed and participating.

Like figure 110, figure 111 is unusual. We don't usually see a group of women positioned as hunters without a man in evidence, although it is quite typical to see women in the field in their long skirts. In this portrait, the women's white blouses and dark skirts are immaculate, their faces resolute, and, with those rifles, this group of forthright women are ready for more than a botanical adventure. The man and woman in figure 112 are displaying four young bucks. In the tradition of trophy display, the deer carcasses have been grouped and positioned with heads facing up and forward, and both hunters are displaying lever-action rifles. The woman is wearing a practical shortened skirt and hunting jacket. There appears to be camping equipment rolled up in the background. Something about their serviceable attire suggests that the venison represented here will serve a household and not simply an ego. The correspondent who used the RPPC had

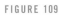

FIGURE 109

Used RPPC, 1908, 9 × 11.5 cm.

FIGURE 110

Mr. and Mrs. Snider. Used
RPPC, 1909–1918, 11 × 6.7 cm.
Wood County, Ohio.

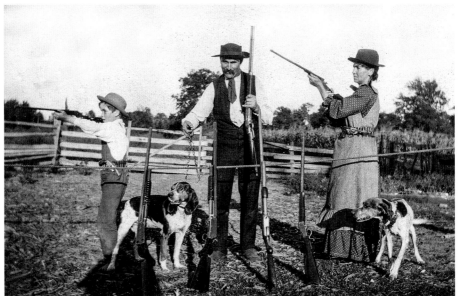

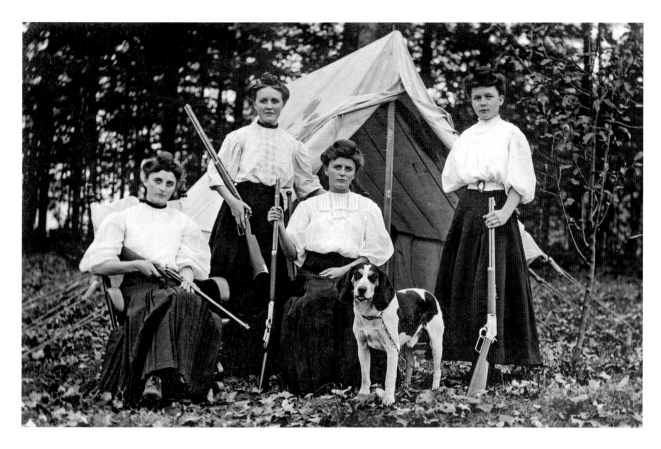

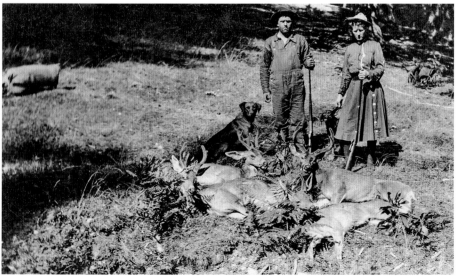

FIGURE 111

[ABOVE] Unused RPPC, 1908,
10.7 × 6.5 cm.

FIGURE 112

[LEFT] Used RPPC,
1910–1918, 13.7 × 7.2 cm.
Photograph by F. F. Sasman.
North Bend, Oregon.

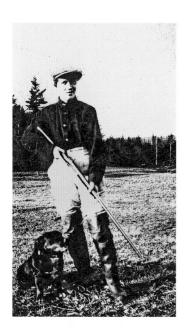

FIGURE 113

Irene Tiviola. Unused RPPC,
1913–1922, 6.9 × 11.5 cm.

something in mind besides the abundance, however, noting, "the girls kill deer the same as the boys." As we move into the twentieth century, more photographs of women practically dressed for hunting become available. Figure 113 presents Irene Tiviola from Michigan, who is poised for the hunt with her rifle and wearing garments that are better designed for tromping around the woods than are skirts and petticoats.

Although I'm not trying to provide a history of women's hunting clothing here, the clothing does give a sense of lingering uneasiness about the gender boundaries that are crossed when women pick up guns and presume to issue death "the same as the boys." The photographic evidence shows that women hunted and shot through the turn of the century. In fact, until World War I, women were treated in magazine and newspaper advertising as competent hunters and were actively recruited by advertising culture and sporting organizations for the sport of trapshooting, which had the advantage of allowing one to wear genteel clothing rather than the practical pants and heavy boots that would be required of a real hunter. In *Dressed for the Photographer*, Joan Severa includes a shooting picture from 1887 that shows three beautifully attired women from Alma, Wisconsin, posing with their specially made Schuetzen rifles. They were invited to participate in a Schuetzenverein, a traditional target-shooting society for men. All three dresses are impeccably tailored in the latest fashion.[15] Looking crisp and efficient, they precede decades of media images of women who are dressed to kill. In real life, however, working-class women hunted and dressed game.

Browder comments on the discrepancy between the polished upper-middle-class woman who appears in media and portraits as the recreational hunter or shooter and the working-class women who "haunt the margins of U.S. culture during the late nineteenth century." The photograph she includes in *Her Best Shot* presents us with three females, including a young girl, guns over their shoulders, game in hand, quarry that are probably destined not for the "trophy shelf but for the stewpot."[16] Middle-class and upper-middle-class women learned to shoot and hunt for sport and recreation, and their rural or frontier counterparts hunted for survival. The presence of hunting women on the frontier did not generate nearly as much controversy as their symbolic invasion of the male domain did, as Daniel Justin Herman demonstrates in *Hunting and the American Imagination*. The cultural issue was that America needed women to be vigorous breeders of white babies, and so women's desire to enjoy the healthful atmosphere of wood and glen in hunting sport could be seen as a positive move. At the same time, however, "women's participation in hunting tended to undermine its promotion of manliness, the very trait that hunting was supposed to save."[17]

PICTURING DOGS, SEEING OURSELVES

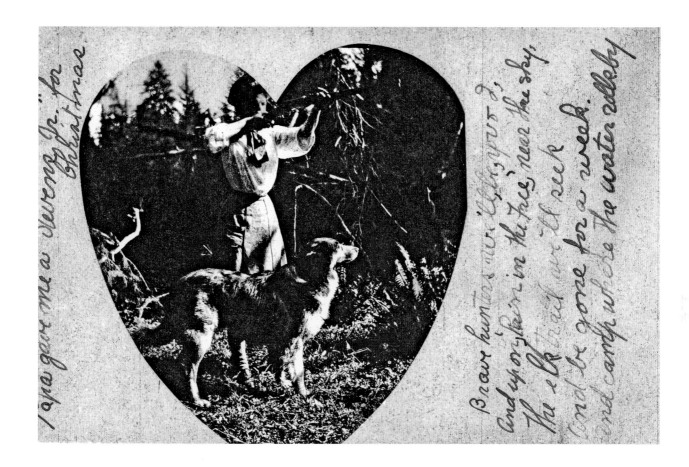

FIGURE 114

Maud G. Used cyanotype RPPC,
1908, 6.9 × 11.5 cm.

Perhaps the idea of girls and women loose in the woods, loose in the world, was just too much for some American writers. Or perhaps, as Elizabeth Janeway suggests, the notable failure of writers to reflect life as it was really lived can be attributed to the tendency of cultural mythmaking "to bring about *what it declares to exist.*"[18] Where literature fails us, pictures supply the rest of the story. While there are many photographs of girls with dogs, photographs of girls with weapons are rare. What we do have are pictures of girls with their dolls, which clearly are the occupational analogue to pictures of boys with guns. But women led far more daring and complicated lives than literature would admit, and we have the visual proof that nicely supports Cogan's argument that American women were not all captives to a cult of true womanhood. Nineteenth- and twentieth-century photographs tell us that girls loved their dogs and that women were successful hunters and sport shooters, something we would not know from reading late nineteenth- and early

twentieth-century literature aimed at a female audience, or from the immensely popular dog stories of the time.

This literary silence robs us of both psychological insight and vicarious experience. For all their overwrought and romanticized prose, the dog and hunting stories offer their readers both escape and access to psychological and spiritual worlds that are at once exciting and beautiful with deferred danger. Real women in fact relished hunting adventures, and like their male counterparts, they were proud of their ability to put food on the table or prove their mettle in the hunt. What we miss in our fictional vaults are the accounts of their joy and a deeper understanding of how they, and those who might have written about them, understood their quest.[19]

To give a glimpse of this missing world, I close with the photograph in figure 114. The young woman in the picture is Maud G., who is writing from somewhere in the vicinity of the Hoh Rainforest in the northwest area of Washington state. She writes to Maude Darnell in Buffalo, Kansas, as follows:

> Clearwater., Dec. 29, '08.
> Dear Maude: Thank you ever so much for the Christmas card, the prettiest one I received. The sun is actually shining today so I've taken advantage of it and printed this card for you. Come and help me use my new gun someday. Lovingly, Maud G.

On the picture side of the card she embellishes her message with a note that reads, "Papa gave me a 'Stevens Jr.' for Christmas," and a limerick:

> *Brave hunters we'll be, you & I*
> *And up on "Rain in the Face," near the sky*
> *The elk trail we'll seek*
> *And be gone for a week*
> *And camp where the water rolls by.*

In the case of women and dogs, one picture is worth all the missing words, and the answer to my opening question, about whether the pretty young woman in figure 98 could be posed with her hunting dog, has to be a resounding yes.

In the past decade we've seen a steady stream of books about remarkable relation-ships with animals. Stacey O'Brien tells about her twenty-year relationship with a barn owl, a story that is notable for the unexpected depths of communication between the bird and the human. Malcolm MacPherson writes movingly in *The Cowboy and His Elephant* about an unlikely partnership between himself and a baby elephant that comes to live on the ranch with him. *The Wild Parrots of Telegraph Hill* documents author Mark Bittner's extraordinary relationship with a flock of par-rots. It seems that many other creatures are capable of profound communication with us when given a chance. While all this anecdotal evidence, not to mention the concomitant talk of cross-species love, could previously have been dismissed by the scientific community, animal studies makes that reflexive move more diffi-cult. Marc Bekoff argues vigorously that anecdote and narrative are "central to the study of animal behavior and animal emotions, as they are to much of science, and rightfully so."[1] Jeffrey Moussaieff Masson says that "we are a story-telling species," and dogs have been central to our stories for centuries. Why? Because they are able to communicate with us like no other species, prompting us to act with them on a shared capacity for love "in all its different manifestations, such as showing sympathy, feeling empathy and expressing compassion."[2] Masson is not alone in

flagging dogs as occupying their own category of special. In this conclusion, I'll take a look at why that is so, and then tie those animal studies insights back to the photographs that have brought us insight through the visual, for I am suggesting that the visual evidence is also a powerful form of cultural narrative.

A short article in the *Washington Post* reports that dogs yawn when they hear people yawn, and in fact are more likely to do so when the yawner is their owner.[3] Is this a physiological response indicating a mere biological similarity, or an empathetic response indicating a more profound cross-species communication? My dog, Rascal, who is not a particularly expressive animal, issues a variety of vocalizations about squirrels and other dogs. He lifts his lips in a canine smile when we come home, wrinkling his nose so much that he sneezes. He focuses intently on my face and demands my eyes when it is supper time or playtime. Every dog owner can minutely detail the communications from her dog. But how did it get that way—that we understand what a dog communicates, that the dog communicates back, and that we invite and relish that communication? Darcy Morey surveys a number of physiological and social factors to explain the human-canine bond, primarily by looking at dog evolution. In the closing chapter of his book *Dogs: Domestication and the Development of a Social Bond*, he examines muzzle length, pack behavior, changes in cerebellum structure, auditory communication, and language receptivity. For example, dogs are uniquely attuned to the human face. In fact, it is theorized that the shorter the dog muzzle, the greater the visual cues available to the canine. The muzzle may have evolved in response to the necessity of communication between canines and humans. Dogs, in other words, have undergone "distinctive physiological changes that render them more receptive to certain forms of human communication than even our closest relatives, the chimps. Indeed, the details of brain structure in dogs changed markedly during domestication, while the animals remained, genetically, all but indistinguishable from wolves."[4]

In concluding his discussion, Morey ventures into the mystical as he ponders the emotional virtuosity of rescue dogs and the musicality of howling, particularly in wolves. The haunting songs of wolves seem to carry a spiritual resonance for us, one that we transfer to our own domesticated canines, as if the song of the wolf is the auditory thread that brings us to our own reverent comprehension of dogs as friends and cherished companions.[5] I've teased Morey, who is my brother, that he really doesn't explain why dogs are so appealing to us, which of course makes him indignant. But even he, ever the scientist, has to resort to the ineffable in trying to describe the emotional bond between humans and dogs. There is something special about this bond, no matter what the physiological, psychological, or evolutionary elements that have composed this relationship.

PICTURING DOGS, SEEING OURSELVES

Increasingly, animal studies scholars are pressing the limits of scientific toler-ance in their enthusiasm for canine empathy. Clinton Sanders frankly proclaims that close observation and anecdotal data provide rich information about animal-human relationships, demonstrating that "our animal companions are thoughtful, emo-tional, intentional, and empathetic partners with us in our social world."[6] In *Loving Animals: Toward a New Animal Advocacy*, Kathy Rudy commences her discussion with the idea that "emotional connections with real animals, connections based on love and shared lives, need to be included in the discourse of animal advocacy in order to maintain and model a better world for them."[7] Jeffrey Moussaieff Masson pro-poses that dogs and humans developed through a kind of reciprocal domestication. Humans and dogs are related through "neoteny," meaning that we find the qualities of the young physically and psychologically appealing. The playful exuberance and unconditioned joy of dogs is a neotenic trait, for example. As humans, we enjoy a prolonged childhood, and we seem to be programmed to find childlike traits dif-ficult to resist. Our disposition to neoteny and the dog's neoteny worked together, Masson suggests, so that this evolving relationship produced two species unique-ly suited for emotional communication and spiritual congress despite the physical barriers. The exchange of beneficial emotions and support was mutual and recipro-cal between humans and dogs; as we domesticated dogs, dogs domesticated us. Their neotenic qualities encourage an emotional suppleness that we would otherwise lack as adults of the species. In Masson's words, "We are striving to remain perpetual adolescents, not in the negative sense of refusing to mature, but in the positive sense of retaining those traits that allow us to remain young at heart."[8]

Masson's championship of the reality of animal emotions and Rudy's advocacy of our affective relationships with animals are part of a controversial and fasci-nating conversation that ranges from animal rights advocates, to animal studies scholars, to scientists of animal behavior. Increasingly, animal studies schol-ars are arguing the merit of anecdotal evidence in considering the possibility of animal emotions, and they are repudiating the common charge that attributing humanlike emotions to animals is a specious anthropomorphizing. Scientists' persistent reluctance to recognize the role of metaphor and storytelling in scien-tific enterprise rejects the point of view of someone like Bekoff, who argues that a good deal of scientific understanding is based upon the data of multiple anecdotes that do in fact become testable narratives, and often essential qualitative evidence that furthers our understanding.

The opposition of scientists to discussion of animal emotions is especially in-teresting because the denial of anecdotal evidence and castigation of anthropo-morphic attribution is so adroitly positioned to assert the superiority of humans,

and white male humans in particular, to all other species. As Masson and McCarthy point out, women are deemed "prone to empathy, hence anthropomorphic error and contamination. Long considered inferior to men precisely on the ground that they feel too much, women were thought to overidentify with the animals they studied. . . . Thus did gender bias and species bias converge in a supposedly objective environment."[9] While the gender bias and species bias of conventional science is a topic for a different book, it is important to acknowledge that the effects of this outlook saturates our cultural landscape.

Feminist scholars who challenge these scientific gender biases have begun a vigorous animal studies conversation, because of the ingrained but largely unacknowledged cultural perception that women are closer to animals (more like animals, less rational, more instinctual) than men, and therefore automatically subordinate to the male of the species. Care theory has been a vital part of feminist and animal rights thinking since the late 1970s, and one of its hallmarks is the idea that the rational, formal, and abstract models for thinking about the world are insufficient tools for our ethical obligations. Emotional and spiritual elements must be part of our information. Often accused of sentimentality, and correspondingly of weakness, this perspective insists that our informed empathy about animals' lives will lead us to find ways to reduce their suffering and exploitation by humans.

The male/female dualism at the heart of patriarchal society is the atavistic basis for much of how we conceptualize the world. Or, as Catherine MacKinnon says, "in spite of the evidence that men socially dominate women and people dominate other animals, the fact that relations of domination and subordination exist between [men and women] is widely denied."[10] Like the entrance of emotion and emotional perception into scientific discussion, the relationship between women, animals, and patriarchy seems to be treated as invisible. Arluke and Sanders, for example, comment on how persons identified with animals—children and African Americans, for example—are infantilized and condescended to as if they were house pets.[11] But they write as though the same issue for women was already resolved, when much of our cultural evidence suggests otherwise.

How to explain the gender blindness of our colleagues? Women have been pondering this mystery for a long time! I think that animal studies offers insightful perspectives, especially when we consider dogs. As noted earlier, dogs cross back and forth between worlds. They transgress the usual species-related boundaries, and they learn to communicate in our world while bringing much of their world with them. The canine facility with cross-cultural relationships isn't always an asset, however. Their fluidity is at once welcomed and repelled, so that even when we account for the variables in the dog-human relationship, it is clear "that

people's attitudes toward dogs remain strangely contradictory," as James Serpell observes.[12] Serpell suggests that this is because our romance with the dog inevitably reminds us of how we treat other animals, as well as bringing us very close to our own animal nature, both topics that cause us discomfort. Dogs serve as mirrors for us, and often we celebrate the ways in which they mirror our emotions and join in our experiences. Additionally, however, we use and abuse dogs as we do many animals, as signs of our power and social dominance. The inconsistency in our treatment of dogs is much like the inconsistency and ambiguity of cultural attitudes toward women, and, as with many a dangerous topic, it remains invisible by the choice of those with the cultural narrative power. The connection between marginalized groups such as women, children, African Americans, and animals is the product of an often pernicious cultural narrative and visual power in which domination is the cultural prize.

Historically, our relationship with dogs, as with all animals, is defined by this consistent thread of domination and mastery. Whether an animal is a companion animal or an instrumental animal, the relationship between the dog and human "epitomized the appropriate relationship between masters and subordinates."[13] In her pioneering study *The Animal Estate,* Harriet Ritvo investigates breeding, pets, zoos, and hunting cultures and provides a complex discussion of how preoccupation with class, sexuality, and society generated double communications about the animal world. The surface communication might express pride, curiosity, or love for the animal. The subliminal communication, however, has always been about domination and exploitation. This double communication, Ritvo suggests, may explain why the prolific metaphorical presence of animals in Victorian life, as in our own, might have escaped the notice of scholars until recently.[14]

Our need to dominate is one part of the equation, but an equally powerful motivation may be our atavistic desire to avoid pollution. Contemplating the extreme ambiguities of our relationship to dogs and how we can seemingly love and loathe them at the same time, several commentators note that dogs are treated in various societies as sources of pollution. The reason we love them is that their love is unconditional, and they do what they are told. The reason we loathe dogs is that they are sexually promiscuous, genital-licking, feces-fascinated and possibly diseased, literal forms of pollution than could also be transmitted to and through humans metonymically.[15] In some contexts, Steve Baker tells us, introducing "animal elements into the image of the body will be understood and acknowledged as a pollution of the purely human."[16] Picturing the beast, then, is a culturally powerful, culturally ambiguous act, and this is why Baker and many others argue that animal representation must be taken seriously. Women have been arguing for at least

two centuries that visual and narrative representations of women in the cultural marketplace do far more than simply reflect "reality." It would be ironic if male scholars finally started paying attention to the visual force of representation because they are newly concerned about animals. In any event, Baker's work forges a parallel pathway with those who are investigating narrative representations of animals. Pictures matter.

The prejudice against using photographs as culturally potent evidence probably stems from much the same prejudices that militate against anecdote in the scientific world. Photographs, like stories, seem too subjective. There is no control; they are too contextually specific to be of utility. But perhaps there is something else at work here besides the rationalist bias. While photographs are responsible for showing us something, when we view them we become responsible for seeing something.[17] Seeing calls forth a responsibility that we may feel ill equipped to handle. In a review of Timothy Pachirat's *Every Twelve Seconds: Industrialized Slaughter and the Politics of Sight*, Tom Bartlett notes how the machinery of civilization depends upon the invisibility of certain activities. Pachirat was interested in "how institutions keep secret from the public, and from their own employees, practices that might cause revulsion were they visible."[18] The spectacle of animal suffering exposes our ambivalence. We can muster indignation over periodic and dramatic accounts of animal cruelty but seemingly never flinch when a corresponding cruelty is visited upon humans. Humane societies learn to select their images of cruelty with an eye toward the middle, because too graphic an image or account and the would-be sympathizers will turn away. Rather like images of the poor, the story must have some measure of aesthetic appeal, lest potential donors are repelled rather than galvanized by the need. At the same time, penalties for animal cruelty are often so modest that it's difficult to see that we are extending our care to the animal world, and child rights advocates would suggest that the same is true for children, who are also property in the eyes of the law. In all of these instances we are considering the impact of what we see when truthful narrative and photographs make visible what goes on behind closed doors. Telling a story, admitting anecdotal evidence, is one kind of insight, but "seeing" doesn't just mean "insight"; it also means literally viewing pictures and being changed by that viewing. Seeing pictures is a physical activity with psychological and narrative impact.

"Photographs excel, more than any other form of either art or journalism," as Susie Linfield reminds us, "in offering an immediate, viscerally emotional connection to the world."[19] Dora Apel and Shawn Michelle Smith argue that "photographic meaning results from what we do with photographic evidence," which is why Laura Wexler's call to overcome photographic *anekphrasis* is so important.

PICTURING DOGS, SEEING OURSELVES

Wexler argues that as a culture, we have avoided taking stock of our visual heritage. What we see, what we observe, comes first. But then we must put words to the seeing, and create narratives that re-form the picture with words. Apel and Smith, looking at lynching photographs, provide an urgent rationale for agreeing to see. "In lynching photographs, photographic *evidence* is always a matter of visual *culture*, and visual culture can be a matter of life or death."[20] In *American Archives*, Smith amplifies this argument as she considers the ways in which archival collections of photographs codify and racialize American identities. The visual collections of our history function as sites through which "narratives of national belonging and exclusion are produced." Moreover, archives mark "the limits of white middle-class American identity," a function that simultaneously surveys the "social body for 'deviant' outsiders. At the same time, the family photograph album offered individuals a colloquial space in which to display practices of national belonging,"[21] as we have seen in chapters 3 and 4 of this volume.

Smith is highlighting the implicit politics of what I have called here vernacular photography. That is, she and many others insist upon and document the cultural power that emanates from the visual force of photographs from the quotidian. Linfield tackles the question of the political efficacy of photography, noting some of the same contradictions mentioned above—that seeing too much of real human suffering can paralyze a potentially sympathetic audience, for example. Nonetheless, Linfield argues that pictures can and do make a difference, and that the truths they offer, no matter how partial or incomplete, are part of the story we are asked to attend to.

Linfield's topic—wartime photography—is much more portentous than mine, of course, and I'm not trying to lend pictures of dogs the same moral valences that adhere to wartime photography or to Apel and Smith's lynching photographs. But my pictures are part of the larger enigma of our visual record, preserving as they do only part of a relationship, leaving undisclosed the full story while offering truth nonetheless. My discussion complicates our pleasure in our dogs by looking at how the dog assumes multiple visual purposes in the photographs. The canine body is a semaphore of our own cultural values and prejudices, and so discussion of the pictures takes us into uncomfortable territory. Readers are asked to think about race and class and gender, and to become attuned to the visual rhetoric that is displayed and make the leap from the picture to our own values and prejudices. Readers are also invited to consider stories—how they inform, shape, or conceal identities—and how stories and pictures may form common cultural pathways.

Although I am aware of the questionable reality that may be on display in any given photograph, I am asserting the simultaneous documentary and generative

function of these photographs. They may not have meaning when isolated as single images, but photographs can reassume meaning when considered in thoughtfully gathered groupings. As Smith has pointed out, many photographic groupings also are sites through which cultural power is accrued and distributed. From archival collections to groups like mine, photographs show us something real. Linfield argues that photographs do have realistic and documentary significance, and that when we look at a picture we are right to consider also the "histories, the politics, the *world* that gave birth to it."[22] She pursues this argument fully and passionately in *The Cruel Radiance: Photography and Political Violence*, refusing to accede to the idea that photographs can have no moral or narrative meaning. As she comments, "it seems churlish to continually deride photographs, as so many critics have, for their inability to tell us more than they do. Photographs cannot express complete truths, and in this they are radically imperfect." Additionally, photographs may be misleading or deceptive, and this is certainly disappointing. "But many things in life are disappointing; in this sense photographs, far from being magic, are pretty much like everything else."[23] Why not, she asks, use them as best we can, knowing that we need all the clues and hints we can get in understanding our imperfect world.

One of the paradoxical outcomes of Linfield's book is that her investigation of suffering exposes unimaginable horror and cruelty, but also beauty. Linfield talks about how our horror of finding beauty in the wrong places prevents us from seeing when we should. Some photographers argue that images of war and cruelty should be taken and printed without aesthetic regard, lest we inadvertently elevate the cruel events being photographed. Linfield disagrees with this approach, arguing that even under dire circumstances beauty can be apprehended. What else is the dignity of the poor, or the tenderness of a soldier for a fallen comrade, or the grace of a child facing unimaginable loss, if not a moment of beauty in unlikely circumstances?

There is no escaping the ambiguity of photographs and our responses to them, but for Linfield that ambiguity may not be used as an excuse for pushing the images aside or refusing our own obligation to see. "There is no doubt that we approach photographs, first and foremost, through emotions," Linfield claims, and it is this emotional pathway that makes photographs such powerful cultural moments.[24] This is true even of my antique photographs, some of which are clearly studied presentations and others of which are improvised. Kathy Rudy might agree, but for different reasons. She proposes that we consider a cultural change toward animals that will be accomplished through affective shifts in how we understand the role of emotion and reason in our relationships with animals. Rudy suggests that "affect" is a combination of emotion and reason—the full coin created by the comingling of the two faculties, and that our relationships with animals are created by this

comingling. Because of affect, our "attachments and enmeshments transform us in ways that seem magical and otherworldly," Rudy says, and this is especially true of our relationships with animals.[25] Photographs, like stories, are part of what establish and nurture the affective pathway.

Rudy's work celebrates the narrative that is part of the affective perspective, but I expect that she would welcome the photographic evidence as well, for these common, ordinary antique photographs also attest to the ineffable quality of our relationship with animals, and particularly with dogs. So it is the beauty of ordinary lives—images and stories in a vernacular tongue—gathered here and reimmersed in some of their cultural dimensions, that I want to celebrate in closing. The photographs that generated this book were composed in the midst of real lives, and their presence links us to our cultural ancestors in all the gratifying ways we might imagine. We share dog love with them. As we have seen, sometimes that love, once examined, doesn't seem so loving after all. This is a romance with its dark side, but it is also replete with the qualities of beauty that Linfield names: dignity, tenderness, grace.

VERNACULAR BEAUTY

Teresa Mangum suggests that the anticipated or actual movement of a dog is an intriguing, implicit element in a photograph, pointing to the brief, pithy André Bazin essay "Death Every Afternoon," in which Bazin talks about the temporal properties of cinema that lend our memories of images the same power as the actual event. Only cinema can repeat or undo an event repeatedly, in which case the moment at stake—death—can be deferred and recapitulated endlessly. A photograph has similar documentary value but cannot always reveal the dramaturgic essence of life. Only motion can do that. When the dog moves in the picture (thus creating a blur where the motion occurred), it reminds us of "the alternate beingness of the dog that is so often incidental in the photograph."[26] The motion reminds us that the life captured in the frame or flickering in the margins of the photo is irrecoverable. This quality of photographs is part of the fascination of these images of people and animals who are no longer alive. Hunting photographs, argues Nigel Rothfels, are not so much about displaying the vanquished animal as they are about "an attempt to make sense of death."[27] While Rothfels is overly generous in this assessment, he's not entirely wrong. Perhaps when we linger over these images we are hunting for understanding of that moment that comes to us all, the death that has taken the subjects before us and yet left these compelling but truncated memories of them behind. We are seeking, yearning even, to reconnect with the life that once moved before the camera in

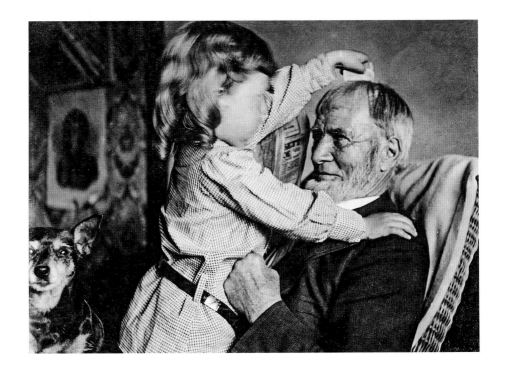

FIGURE 115

Spark and Dwight and Father.
Cabinet card, 1900–1910,
12.2 × 9.5 cm.

order to understand the death that took it away, making our gaze part and parcel of the Edenic impulse that animates our encounter with these images.

Whatever the reason for our fascination with these antique photographs, there is something touching about these images of animals and people long dead. Curiously, while the people sometimes look antique, the dogs look timeless. Having traveled so successfully back and forth between the canine and human worlds, and the male and female worlds, now they navigate with similar facility from one century to another. Figure 115 records the typical position of many a photographed dog. "Spark" is the "face in the corner," joining "Dwight and Father" in a moment of child's play as Dwight combs his grandfather's hair. So much do we take for granted their presence that dogs are often included in the frame inadvertently, often to comical effect (see the introduction, figure 10). In figure 116 a scowling grandfather faces the camera, holding an infant securely behind his clasped hands. His dignity is partially undone, however, by the telephone tower sprouting behind his head, in collusion with the exuberant dog launching itself into the moment.

Although figure 117 is not an especially crisp photograph, the moment is lovely. A woman and a dog have met on the street. The woman kneels to better communicate with the animal, clasping its extended forepaw. The young girl in figure

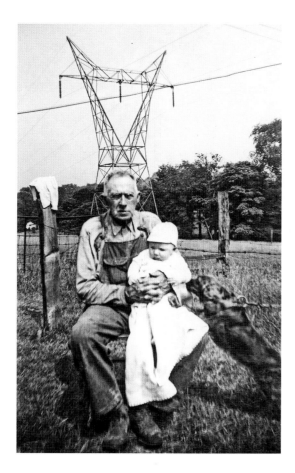

FIGURE 116

Snapshot, 1940s, 7.7 × 13.4 cm.

118 conveys an intensity that gives the image a dramatic feel, a quality amplified by the vertical struts of wood that surround her like an open-air cage. Her gaze reminds me of the young girl poised on the threshold of a dark doorway in chapter 4 (figure 67), as though a coming of age were portended by the image. Clasping her dog and her doll tightly, she faces the future. The young man in figure 119 radiates a palpable confidence. There is a fair amount of unreadable pencil writing on the back of this battered cabinet card. This is Alex Voyle, who has dressed in a nice dark suit but didn't hesitate to gather his worried white pooch onto his lap for the photograph. One hand protectively cups the animal's hindquarters, which might have been slipping in that particular pose. Despite the formality of the moment, Alex has taken time to consider the animal's comfort. The expression on his face is good-natured; there is an appealing hopefulness in his demeanor. He is a young African American man, facing the world in his nice suit and scuffed

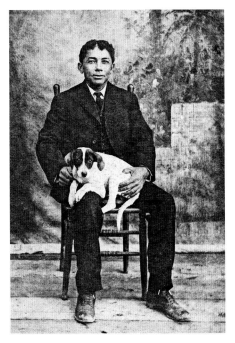

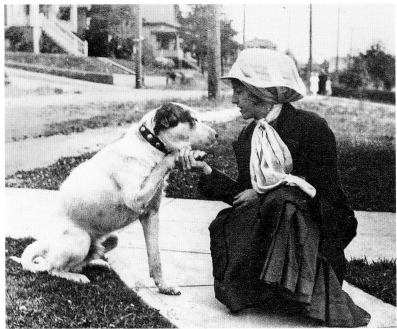

FIGURE 117

[TOP RIGHT] Snapshot, 1910s,
7.9 × 5.3 cm.

FIGURE 118

[BOTTOM RIGHT] Unused RPPC,
1907, 10 × 7.5 cm.

FIGURE 119

[ABOVE] Alex Voyle. Cabinet
card, 1900–1910, 10 × 14.2 cm.

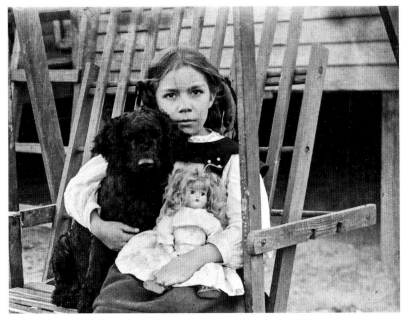

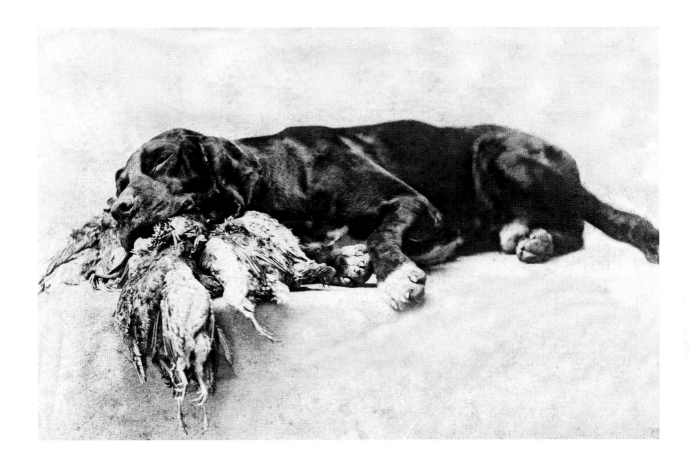

shoes with his dog. His confidence and amiability shine through. Alex Voyle is a refreshing alternative to the coerced images of African Americans attending to someone else's dog.

The reverence with which our ancestors buried dogs and with which many people still dispose of their pets is one poignant attestation to the powerful bond between dogs and humans. Occasionally, we see a photograph of a dog in its coffin, or an animal that has been preserved by the taxidermist for the bereaved owners. Figure 120 features a dog that is probably dead, his last hunt lovingly recorded. The dog's head seems to be cradled by the game that bespeaks his hunting prowess. It's a peaceful image, beautiful in its composure, attesting to a grieving owner outside the frame.

In many of these images, there is a joyfulness that transcends the long-gone moment. Two adolescent boys have been stopped in their adventures and stand proudly, smiling, with their large, capable dog (figure 121). They have some kind

FIGURE 120

Cabinet card, 1890s, 13.9 × 9.9 cm. Photograph by Martin, successor to King. Circleville [Ohio].

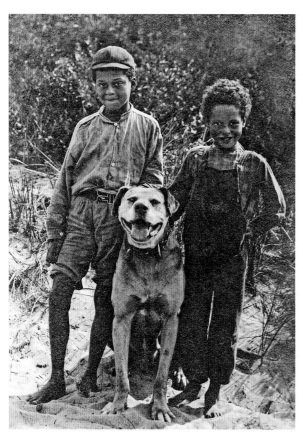

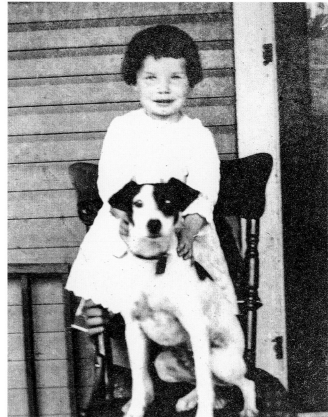

of sandy paradise for their roaming—maybe Florida—and it's not hard to imagine that they have been scouting for snakes, oranges, or turtles. An image that I didn't include because it was so poorly processed records "my wire hair terior John Mutt." The writing is scrawled along the bottom of the art-deco folder that holds the tin-type. The man, dressed in overalls and a big smile, brought a chair out into the street for the dog, probably to make it easier to show off the dog to best advantage. The dog looks just about as alert and happy as his owner. Even without the scribbled words on the paper frame, the pride of the moment is obvious and delightful. There are three beings in figure 122. Nella and her dog seem to be one figure, so effortlessly does the child's body blend with the dog's. Mom is crouched behind the chair, her right hand visible gripping the chair back. The child and dog face the camera with such vitality that this picture could stand for all of the profound and radiant relationships people have had with their dogs.

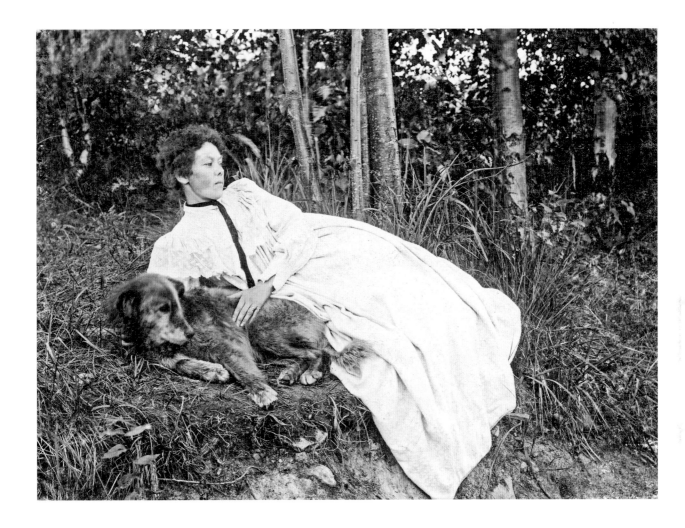

FIGURE 123

Lydia and Yell. Cabinet card,
1900–1910, 15.1 × 11 cm.

The final photograph calls to mind an often quoted, and apparently mistrans-
lated, statement by Claude Levi-Strauss: "Il fait bon penser en compagnie d'un
animal," which Masson translates as "it is good to think when you are in the com-
pany of animals."[28] This sentiment seems a perfect accompaniment to the moment
shared by Lydia and Yell (figure 123). Lydia may be African American. She is wear-
ing what looks to be a wedding band on her left hand as well as a pinkie ring, but,
for whatever reason, she chose to have her picture taken in this natural setting in
an intimate pose with her dog. It's possible that she is positioned on the bank of a
streambed, and she doesn't seem to have worried about getting her clothing dirty.
There is no blanket or piece of carpet to suggest concern about her middle-class

appearance. The flow of her garment, her prone position beside the dog, and her hand on the dog's flank add to a composition that conveys a complex emotional moment in which the two companions are simply together.

This last image captures beautifully the Edenic longings that have accrued to dogs, who, the legend reminds us, voluntarily joined us in our worldly travails. We feel so close to them; they are our best friends. And yet at the same time, we turn a blind eye to the things about their lives we don't want to see, to the ways in which we have conscripted them into our own dubious value systems. Our relationships with dogs, and, increasingly, with other nonhuman forms of life, challenge our sense of species superiority, and our ambivalence about dogs expresses our perception of that challenge. As Serpell concludes, we feel a "profound uncertainty . . . concerning our assumed 'right' to live at the expense of other sentient creatures," and our ambivalence about dogs is a perfect expression of that uncertainty.[29]

The Rockingham/Harrisonburg SPCA in Harrisonburg, Virginia, published a four-year-old's explanation of why dogs don't live longer: "People are born so they can learn how to live a good life—like loving everybody all the time and being nice, right? Well, dogs already know how to do that, so they don't have to stay as long."[30] The images in this book attest to the radically disproportionate impact of dogs in our lives, relative to their actual lifespan. In addition to the fascinating social dynamics recorded through the presence of the dog, these images are evidence of the beauty of the relationship we share with these adaptable creatures, who were with God even before the creation.

PICTURING DOGS, SEEING OURSELVES

NOTES

Preface

1. Cohen and Taylor, *Dogs and Their Women*, ix.
2. Amad, *Counter-Archive*, 18.
3. Olian, *Everyday Fashions*; Blum, *Everyday Fashions of the Twenties*; Dalrymple, *American Victorian Costume*; Harris, *Victorian Fashion in America*.
4. hooks, "In Our Glory," 46.

Introduction

1. Saunders, *Beautiful Joe*, 192.
2. Attributed to Milan Kundera.
3. Mitchell, *Picture Theory*, 334.
4. See Baker, *Picturing the Beast* and *Postmodern Animal*; Lippit, *Electric Animal*; and Wolfe, *Animal Rites* and "Human, All Too Human."
5. Fuller, "Messes Animals Make in Metaphysics," 833.
6. Wolfe, "Human, All Too Human," 565.
7. See Bowron et al., *Best in Show*; Pickeral, *Dog*; Secord, *Dog Painting*.
8. McHugh, *Animal Stories*, 2.
9. Fudge, "Left-Handed Blow," 11.
10. See Lundblad, "From Animal to Animality Studies"; Wolfe, "Human, All Too Human."
11. Wolfe, "Human, All Too Human," 572.
12. Lippit, *Electric Animal*, 6.
13. Ibid., 50–51.
14. Grandin and Johnson, *Animals in Translation*, 57.
15. Leach, *God Had a Dog*, 3.
16. Hoban, *Riddley Walker*, 19–20.
17. Morey, "Burying Key Evidence," 158, 162, 165.
18. Radway, *Reading the Romance*, 119–56.
19. Serpell, *Domestic Dog*, 248.

20. DeKoven, "Why Animals Now"; Adams, *Sexual Politics of Meat*; Donovan and Adams, *Feminist Care Tradition*; and MacKinnon, "Of Mice and Men" discuss the rhetorical connections made between women and dogs.
21. Mason, *Civilized Creatures*, 7.
22. McHugh, *Animal Stories*, 7.
23. Parkhurst, *Dogs of Babel*, 13, 14.
24. Hayes, "Introduction: Visual Genders," 2.
25. Horowitz, *Inside of a Dog*, 119.
26. Berger, "Appearances," 97.
27. Ibid., 128.
28. Hirsch, *Family Photographs*, 45.
29. DeKoven, "Why Animals Now," 363.
30. Ritvo, *Animal Estate*, 91.
31. Wolfe, *Animal Rites*, 8.
32. Garber, *Dog Love*, 129.
33. See Bauer, *Dog Heroes of September 11th*; Dumas, *Retrieved*; Hingson and Flory, *Thunder Dog*.
34. See, for example, Hall et al., "Psychological Impact of the Animal-Human Bond"; Ratliff, "New Tricks from Old Dogs"; and Serpell, "Beneficial Effects of Pet Ownership."
35. Garber, *Dog Love*, 37.

Chapter 1

1. Mace, *Collector's Guide to Early Photographs*, 21; Thomas, *Time in a Frame*, 14.
2. Mensel, "'Kodakers Lying in Wait,'" 29, 31.
3. Greenough and Waggoner, *Art of the American Snapshot*, 14.
4. Schroeder, "Say Cheese!," 110, 115.

5. Information about cabinet cards, *cartes de visite*, and tintypes is drawn from Mace, *Collector's Guide to Early Photographs*; Moorshead, *Family Chronicle's Dating Old Photographs*; Reilly, *Care and Identification*; and Welling, *Photography in America*.

6. Greenough and Waggoner, *Art of the American Snapshot*, 260.

7. Severa, *Dressed for the Photographer*, 454–540; see image on 514.

8. Ames, *Death in the Dining Room*, 187–88.

9. Information about the RPPC is drawn from Bogdan and Weseloh, *Real Photo Postcard Guide*; Morgan and Brown, *Prairie Fires and Paper Moons*; and Vaule, *As We Were*.

10. Greenough and Waggoner, *Art of the American Snapshot*, 4.

11. Wright, *Building the Dream*, 113.

12. Lears, "From Salvation to Self-Realization," 23.

13. Wexler, *Tender Violence*, 5.

14. Ibid., 59.

15. Linfield, "Treacherous Medium," 6.

16. Trachtenberg, *Reading American Photographs*, xv.

17. Willumson, *W. Eugene Smith*, 16.

18. Orvell, *After the Machine*, 44.

19. Wallis and Willis, *African American Vernacular Photography*, 9.

20. Wexler, *Tender Violence*, 42.

21. Vaule, *As We Were*, 197.

22. Berger, "Appearances," 89.

23. Trachtenberg, *Reading American Photographs*, 208–9.

24. Baker, *Picturing the Beast*, 10, 88.

25. Arluke and Sanders, *Regarding Animals*, 186.

26. Ibid., 67.

27. Weingarten and Williamson, *Old Dogs Are the Best Dogs*, 9.

Chapter 2

1. Quoted in Secord, *Dog Painting*, 15.

2. Ritvo, *Animal Estate*, 91, 93.

3. McHugh, *Dog*, 195.

4. Holland, Spence, and Watney, "Introduction," 1.

5. Fitzgerald, *Great Gatsby*, 8. Hereafter cited parenthetically in the text.

6. Kreilkamp, "Dying Like a Dog," 90.

7. Dessner, "Photography and *The Great Gatsby*," 178.

8. Donaldson, "Possessions in *The Great Gatsby*," 193.

9. Barrett, "'Material Without Being Real,'" 542.

10. Avedon, "Borrowed Dogs," unpaginated.

11. DeKoven, "Why Animals Now," 362.

12. For more on this development, see Grier, *Pets in America*; Jones, *Valuing Animals*.

13. Turner provides a good summary of this dynamic in *Reckoning with the Beast*, 53–59.

14. Ibid., 54.

15. Ritvo, *Animal Estate*, 131.

16. Derr, *Dog's History of America*, 163.

17. McHugh, *Dog*, 101.

18. Derr, *Dog's History of America*, 162.

19. Veblen, *Theory of the Leisure Class*, 141, 142, 40, 51.

20. Litvag, *Master of Sunnybank*, 113.

21. Several editions of *Lad: A Dog* are available. Amazon's best-seller status refers to a 1993 paperback edition with illustrations by Sam Savitt.

22. Bowers, *Dog Owner's Handbook*, 3, 19.

23. Ewen, *Captains of Consciousness*, 79.

24. Ibid., 94.

25. McCandless, "Portrait Studio and the Celebrity," 49.

26. Orvell, *American Photography*, 26–27.

27. Vaule, *As We Were*, 199.

28. Gordon, *Comic Strips and Consumer Culture*, 51.

29. Ibid., 62.

30. Derr, *Dog's History of America*, 238.

31. Jacobson, *Whiteness of a Different Color*, 80.

32. Grant, *Passing of the Great Race*, 60.

33. See Michaels, "Souls of White Folk," 195.

Chapter 3

1. Baker, *Picturing the Beast*, 224.

2. Linfield, *Cruel Radiance*, 71.

3. Derr, *Dog's History of America*, 314–15.

4. Morgan, *Uncle Tom's Cabin as Visual Culture*, 39.

5. See Garber, *Dog Love*, 232.

6. Ormond, *Sir Edwin Landseer*, 13.

7. Quoted in Donald, *Picturing Animals in Britain*, 154, 153.

8. Ibid., 153.

9. Armstrong, *Sounder*, 116.

10. Douglass, "Horrors of Slavery," 371.

11. See Wallis and Willis, *African American Vernacular Photography*.

12. For examples, see Goings, *Mammy and Uncle Mose*.

13. Harris, *Colored Pictures*, 92, 14.

14. See Allen et al., *Without Sanctuary*, for chilling documentation of lynching photographs.

15. Marvin elaborates the ways in which technologies were used to intimidate social outsiders in *When Old Technologies Were New*, 18, 35–36.
16. Smith, *American Archives*, 58.
17. Walker, "Gazing Colored," 66.
18. Genovese, *Roll, Jordan, Roll*, 6.
19. Wexler, *Tender Violence*, 66.
20. Sutherland, "Modernizing Domestic Service," 243.
21. For more on the Mammy image, see Collins, *Black Feminist Thought*, 69–96.
22. I was outbid in the eBay auction for this photo in May 2013. The CDV sold for $455.
23. Harris, *Colored Pictures*, 40–41.
24. Clinton, *Plantation Mistress*, 201–4.
25. Wexler, *Tender Violence*, 89.
26. In my collection I have a photograph of a child in the same kind of garment and hair bow, but his genitals are exposed, so I hesitate to identify the child in figure 58 as male or female.
27. See Derr, *Dog's History of America*; Schaffer, *One Nation Under Dog*.
28. Arluke and Sanders, *Regarding Animals*, 156, 160, 158.
29. Morrison, *Song of Solomon*, 52.

Chapter 4

1. Kuhn, *Family Secrets*, 11.
2. Aries, *Centuries of Childhood*, 415.
3. Wexler, *Tender Violence*, 67.
4. Saunders, *Beautiful Joe*, 119.
5. Grier, *Pets in America*, 153.
6. MacKinnon, "Of Mice and Men," 263.
7. Arluke and Bogdan, *Beauty and the Beast*, 27.
8. For a good study of the transformation of childhood play in recent years, see Chudacoff, *Children at Play*.
9. Mintz, *Huck's Raft*, 135.
10. Garber, *Dog Love*, 59.
11. Morrison, *Playing in the Dark*, 47.
12. Wexler, *Tender Violence*, 60.
13. Willis-Braithwaite, "They Knew Their Names," 13.
14. Wright, *Building the Dream*, 98.
15. For good discussions of the theme of home and family as havens in a heartless world, see Clark, *American Family Home*, 237–43, and Coontz, *Social Origins of Private Life*, 251–86.
16. Wright, *Building the Dream*, 99.
17. Grier, "Decline of the Memory Palace," 56.
18. Wright, *Building the Dream*, 51.

19. Ibid., 112.
20. Ross, "Hearth to Hearth."
21. Grier, "Decline of the Memory Palace," 53.
22. For more on this theme, see Bachelard, *Poetics of Space*, 3–37.
23. Bloomer and Moore, *Body, Memory, and Architecture*, 4–5.
24. Ibid., 46–47.
25. For more on the symbolic significance of furniture and how it articulates class information, see Ames, *Death in the Dining Room*, 7–43.
26. Holland, Spence, and Watney, "Introduction," 1.
27. Hirsch, *Family Photographs*, 70.
28. See especially Grier, "Introduction: Symbols and Sensibility," in *Culture and Comfort*, 1–21. For additional discussion of the social symbolism contained in the parlor, see Grier, "Decline of the Memory Palace."
29. Stokes, "Family Photograph Album," 197.
30. Wexler, *Tender Violence*, 67–68.
31. Holland, Spence, and Watney, "Introduction," 1.
32. Ames, *Death in the Dining Room*, 202, 215.
33. Nixon, *Family Pictures*, 7, 8.
34. Coontz, *Way We Never Were*, 11.
35. Stein, *Art of Racing in the Rain*, 20.

Chapter 5

1. Severa, *Dressed for the Photographer*, 107, 388.
2. For examples, see Olian, *Everyday Fashions*, 22–23.
3. Severa, *Dressed for the Photographer*, 235.
4. For discussion of the management of children's play by gender, see Avery, *Behold the Child*, 155–210; Mintz, *Huck's Raft*, 82–87; and Chudacoff, *Children at Play*, 74–97.
5. Saunders, *Beautiful Joe*, 25.
6. Grier, *Pets in America*, 142.
7. Ibid., 152.
8. On boy culture and masculinity, see Rotundo, *American Manhood*, 31–55, and Seltzer, *Bodies and Machines*, 149–55.
9. Avery, *Behold the Child*, 205, quoting John Habberton, *Some Boys' Doings* (Philadelphia, 1901).
10. Proctor, *Bathed in Blood*, 44.
11. Rotundo, *American Manhood*, 35–36.
12. Ibid., 38.
13. Ibid., 105.
14. Ibid., 228.
15. Kimmel, *Manhood in America*, 92.

16. For further discussion of the male need to dominate and feminize the quarry, see Proctor, *Bathed in Blood*, 37–60; Cartmill, *View to a Death*, 9–14, 28–31.

17. Luke, *Brutal*, 84.

18. Cartmill, *View to a Death*, 238.

19. Luke, *Brutal*, 86, 128.

20. Cartmill, *View to a Death*, 29.

21. Wolfe, *Animal Rites*, 8. For those who enjoy theory, the term in play is Derrida's "carnophallogocentrism," as Wolfe notes. Or "'carnivorous arrogance' (Simone de Beavoir), 'gynocidal gluttony' (Mary Daly), 'sexual cannibalism' (Kate Millet), 'psychic cannibalism' (Andrea Dworkin), and 'metaphysical cannibalism' (Ti-Grace Atkinson)." Terms are cited in Adams, *Sexual Politics of Meat*, 89.

22. Quoted in Seltzer, *Bodies and Machines*, 170.

23. Cited in Kotchemidova, "Why We Say 'Cheese,'" 7.

24. Greenough and Waggoner, *Art of the American Snapshot*, 94.

25. Seltzer, *Bodies and Machines*, 170.

26. Arluke and Bogdan, *Beauty and the Beast*, 148.

27. Proctor, *Bathed in Blood*, 25.

28. Ibid., 27.

29. Arluke and Bogdan, *Beauty and the Beast*, 176.

30. Ibid., 177.

31. Owenby, *Subduing Satan*, 26.

32. Mason, *Civilized Creatures*, 137.

33. Proctor, *Bathed in Blood*, 67.

34. Serpell, *Domestic Dog*, 248.

35. Proctor, *Bathed in Blood*, 44.

36. Derr, *Dog's History of America*, 85.

37. Pendergast, *Creating the Modern Man*, 110.

38. Wood, *Lynching and Spectacle*, 94, 97.

39. Kimmel, *Manhood in America*, 62–67.

40. Bederman, *Manliness and Civilization*, 25.

41. Youngquist, "Cujo Effect," 67.

42. Spiegel, *Dreaded Comparison*, 64.

43. Arluke and Bogdan, *Beauty and the Beast*, 81.

44. The term "microaggression" comes from Derald Wing Sue, *Microaggressions in Everyday Life*. For definitions and perspective on this term, see especially 3–41.

45. For a good account of the use of sled dogs in the settling of the Alaskan frontier, see Derr, *Dog's History of America*, 218–32.

46. Rotundo, *American Manhood*, 229.

47. In *Bodies and Machines*, 166–72, Seltzer discusses the "men-in-furs" trope by examining the writing of Jack London.

48. See Lundblad, "From Animal to Animality Studies."

49. In addition to the Jack London tales, "man and dog" novels include Arthur C. Bartlett's *Spunk, Leader of the Dog Team* (1926) and *Gumpy, Son of Spunk* (1930); Thomas Hinkle's *Trueboy: The Story of a Great Dog* (1928), *Bugle: A Dog of the Rockies* (1929), and *Gray: The Story of a Brave Dog* (1953); James Oliver Curwood's *Kazan the Wolf Dog* (1914) and *Baree: The Story of a Wolf-Dog* (1917); Eric Knight's *Lassie Come Home* (1940), and Jim Kjelgaard's *Outlaw Red* (1953). The persistence of these stories well into the twentieth century suggests just how appealing they were to a variety of readers.

50. Gipson, *Hound-Dog Man*, 12. Hereafter cited parenthetically in the text.

51. The fiest, fyce, fice, or fox terrier was a staple hunting animal for rural families. These dogs policed the barn for rats and treed squirrels or possum. They often were small enough to carry in a saddle bag, and tough and courageous enough to take on a bear. The spelling is variable, and I follow Gipson's spelling.

Chapter 6

1. See Wolitzer, "Second Shelf."

2. In *The Sexual Politics of Meat*, 48–60, Adams argues that the traditional male role of hunter accounts for why it is common to think of men as meat eaters and meat as a masculine food; Luke, in *Brutal*, 81–108, elaborates on the connection between hunting and male erotic power over the environment.

3. Proctor, *Bathed in Blood*, 45, 52.

4. Arluke and Bogdan, *Beauty and the Beast*, 158–60.

5. See, for example, Browder, *Her Best Shot*; Kelly, *Blown Away*; and Homsher, *Women and Guns*.

6. Stange, *Woman the Hunter*, 125.

7. Severa, *Dressed for the Photographer*, 451, 488, 496.

8. Olian, *Everyday Fashions*, 3, 100.

9. For discussion of women's roles in establishing humane societies then and now, consult Beers, *For the Prevention of Cruelty*, 8–10, 39–58; Gaarder, *Women and the Animal Rights Movement*, 41–60.

10. Mintz, *Huck's Raft*, 195.

11. Cott, "On Men's History and Women's History," 207.

12. Severa, *Dressed for the Photographer*, 88. For discussion of the bloomer, see 87–89, 275.
13. Browder, *Her Best Shot*, 40.
14. Ibid., 75–93.
15. Severa, *Dressed for the Photographer*, 434–35.
16. Browder, *Her Best Shot*, 11.
17. Herman, *Hunting and the American Imagination*, 232.
18. Janeway, *Man's World, Woman's Place*, 37.
19. For an idea of what the record might contain, see Stange, *Heart Shots*, which reproduces essays, letters, and memoirs by women about hunting. Selections range from 1900 to the early twenty-first century.

Conclusion

1. Bekoff, *Emotional Lives of Animals*, 121.
2. Masson, *Dog Who Couldn't Stop Loving*, xi.
3. Marcos, "Dogs Yawn When They Hear People Yawn."
4. Morey, *Dogs*, 194.
5. Ibid., 224–25.
6. Sanders, *Understanding Dogs*, 148.
7. Rudy, *Loving Animals*, xii.
8. Masson, *Dog Who Couldn't Stop Loving*, 98.

9. Masson and McCarthy, *When Elephants Weep*, 33.
10. MacKinnon, "Of Mice and Men," 264.
11. Arluke and Sanders, *Regarding Animals*, 172.
12. Serpell, *Domestic Dog*, 254.
13. Ritvo, *Animal Estate*, 20.
14. Ibid., 6.
15. Ibid., 175; Serpell, *Domestic Dog*, 254.
16. Baker, *Picturing the Beast*, 224.
17. Linfield, *Cruel Radiance*, 60.
18. Quoted in Bartlett, "Seeing Is Believing," B15.
19. Linfield, *Cruel Radiance*, 22.
20. Apel and Smith, *Lynching Photographs*, 41.
21. Smith, *American Archives*, 5–6.
22. Linfield, *Cruel Radiance*, xvii.
23. Ibid., 201–2.
24. Ibid., 22.
25. Rudy, *Loving Animals*, xviii.
26. Mangum, personal correspondence with the author.
27. Rothfels, "Trophies and Taxidermy," 136.
28. Masson, *Dog Who Couldn't Stop Loving*, 89.
29. Serpell, *Domestic Dog*, 255.
30. "Why Dogs Don't Live Longer."

Adams, Carol J. *The Sexual Politics of Meat: A Feminist-Veg-etarian Critical Theory*. Twentieth anniversary edition. New York: Continuum, 2010.

Allen, James, Hilton Als, John Lewis, and Leon F. Litwack. *Without Sanctuary: Lynching Photography in America*. Santa Fe: Twin Palms, 2005.

Amad, Paula. *Counter-Archive: Film, the Everyday, and Albert Kahn's Archives de la Planète*. New York: Columbia University Press, 2010.

Ames, Kenneth L. *Death in the Dining Room and Other Tales of Victorian Culture*. Philadelphia: Temple University Press, 1992.

Apel, Dora, and Shawn Michelle Smith. *Lynching Photographs*. Berkeley: University of California Press, 2007.

Aries, Philippe. *Centuries of Childhood: A Social History of Family Life*. Trans. Robert Baldick. New York: Vintage Books, 1962.

Arluke, Arnold, and Robert Bogdan. *Beauty and the Beast: Human-Animal Relations as Revealed in Real Photo Postcards, 1905–1935*. Syracuse: Syracuse University Press, 2010.

Arluke, Arnold, and Clinton R. Sanders. *Regarding Animals*. Philadelphia: Temple University Press, 1996.

Armstrong, William H. *Sounder*. 1969. New York: Harper & Row Perennial Library, 1989.

Avedon, Richard. "Borrowed Dogs." In *Richard Avedon Portraits*, exh. cat. New York: Harry N. Abrams and the Metropolitan Museum of Art, 2002.

Avery, Gillian. *Behold the Child: American Children and Their Books, 1621–1922*. Baltimore: Johns Hopkins University Press, 1994.

Bachelard, Gaston. *The Poetics of Space*. Foreword by John R. Stilgoe. 1964. Boston: Beacon Press, 1994.

Baker, Steve. *Picturing the Beast: Animals, Identity, and Representation*. 1993. Urbana: University of Illinois Press, 2001.

———. *The Postmodern Animal*. London: Reaktion Books, 2000.

Baldwin, James. "Going to Meet the Man." In Baldwin, *Going to Meet the Man: Stories*, 229–49. New York: Vintage International, 1995.

Barrett, Laura. "'Material Without Being Real': Photography and the End of Reality in *The Great Gatsby*." *Studies in the Novel* 30, no. 4 (1998): 540–57.

Bartlett, Arthur C. *Gumpy, Son of Spunk: The Story of a Little Sled Dog with a Big Heart*. Illustrated by Harold Cue. Boston: W. A. Wilde, 1930.

———. *Spunk, Leader of the Dog Team*. Illustrated by P. L. Martin. Boston: W. A. Wilde, 1926.

Bartlett, Tom. "Seeing Is Believing." *Chronicle Review*, December 2, 2011, B15.

Bauer, Nona Kilgore. *Dog Heroes of September 11th: A Tribute to America's Search and Rescue Dogs*. Allenhurst, N.J.: Kennel Club Books, 2006.

Bazin, André. "Death Every Afternoon." Translated by Mark A. Cohen. In *Rites of Realism: Essays on Corporeal Cinema*, ed. Ivone Margulies, 27–31. Durham: Duke University Press, 2003.

Bederman, Gail. *Manliness and Civilization: A Cultural History of Gender and Race in the United States, 1880–1917*. Chicago: University of Chicago Press, 1995.

Beers, Diane L. *For the Prevention of Cruelty: The History and Legacy of Animal Rights Activism in the United States*. Athens, Ohio: Swallow Press, 2006.

Bekoff, Marc. *The Emotional Lives of Animals.* Novato, Calif.: New World Library, 2007.

Berger, John. *About Looking.* New York: Pantheon Books, 1980.

——. "Appearances." In John Berger and Jean Mohr, *Another Way of Telling,* 83–129. London: Writers and Readers, 1982.

Bittner, Mark. *The Wild Parrots of Telegraph Hill: A Love Story . . . with Wings.* New York: Three Rivers Press, 2005.

Bloomer, Kent C., and Charles W. Moore. *Body, Memory, and Architecture.* New Haven: Yale University Press, 1977.

Blum, Stella, ed. *Everyday Fashions of the Twenties, as Pictured in Sears and Other Catalogs.* New York: Dover, 1981.

Bogdan, Robert, and Todd Weseloh. *Real Photo Postcard Guide: The People's Photography.* Syracuse: Syracuse University Press, 2006.

Bowers, Fredson Thayer. *The Dog Owner's Handbook.* Boston: Houghton Mifflin, 1936.

Bowron, Edgar Peters, Carolyn Rose Rebbert, Robert Rosenblum, and William Secord. *Best in Show: The Dog in Art from the Renaissance to Today.* Exh. cat. New Haven: Yale University Press, 2006.

Brackman, Barbara, and Jane Brackman. *The Dog in the Picture.* Lawrence, Kans.: Sirius Press, n.d.

Browder, Laura. *Her Best Shot: Women and Guns in America.* Chapel Hill: University of North Carolina Press, 2006.

Burnett, Frances Hodgson. *Little Lord Fauntleroy.* Illustrated by Reginald Birch. 1886. New York: Charles Scribner's Sons, 1955.

Cameron, W. Bruce. *A Dog's Purpose: A Novel for Humans.* New York: Forge, 2010.

Cartmill, Matt. *A View to a Death in the Morning: Hunting and Nature Through History.* Cambridge: Harvard University Press, 1993.

Chudacoff, Howard P. *Children at Play: An American History.* New York: New York University Press, 2007.

Clark, Clifford Edward, Jr. *The American Family Home, 1800–1960.* Chapel Hill: University of North Carolina Press, 1986.

Clinton, Catherine. *The Plantation Mistress: Woman's World in the Old South.* New York: Pantheon Books, 1982.

Cogan, Frances B. *All-American Girl: The Ideal of Real Womanhood in Mid-Nineteenth-Century America.* Athens: University of Georgia Press, 1989.

Cohen, Barbara, and Louise Taylor. *Dogs and Their Women.* Boston: Little, Brown, 1989.

Collins, Patricia Hill. *Black Feminist Thought: Knowledge, Consciousness, and the Politics of Empowerment.* Boston: Unwin Hyman, 1990.

Coontz, Stephanie. *The Social Origins of Private Life: A History of American Families, 1600–1900.* New York: Verso, 1988.

——. *The Way We Never Were: American Families and the Nostalgia Trap.* New York: Basic Books, 1992.

Cott, Nancy. "On Men's History and Women's History." In *Meanings for Manhood: Constructions of Masculinity in Victorian America,* ed. Mark C. Carnes and Clyde Griffen, 205–11. Chicago: University of Chicago Press, 1989.

Curwood, James Oliver. *Baree: The Story of a Wolf-Dog.* 1917. N.p.: Feather Trail Press, 2009.

——. *Kazan the Wolf Dog.* 1914. New York: Grosset & Dunlap, 1941.

Dalrymple, Priscilla Harris. *American Victorian Costume in Early Photographs.* New York: Dover, 1991.

DeKoven, Marianne. "Why Animals Now?" *PMLA* 124 (March 2009): 361–69.

Derr, Mark. *A Dog's History of America: How Our Best Friend Explored, Conquered, and Settled a Continent.* New York: North Point Press, 2004.

Dessner, Lawrence Jay. "Photography and *The Great Gatsby.*" In *Critical Essays on F. Scott Fitzgerald's "The Great Gatsby,"* ed. Scott Donaldson, 175–86. Boston: G. K. Hall, 1984.

Donald, Diana. *Picturing Animals in Britain, 1750–1850.* New Haven: Yale University Press, 2007.

Donaldson, Scott. "Possessions in *The Great Gatsby.*" *Southern Review* 37, no. 2 (2001): 187–210.

Donovan, Josephine, and Carol J. Adams, eds. *The Feminist Care Tradition in Animal Ethics: A Reader.* New York: Columbia University Press, 2007.

Douglass, Frederick. "The Horrors of Slavery and England's Duty to Free the Bondsman: An Address Delivered in Taunton, England, on September 1, 1846." In *The Frederick Douglass Papers: Series One—Speeches, Debates, and Interviews,* ed. John Blassingame et al., 1:371. New Haven: Yale University Press, 1979. http://www.yale.edu/glc/archive/1081.htm.

Dumas, Charlotte. *Retrieved.* Los Angeles: Ice House, 2011.

Eichhorn, Gary E., and Scott B. Jones. *The Dog Album: Studio Portraits of Dogs and Their People*. New York: Stewart, Tabori & Chang, 2000.

Erdrich, Louise. *The Last Report on the Miracles at Little No Horse*. New York: HarperCollins, 2001.

Ewen, Stuart. *Captains of Consciousness: Advertising and the Social Roots of the Consumer Culture*. 1976. Twenty-fifth anniversary edition. New York: Basic Books, 2001.

Faulkner, William. *The Bear*. In Faulkner, *Three Famous Short Novels: Spotted Horses, Old Man, The Bear*. New York: Vintage Books, 1961.

Fiedler, Leslie A. *Love and Death in the American Novel*. 1960. New York: Stein and Day, 1975.

Fitzgerald, F. Scott. *The Great Gatsby*. 1925. New York: Scribner, 1995.

Fudge, Erica. "A Left-Handed Blow: Writing the History of Animals." In *Representing Animals*, ed. Nigel Rothfels, 3–18. Bloomington: Indiana University Press, 2002.

Fuller, B. A. G. "The Messes Animals Make in Metaphysics." *Journal of Philosophy* 46, no. 26 (1949): 829–38.

Gaarder, Emily. *Women and the Animal Rights Movement*. New Brunswick: Rutgers University Press, 2011.

Garber, Marjorie. *Dog Love*. New York: Simon & Schuster, 1997.

Genovese, Eugene D. *Roll, Jordan, Roll: The World the Slaves Made*. New York: Pantheon Books, 1974.

Gibson, Robin. *The Face in the Corner: Animals in Portraits from the Collections of the National Portrait Gallery*. London: National Portrait Gallery, 1998.

Gipson, Fred. *Hound-Dog Man*. New York: Harper & Brothers, 1947.

———. *Old Yeller*. New York: Harper Trophy, 1956.

Goings, Kenneth W. *Mammy and Uncle Mose: Black Collectibles and American Stereotyping*. Bloomington: Indiana University Press, 1994.

Gordon, Ian. *Comic Strips and Consumer Culture, 1890–1945*. Washington, D.C.: Smithsonian Institution Press, 1998.

Grandin, Temple, and Catherine Johnson. *Animals in Translation: Using the Mysteries of Autism to Decode Animal Behavior*. New York: Harcourt, 2005.

———. *Animals Make Us Human: Creating the Best Life for Animals*. Boston: Houghton Mifflin Harcourt, 2009.

Grant, Madison. *The Passing of the Great Race, or The Racial Basis of European History*. New York: Charles Scribner's Sons, 1922.

Greenough, Sarah, and Diane Waggoner, with Sarah Kennel and Matthew S. Witkovsky. *The Art of the American Snapshot, 1888–1978*. Princeton: Princeton University Press, 2007.

Grier, Katherine C. *Culture and Comfort: Parlor Making and Middle-Class Identity, 1850–1930*. Washington, D.C.: Smithsonian Institution Press, 1988.

———. "The Decline of the Memory Palace: The Parlor After 1890." In *American Home Life, 1880–1930: A Social History of Spaces and Services*, ed. Jessica H. Foy and Thomas J. Schlereth, 49–74. Knoxville: University of Tennessee Press, 1992.

———. *Pets in America: A History*. Chapel Hill: University of North Carolina Press, 2006.

Hall, Libby. *Postcard Dogs*. New York: Bloomsbury USA, 2005.

———. *Prince and Other Dogs, 1850–1940*. New York: Bloomsbury USA, 2000.

———. *These Were Our Dogs*. London: Bloomsbury, 2007.

Hall, Molly J., Anthony Ng, Robert J. Ursano, Harry Holloway, Carol Fullerton, and Jacob Casper. "Psychological Impact of the Animal-Human Bond in Disaster Preparedness and Response." *Journal of Psychiatric Practice* 10 (November 2004): 368–74.

Halttunen, Karen. *Confidence Men and Painted Women: A Study of Middle-Class Culture in America, 1830–1870*. New Haven: Yale University Press, 1982.

Haraway, Donna. *The Companion Species Manifesto: Dogs, People, and Significant Otherness*. Chicago: Prickly Paradigm Press, 2003.

Harris, Kristina, ed. *Victorian Fashion in America: 264 Vintage Photographs*. New York: Dover, 2002.

Harris, Michael D. *Colored Pictures: Race and Visual Representation*. Chapel Hill: University of North Carolina Press, 2003.

Hayes, Patricia. "Introduction: Visual Genders." In *Visual Genders, Visual Histories*, ed. Patricia Hayes, 1–19. Malden, Mass.: Blackwell, 2006.

Herman, Daniel Justin. *Hunting and the American Imagination*. Washington, D.C.: Smithsonian Institution Press, 2001.

Hingson, Michael. *Thunder Dog: The True Story of a Blind Man, His Guide Dog, and the Triumph of Trust at Ground Zero*. New York: Thomas Nelson, 2011.

Hinkle, Thomas C. *Bugle: A Dog of the Rockies*. New York: William Morrow, 1929.

———. *Gray: The Story of a Brave Dog*. New York: William Morrow, 1953.

———. *Trueboy: The Story of a Great Dog*. New York: William Morrow, 1928.

Hirsch, Julia. *Family Photographs: Content, Meaning, and Effect*. New York: Oxford University Press, 1981.

Hirsch, Marianne, ed. *The Familial Gaze*. Hanover: University Press of New England, 1999.

———. *Family Frames: Photography, Narrative, and Postmemory*. Cambridge: Harvard University Press, 1997.

Hoban, Russell. *Riddley Walker*. Bloomington: Indiana University Press, 1998.

Holland, Patricia. "Introduction: History, Memory and the Family Album." In *Family Snaps: The Meanings of Domestic Photography*, ed. Jo Spence and Patricia Holland, 1–14. London: Virago Press, 1991.

Holland, Patricia, Jo Spence, and Simon Watney. "Introduction: The Politics and Sexual Politics of Photography." In *Photography/Politics: Two*, ed. Patricia Holland, Jo Spence, and Simon Watney, 1–7. London: Comedia, 1986.

Homsher, Deborah. *Women and Guns: Politics and the Culture of Firearms in America*. Armonk, N.Y.: M. E. Sharpe, 2001.

hooks, bell. "In Our Glory: Photography and Black Life." In *Picturing Us: African American Identity in Photography*, ed. Deborah Willis, 43–53. New York: New Press, 1994.

Horowitz, Alexandra. *Inside of a Dog: What Dogs See, Smell, and Know*. New York: Scribner, 2009.

Jacobson, Matthew Frye. *Whiteness of a Different Color: European Immigrants and the Alchemy of Race*. Cambridge: Harvard University Press, 1999.

Janeway, Elizabeth. *Man's World, Woman's Place: A Study in Social Mythology*. New York: Morrow, 1971.

Johnson, Catherine. *Dogs*. Words by William Wegman and Quotes by Others. London: Phaidon Press, 2007.

Jones, Susan D. *Valuing Animals: Veterinarians and Their Patients in Modern America*. Baltimore: Johns Hopkins University Press, 2003.

Kelbaugh, Ross J. *Introduction to African American Photographs, 1840–1950: Identification, Research, Care, and Collecting*. Gettysburg: Thomas Publications, 2005.

Kelly, Caitlin. *Blown Away: American Women and Guns*. New York: Pocket Books, 2004.

Kimmel, Michael S. *Manhood in America: A Cultural History*. 2nd ed. New York: Oxford University Press, 2006.

Kjelgaard, Jim. *Big Red*. 1945. New York: Scholastic Book Services, 1970.

———. *Snow Dog*. 1948. New York: Yearling Books, 2001.

Knight, Eric. *Lassie Come Home*. Illustrated by Marguerite Kirmse. Chicago: John C. Winston, 1940.

Kotchemidova, Christina. "Why We Say 'Cheese': Producing the Smile in Snapshot Photography." *Critical Studies in Media Communication* 22, no. 1 (2005): 2–25.

Kreilkamp, Ivan. "Dying Like a Dog in *Great Expectations*." In *Victorian Animal Dreams: Representations of Animals in Victorian Literature and Culture*, ed. Deborah Penenholz Morse and Martin Danahay, 81–94. Hampshire, UK: Ashgate, 2007.

Kuhn, Annette. *Family Secrets: Acts of Memory and Imagination*. London: Verso, 1995.

Landes, Joan B., Paula Young Lee, and Paul Youngquist, eds. *Gorgeous Beasts: Animal Bodies in Historical Perspective*. University Park: Pennsylvania State University Press, 2012.

Leach, Maria. *God Had a Dog*. New Brunswick: Rutgers University Press, 1961.

Lears, T. J. Jackson. "From Salvation to Self-Realization: Advertising and the Therapeutic Roots of the Consumer Culture, 1880–1930." In *The Culture of Consumption: Critical Essays in American History, 1880–1980*, ed. Richard Wightman Fox and T. J. Jackson Lears, 3–37. New York: Pantheon Books, 1983.

Linfield, Susie. *The Cruel Radiance: Photography and Political Violence*. Chicago: University of Chicago Press, 2010.

———. "The Treacherous Medium: Why Photography Critics Hate Photographs." *Boston Review*, September–October 2006, 1–14. http://www.bostonreview.net/susie-linfield-why-photography-critics-hate-photographs.

Lippit, Akira Mizuta. *Electric Animal: Toward a Rhetoric of Wildlife*. Minneapolis: University of Minnesota Press, 2008.

Litvag, Irving. *The Master of Sunnybank: A Biography of Albert Payson Terhune*. Lincoln, Neb.: iUniverse, 2001.

London, Jack. *The Call of the Wild*. 1903. New York: Puffin Books, 1994.

———. *White Fang*. 1905. New York: Puffin Books, 1994.

Long, Donna. *The Best Dog in the World: Vintage Portraits of Children and Their Dogs*. Berkeley: Ten Speed Press, 2007.

Luke, Brian. *Brutal: Manhood and the Exploitation of Animals*. Urbana: University of Illinois Press, 2007.

Lundblad, Michael. "From Animal to Animality Studies." *PMLA* 124 (March 2009): 496–502.

Mace, Henry O. *Collector's Guide to Early Photographs*. 2nd ed. Iola, Wisc.: Krause, 1999.

MacKinnon, Catherine A. "Of Mice and Men: A Feminist Fragment on Animal Rights." In *Animal Rights: Current Debates and New Directions*, ed. Cass R. Sunstein and Martha C. Nussbaum, 263–76. Oxford: Oxford University Press, 2004.

MacPherson, Malcolm. *The Cowboy and His Elephant: The Story of a Remarkable Friendship*. New York: St. Martin's Griffin, 2002.

Mangum, Teresa. "Animal Angst: Victorians Memorialize Their Pets." In *Victorian Animal Dreams: Representations of Animals in Victorian Literature and Culture*, ed. Deborah Denenholz Morse and Martine A. Danahay, 15–34. Hampshire, UK: Ashgate, 2007.

———. "Dog Years, Human Fears." In *Representing Animals*, ed. Nigel Rothfels, 35–47. Bloomington: Indiana University Press, 2002.

Marcos, Zuberoa. "Dogs Yawn When They Hear People Yawn." *Washington Post*, May 14, 2012.

Margulies, Ivone, ed. *Rites of Realism: Essays on Corporeal Cinema*. Durham: Duke University Press, 2003.

Marvin, Carolyn. *When Old Technologies Were New: Thinking about Communication in the Late Nineteenth Century*. New York: Oxford University Press, 1988.

Mason, Jennifer. *Civilized Creatures: Urban Animals, Sentimental Culture, and American Literature, 1850–1900*. Baltimore: Johns Hopkins University Press, 2005.

Masson, Jeffrey Moussaieff. *The Dog Who Couldn't Stop Loving: How Dogs Have Captured Our Hearts for Thousands of Years*. New York: Harper, 2010.

Masson, Jeffrey Moussaieff, and Susan McCarthy. *When Elephants Weep: The Emotional Lives of Animals*. New York: Delta, 1995.

McCandless, Barbara. "The Portrait Studio and the Celebrity: Promoting the Art." In *Photography in Nineteenth-Century America*, ed. Martha A. Sandweiss, 49–75. New York: Harry N. Abrams, 1991.

McHugh, Susan. *Animal Stories: Narrating Across Species Lines*. Minneapolis: University of Minnesota Press, 2011.

———. *Dog*. London: Reaktion Books, 2004.

———. "Literary Animal Agents." *PMLA* 124 (March 2009): 487–95.

Mensel, Robert E. "'Kodakers Lying in Wait': Amateur Photography and the Right of Privacy in New York, 1885–1915." *American Quarterly* 43, no. 1 (1991): 24–45.

Michaels, Walter Benn. "The Souls of White Folk." In *Literature and the Body: Essays on Populations and Persons*, ed. Elaine Scarry, 185–209. Baltimore: Johns Hopkins University Press, 1988.

Mintz, Steven. *Huck's Raft: A History of American Childhood*. Cambridge: Belknap Press of Harvard University Press, 2004.

Mitchell, W. J. T. *Picture Theory: Essays on Verbal and Visual Representation*. Chicago: University of Chicago Press, 1994.

Moorshead, Halvor, ed. *Family Chronicle's Dating Old Photographs, 1840–1929*. Toronto: Moorshead Magazines, n.d.

Morey, Darcy F. "Burying Key Evidence: The Social Bond between Dogs and People." *Journal of Archeological Science* 33, no. 2 (2006): 158–75.

———. *Dogs: Domestication and the Development of a Social Bond*. New York: Cambridge University Press, 2010.

Morey, Donald F. "From One Generation to Another: A Pictorial Autobiography." Unpublished memoir, 2007.

Morgan, Hal, and Andreas Brown. *Prairie Fires and Paper Moons: The American Photographic Postcard, 1900–1920*. Boston: David R. Godine, 1981.

Morgan, Jo-Ann. *Uncle Tom's Cabin as Visual Culture*. Columbia: University of Missouri Press, 2007.

Morrison, Toni. *Playing in the Dark: Whiteness and the Literary Imagination*. Cambridge: Harvard University Press, 1992.

———. *Song of Solomon*. New York: Plume, 1987.

Nixon, Nicholas. *Family Pictures: Photographs by Nicholas Nixon*. Washington, D.C.: Smithsonian Institution Press, 1990.

O'Brien, Jack. *Silver Chief: Dog of the North*. 1933. New York: Holt, Rinehart and Winston, 1961.

O'Brien, Stacey. *Wesley the Owl: The Remarkable Love Story of an Owl and His Girl.* New York: Free Press, 2009.

Olian, JoAnne, ed. *Everyday Fashions, 1909–1920: As Pictured in Sears Catalogs.* New York: Dover, 1995.

Ormond, Richard. *Sir Edwin Landseer.* Exh. cat. New York: Rizzoli; London: Thames and Hudson, 1981.

Orvell, Miles. *After the Machine: Visual Arts and the Erasing of Cultural Boundaries.* Jackson: University Press of Mississippi, 1995.

———. *American Photography.* New York: Oxford University Press, 2003.

Owenby, Ted. *Subduing Satan: Religion, Recreation, and Manhood in the Rural South, 1865–1920.* Chapel Hill: University of North Carolina Press, 1990.

Parkhurst, Carolyn. *The Dogs of Babel.* New York: Little, Brown, 2003.

Pendergast, Tom. *Creating the Modern Man: American Magazines and Consumer Culture, 1900–1950.* Columbia: University of Missouri Press, 2000.

Pickeral, Tamsin. *The Dog: 5,000 Years of the Dog in Art.* New York: Merrell, 2010.

Pilling, Arnold. "Dating Early Photographs by Card Mounts and Other External Evidence: Tentative Suggestions." *Image* 17, no. 1 (1974): 11–16.

Pinney, Christopher. *"Photos of the Gods": The Printed Image and Political Struggle in India.* New York: Reaktion Books, 2004.

Playle's Online Auctions. "How to Identify and Date Real Photo Vintage Postcards." http://www.playle.com/realphoto/.

Proctor, Nicholas W. *Bathed in Blood: Hunting and Mastery in the Old South.* Charlottesville: University Press of Virginia, 2002.

Radway, Janice A. *Reading the Romance: Women, Patriarchy, and Popular Literature.* Chapel Hill: University of North Carolina Press, 1991.

Ratliff, Evan. "New Tricks from Old Dogs: Robert Clark, Photographer." *National Geographic,* February 2012, 34–52.

Reilly, James M. *Care and Identification of Nineteenth-Century Photographic Prints.* Rochester, N.Y.: Eastman Kodak, 1986.

Ritvo, Harriet. *The Animal Estate: The English and Other Creatures in the Victorian Age.* Cambridge: Harvard University Press, 1987.

Ross, Alice. "Hearth to Hearth: Cottolene and the Mysterious Disappearance of Lard." *Journal of Antiques and Collectibles,* February 2002. http://www.journalofantiques.com/Feb02/hearthfeb.htm.

Rothfels, Nigel, ed. *Representing Animals.* Bloomington: Indiana University Press, 2002.

———. "Trophies and Taxidermy." In *Gorgeous Beasts: Animal Bodies in Historical Perspective,* ed. Joan B. Landes, Paula Young Lee, and Paul Youngquist, 117–36. University Park: Pennsylvania State University Press, 2012.

Rotundo, E. Anthony. *American Manhood: Transformations in Masculinity from the Revolution to the Modern Era.* New York: Basic Books, 1993.

Rudy, Kathy. *Loving Animals: Toward a New Animal Advocacy.* Minneapolis: University of Minnesota Press, 2011.

Sanders, Clinton R. *Understanding Dogs: Living and Working with Canine Companions.* Philadelphia: Temple University Press, 1999.

Sandweiss, Martha A., ed. *Photography in Nineteenth-Century America.* New York: Harry N. Abrams, 1991.

Saunders, Marshall. *Beautiful Joe: A Dog's Own Story.* 1893. New York: Grosset & Dunlap, n.d.

Schaffer, Michael. *One Nation Under Dog: Adventures in the New World of Prozac-Popping Puppies, Dog-Park Politics, and Organic Pet Food.* New York: Henry Holt, 2009.

Schomburg Center for Research in Black Culture, New York Public Library. *Images of African Americans from the Nineteenth Century.* http://digital.nypl.org/schomburg/images_aa19/.

Schroeder, Fred E. H. "Say Cheese! The Revolution in the Aesthetics of Smiles." *Journal of Popular Culture* 32, no. 2 (1998): 103–45.

Secord, William. *Dog Painting: A History of the Dog in Art.* 2nd ed. Suffolk, UK: Antique Collectors' Club, 2009.

Seltzer, Mark. *Bodies and Machines.* New York: Routledge, 1992.

Serpell, James. "Beneficial Effects of Pet Ownership on Some Aspects of Human Health and Behavior." *Journal of the Royal Society of Medicine* 84 (1991): 717–20.

———, ed. *The Domestic Dog: Its Evolution, Behaviour, and Interactions with People.* Cambridge: Cambridge University Press, 1995.

Severa, Joan. *Dressed for the Photographer: Ordinary Americans and Fashion, 1840–1900.* Kent: Kent State University Press, 1995.

Silverman, Ruth, ed. *The Dog Observed: Photographs, 1844–1983*. New York: Knopf, 1985.

Smith, Shawn Michelle. *American Archives: Gender, Race, and Class in Visual Culture*. Princeton: Princeton University Press, 1999.

———. *Photography on the Color Line: W. E. B. Du Bois, Race, and Visual Culture*. Durham: Duke University Press, 2004.

Spiegel, Marjorie. *The Dreaded Comparison: Human and Animal Slavery*. New York: Mirror Books, 1996.

Staff, Frank. *The Picture Postcard and Its Origins*. New York: Praeger, 1966.

Stange, Mary Zeiss, ed. *Heart Shots: Women Write About Hunting*. Mechanicsburg, Pa.: Stackpole Books, 2003.

———. *Woman the Hunter*. Boston: Beacon Press, 1997.

Stange, Mary Zeiss, and Carol K. Oyster. *Gun Women: Firearms and Feminism in Contemporary America*. New York: New York University Press, 2000.

Stein, Garth. *The Art of Racing in the Rain*. New York: Harper, 2008.

Stokes, Philip. "The Family Photograph Album: So Great a Cloud of Witnesses." In *The Portrait in Photography*, ed. Graham Clarke, 193–205. London: Reaktion Books, 1992.

Sue, Derald Wing. *Microaggressions in Everyday Life: Race, Gender, and Sexual Orientation*. Hoboken: John Wiley & Sons, 2010.

Sutherland, Daniel E. "Modernizing Domestic Service." In *American Home Life, 1880–1930: A Social History of Spaces and Services*, ed. Jessica H. Foy and Thomas J. Schlereth, 242–65. Knoxville: University of Tennessee Press, 1992.

Terhune, Albert Payson. *The Further Adventures of Lad*. New York: Grosset & Dunlap, 1922.

———. *Lad: A Dog*. 1919. New York: Puffin Books, 1959.

Thomas, Alan. *Time in a Frame: Photography and the Nineteenth-Century Mind*. New York: Schocken Books, 1977.

Trachtenberg, Alan. *Reading American Photographs: Images as History, Mathew Brady to Walker Evans*. New York: Hill and Wang, 1989.

Turner, James. *Reckoning with the Beast: Animals, Pain, and Humanity in the Victorian Mind*. Baltimore: Johns Hopkins University Press, 1980.

Vaule, Rosamond B. *As We Were: American Photographic Postcards, 1905–1930*. Boston: David R. Godine, 2004.

Veblen, Thorstein. *The Theory of the Leisure Class: An Economic Study of Institutions*. 1899. New York: Viking Press, 1935.

Walker, Brian. *The Comics Before 1945*. New York: Harry N. Abrams, 2004.

Walker, Christian. "Gazing Colored: A Family Album." In *Picturing Us: African American Identity in Photography*, ed. Deborah Willis, 64–70. New York: New Press, 1994.

Wallis, Brian, and Deborah Willis. *African American Vernacular Photography: Selections from the Daniel Cowin Collection*. New York: ICP/STEIDL, 2005.

Weingarten, Gene, and Michael S. Williamson. *Old Dogs Are the Best Dogs*. New York: Simon & Schuster, 2008.

Welling, William. *Photography in America: The Formative Years*. Albuquerque: University of New Mexico Press, 1978.

Welter, Barbara. *Dimity Convictions: The American Woman in the Nineteenth Century*. Athens: Ohio University Press, 1976.

Wexler, Laura. *Tender Violence: Domestic Visions in an Age of U.S. Imperialism*. Chapel Hill: University of North Carolina Press, 2000.

"Why Dogs Don't Live Longer." *Tattle Tails* (newsletter of the Rockingham/Harrisonburg SPCA, Harrisonburg, Virginia), Winter 2006, 6.

Wilder, Laura Ingalls. *Little House on the Prairie*. 1935. New York: Harper & Row, 1953.

Willis, Deborah, ed. *Picturing Us: African American Identity in Photography*. New York: New Press, 1994.

———. *Reflections in Black: A History of Black Photographers, 1840–Present*. New York: W. W. Norton, 2000.

Willis-Braithwaite, Deborah. "They Knew Their Names." In *VanDerZee: Photographer, 1886–1983*, 8–25. Exh. cat. New York: Harry N. Abrams/National Portrait Gallery, 1994.

Willumson, Glenn G. *W. Eugene Smith and the Photographic Essay*. New York: Cambridge University Press, 1992.

Wolfe, Cary. *Animal Rites: American Culture, the Discourse of Species, and Posthumanist Theory*. Chicago: University of Chicago Press, 2003.

———. "Human, All Too Human: 'Animal Studies' and the Humanities." *PMLA* 124 (March 2009): 564–75.

Wolitzer, Meg. "The Second Shelf: Are There Different Rules for Men and Women in the World of

Literary Fiction?" *New York Times Book Review*, April 1, 2012, 12–13.

Woo, Cameron. *Photobooth Dogs*. San Francisco: Chronicle Books, 2010.

Wood, Amy Louise. *Lynching and Spectacle: Witnessing Racial Violence in America, 1890–1940*. Chapel Hill: University of North Carolina Press, 2009.

Wright, Gwendolyn. *Building the Dream: A Social History of Housing in America*. Cambridge: MIT Press, 1992.

Youngquist, Paul. "The Cujo Effect." In *Gorgeous Beasts: Animal Bodies in Historical Perspective*, ed. Joan B. Landes, Paula Young Lee, and Paul Youngquist, 57–72. University Park: Pennsylvania State University Press, 2012.

INDEX

Page numbers in *italics* indicate illustrations.

parlors, *114*, 114–17, *117*, 121

paternalism, 87, 94

patriarchy, 190

patriotism

 family backyard portraits and imagery suggesting, 107, *108*

 family portraits and props symbolizing, 113, *114*, 115, 116, *117*

 home/domesticity symbolism, 25

Petry, Ann, 88

Photobooth Dogs (Woo), xii

photographic anekphrasis, 44, 192–93

photographs, overview

 active refusal to read, 44, 192–93

 collection development and costs of, xiii

 as cultural evidence, challenges to, 192–94

 dating methods, xiii, xiv, 31, 33

 dogs as compositional enrichments to, *22*, *23*, 23, 24, *24*, 196, *197*

 formats for, 27, 32–35, 38–40, 41

 as narrative artifacts, 15, 44–46, 48, 194

photography, overview

 collection studies, 44–48, 89, 194, 195–202

 early development and conventions in, 27, 28, 30

 hunting metaphors describing, 148

 popularity growth, 30

 race and class oppression, roles in, 85–87, 109–10

 social/documentary roles of, 44–46

 vernacular, 46–48, 195–202

Picturing the Beast (Baker), 8, 49

Pinney, Christopher, 14

pit bulls, *72*, 72–73

play, childhood, 19–20, *20*, 57, 106

politicians, 25, 76, 78–80, *79*

pollution, 49, 191

Pollyanna, 177

"Poor Lil' Mose" (comic strip character), 71–72

porches, *118*, 119–20, *121*, 135

possession displays. *See also* domestic servants

 family portraits and interior home settings, 113–17, *114*, *117*

 frontier property, 123, *124*

 social status and, 16, 28–29, *29*, 30

postcards. *See* real photo postcards (RPPCs)

postmarks, xiii

pothunters, 153

presidents' dogs, 25, 76, 79–80

primitivism, 13, 146

Proctor, Nicholas, 156, 167

props. *See also* backdrops; furniture; guns; replicas, dog

 borrowed, 35, 54, 56, 122, *122*

 cars as, 130, *130*

 of children, 37–38, 38, *39*, 68, *71*, 110, 111, 169, *170*

 classical style as worldliness indicator, 31, 64, 65, *65*, 66

 educational attainment and knowledge, 63, 65, 66, 110, 111, 179, *179*

 for hunting pictures, conventions, 150

 patriotism, 113, *114*, 115, 116

 as social status indicators, overview, 54, 63–65, *65*, 66

purebred dogs

 breed selection indicating social status, 51–54, 56, 58, 179, *179*

 in literature, 59–61

 organizations promoting sport of pedigree breeding, 58

 presidents' selection of, 76

 racial purity and superiority of, 74

 replicas of, 64, *65*

 uselessness of, *69*

Queedle (dog), 37, *38*

race. *See also* African Americans; racism

 civilization associated with, 157

 dogs and boundary-crossing inclusivity, 19, 190

 intolerance and concept of, 105

 middle-class conventions and status, 84

 and mongrelization, 51, 57–58, 74

 racial purity standards and whiteness, 73–74

racism. *See also* domestic servants

 African American status, 77–78, *80*, 80–89, *88*, *89*, 109–10, 156–59, *158*

 collection studies and, 48

 dog metaphors and, 58, 74

 in dog stories, 162

 non-whites as threat, 108–9

 overview, 16–17

 photography as oppression and revictimization tool, 78, 85–87, 109–10

 southern white hunter culture, 17, 83, 102, 155–59

 studio setting restrictions, 35

 white silence as, 82

Rascal (dog), xviii

real photo postcards (RPPCs)

 black Americana and, 85

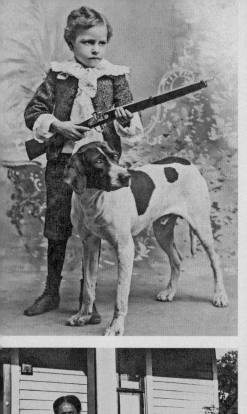

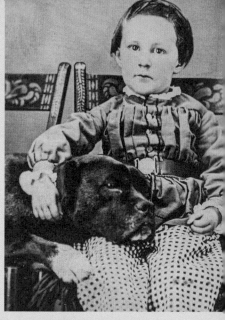
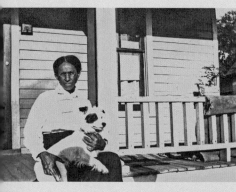
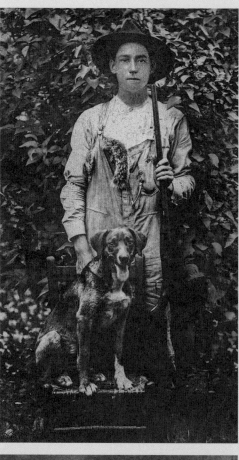
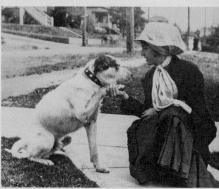
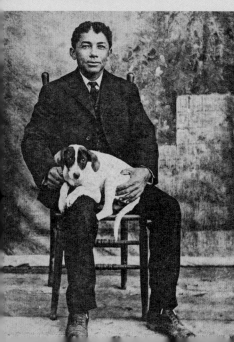
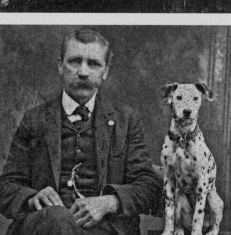
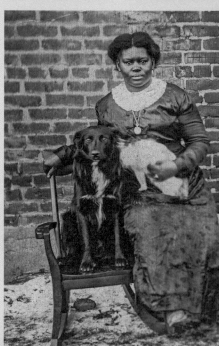